CLARKE WANDERS: THE WORLD

..

OR

HOW A VERY SOBER, MOSTLY VEGAN,
SPINSTER CHEF
WANDERED A WELCOMING WORLD
FOR A YEAR

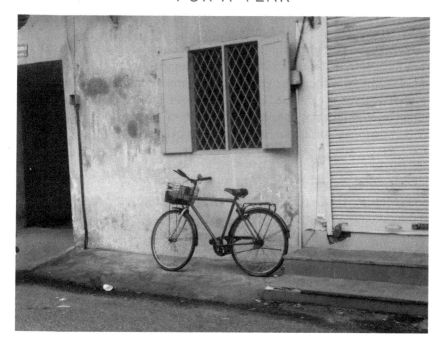

CHRIS CLARKE

Round-the-World Travel Tips and Final Thoughts267

Acknowledgments ..273

This Book is dedicated to my mom,
Joanne Clarke
(The Old Bird).
As without her, there would never have been an Around the World Journey.
Forever with me, wherever I may be.

"It's a dangerous business, Frodo, going out of your door," he used to say. "You step into the Road, and if you don't keep your feet, there is no knowing where you might be swept off to."
—J.R.R. TOLKIEN, *THE FELLOWSHIP OF THE RING*

INTRODUCTION

The working title I wanted for this book was "Eat, Fuck, Run"—though to be truthful, "Eat, Nope, and Occasionally" would have been slightly more accurate. What follows is the story of one woman's experiences traveling the world for a year in search of good food, good people, and a good time.

You were expecting enlightenment? Soul cleansing? You've come to wrong place. This is simply how my life works. Missteps and misadventures abound. Hopefully, I can entertain you for a while, and maybe offer a tiny bit of inspiration.

Food consumes me as much as I consume it. It goes so far beyond hunger that it can only be classified as a personal obsession. The purpose of this book is to share recipes and tales that seduce and entice you, so we're in this together, gentle reader; my passion will be yours.

Who the fuck am I to know what you enjoy or what you are interested in? It's a lofty goal and may sound arrogant. Even pretentious. Food is personal. That is what I do know. So let's start there. Let's you and I get personal while I tell you all about this crazy-ass journey and all the ridiculously sexy food I ate, cooked, and shared.

..

HOW IT ALL BEGAN

I n January of 2015, I lost my position as a corporate chef. It had been a dream job when I first took it; developing recipes, styling food for photo shoots, and creating and curating recipe content for an online grocery delivery start-up. After I was let go, I realized that although it was, in itself, a perfect job, it was not perfect for me. It was like putting an orangutan in a dress. Cute to look at, but not at all practical for either the simian or the garment.

I'd bumped up against this often in my career. Folks warning me I was too "aggressive," "pushy," and that I needed to calm down. Toe the line, they told me, and I would get to where they wanted me to go.

Telling me to calm down, be less aggressive, or become more publicly palatable is like telling a lioness not to hunt. It's fucking inconceivable and for me, an exercise in futility. As the lion does her best for her pride, I do the same for my tribe. It's messy, fun, sexy, awkward, and beautiful. If it makes you uncomfortable and you want kittens and rainbow-shitting unicorns, you'll find them everywhere but here. There is only one me, and I glory in it. So please, join me on this ridiculously good time, and let's wander.

For years now, I have been living by one simple rule: Be Better. And I don't just mean better at eating all the noodles, which I am, so just back off. I sobered my drunk ass up, after years of self-destructive binge drinking. I learned to acknowledge and begin deal with my binge-eating disorder, which initially only exacerbated my binging as a means to cover and hide my emotions. I worked out how to put healthier eats into my gob, when I found out my high cholesterol and belly-fat would definitely kill me by the time I was 45. I began to exercise in a way that would keep me from perishing from obesity or suicide. Running soon became a way for me to calm the anxiety and lift the depression that had long plagued me and were blunted by the tag team of alcohol and food. Eventually, tentatively taking my first steps in the direction of possible romantic relationships by putting myself out there emotionally and physically. I mean I actually dated men! Men who weren't drunk, but actually liked me. How weird is that?

I'd done so much work and seemingly had cracked my life open in a bazillion ways. Yet, I still felt fucked up and boxed in. I was stifling myself; a self-imposed box holding me back.

My unhappiness with my professional life had overflowed into my personal life, and this combination was affecting my physical and mental state. I'd begun to slack on my running, and slowly started to get back into drowning my emotions with sugar, that legal sweet white powder taking the place of alcohol in stunting my emotional awareness. My weight went up in an

inverse relationship to my lowered self-esteem. A ballooning waistline was a true (and visible) daily reminder to how unmindful I had become.

That box that I had allowed myself to be put into (and to some extent put myself into) all these years later needed to be busted wide open. The initial impetus wasn't only the job loss; part was due to the rumblings I felt coming down from the changing political climate in the country. I saw a bright future ahead when Hillary Clinton announced her run for the presidency in April 2015. It was inspiring, and I was ready to throw myself out there in a similar way. Paradigm shift.

I floundered for a month or so trying to find a career. All I know is food. At 15, I got my first restaurant job. The diversity of jobs I've held in the 30-plus years since have all been connected via my kitchen and plate obsessions.

From working with a caterer for 10 years through high school and college to BSing my way into an actual executive chef position in a tiny hometown diner. As a waitress, a head wait, a restaurant manager, cooking-school kitchens manager, cooking-school instructor, working in almost every department of a nationally known organic grocery, then finally the last position at an online grocery. All leading up to this moment.

Although my adventures in food had been varied, I'd never physically traveled farther than Canada and Mexico from the U.S. I knew nothing of the world out there unless I read about it in *National Geographic*. I was always restless, but it was at a fever pitch. Doing something just for me, something I always have wanted to do...could I do it?

I texted my friend KB. ...

"What if...I sold it all and traveled around the world for a year?"

Her response?

"Do it!"

I was hesitant to make the next, but most important call—to my mom, The Old Bird. Being responsible hasn't ever been a strong point for anyone in my family. But my mother said the same thing. "Do it!"

And so, I did. I put my condo on the market, sold or gave away 90% of my possessions (including 15 cases of cookbooks and books!), paid off all my loans (one car and two motherfucking, soul-crushing son-of-a-bitch student), spent months researching, crowdsourcing, sort of planning, and on July 11, 2015, I unmoored myself from a perfectly good life and headed out to see and taste a world that I knew not all that much about.

What Awaits?

It was with happiness that I left what I felt was a strong American culture with a positive outlook. My return only a year later was jarring. I'd brought myself back to a country I barely recognized. This wander I'd taken brought about a shift in my view of the world and my place in it. And then there was that small part of the world I call home, which had also suffered a shattering emotional shift while I was gone.

Before and after my trip, everyone I've talked to about my travels voiced their fear. When I told them of my journey, which 98% of them wistfully envied, they would say, "I could never go, weren't you afraid?" It is a dream for most of us, I think, to chuck it all and head out. And yet I didn't understand why they would exclaim, "You're so brave!" I mean, I see why they might think that, but honestly my only thought 95% of the time was, *Where am I going to eat?* I'll elaborate more on the kindness and the freedom traveling brought me. Ultimately, the world welcomed me, and I it.

My mother instilled in me, from a very young age, that there are connections everywhere you go. In my teens and early 20s, I was mortified by her attempts for me to connect with people I hardly knew. "You can stay with so-and-so, I've known them since I was a teenager," she would nudge me when I was traveling to a new place where I knew no one. Now, after years of her lessons, and then via social media, the connections I have made through her or my own tribe of family, friends, former coworkers, and other like-minded folk, gave me links to people and places around the world that I was now hoping to rely on for both accommodations and advice.

I headed out a few weeks into June 2015, with my car and a few bags of possessions. The first few months were spent visiting family and old friends

in familiar towns along the West Coast of the U.S. When my time catching up and preplanning was at an end and it was time to travel, I handed off my car to a lifelong friend for safekeeping and boarded a plane in Lost Angeles to see where I could go. This was July 30, 2015.

Recipe and Cooking Tips from the Wandering Chef

Not everyone is the nut I am for foreign, ethnic, and sometimes downright weird ingredients. Therefore, the recipes are set up so you can replicate them in a way that is comfortable for you. For example, I may call for vegan margarine, and I'll let you know that butter will work fine.

For those of you who are rabid about following directions, recipes are guidelines, not laws. Add less or more ginger. As always, do what tastes good to you.

When it says season to taste in a recipe, it means just that. I am probably not going to be right by your side when you're making a dish, so you taste it. If it needs more salt or pepper, add it in.

There are some truly easy recipes and some that are way more involved. I hope you'll try all of them. And I understand if you just want to look at the tasty pictures. You're the one who bought the book, you use it as you see fit.

Now back to those crazy ingredients. Most of you have a computer and access to online shopping. You can find 98% of the ingredients there. Though,

as this book is all about adventures taken, I encourage you to use the computer to find where the nearest natural grocers, Asian markets, Indian markets, and farmers' market are. Go search there. You may or may not find what you are looking for, but I'll bet you dollars to doughnuts, you'll find a lot of interesting things. (Green Tea KitKats anyone? #notvegan).

Speaking of vegan, I call myself "Mostly Vegan." Looking at you, *pan au chocolat*.

And if you are vegan, the recipes will work great for you. If you aren't, as stated before, there will be notes so you can use full dairy cheese or chicken broth.

Fair warning, folks: There will also be times in my journey where I ate and took pictures of non-vegan food. When traveling, I wanted to try things that were super amazing, fresh, and the like. And, my goodness, I did.

You do you, and I'll do my mostly vegan me. More *pan au chocolat* anyone?

..

NEW ZEALAND AND AUSTRALIA

Cheers, New Zealand

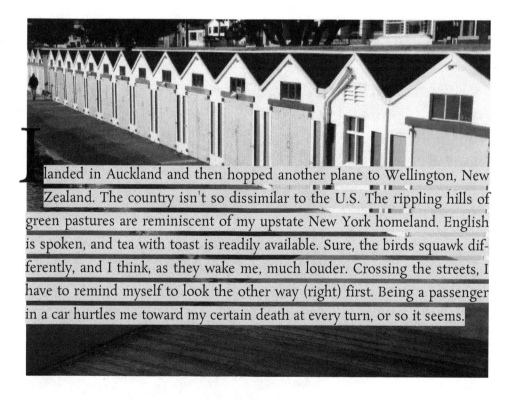

I landed in Auckland and then hopped another plane to Wellington, New Zealand. The country isn't so dissimilar to the U.S. The rippling hills of green pastures are reminiscent of my upstate New York homeland. English is spoken, and tea with toast is readily available. Sure, the birds squawk differently, and I think, as they wake me, much louder. Crossing the streets, I have to remind myself to look the other way (right) first. Being a passenger in a car hurtles me toward my certain death at every turn, or so it seems.

Then I start to see how really things are different. There is no fucking about with sales tax. Instead, whatever the tag or menu says is the price. That's what you pay. It's all factored in. Tim Tams, which consist of two malt-flavored cookies separated by a light chocolate cream filling and coated in a thin layer of textured chocolate, blow Oreos out of the water in the cookie department. There is a sense of environmental responsibility that runs deep, as it's a country made up of islands with limited natural resources. This awareness is only now coming to the forefront as domestic species are being decimated by invasive ones. The rugby here, I am told, is close to religion. When their Rugby World Cup Team lineup is announced in New Zealand parliament, I begin to believe it.

The entire country is set up well for travelers, backpackers, and tourists of all kinds. Every village, town, or city has an i-SITE (information booth), public toilets (well-maintained, clean, and sometimes even works of art, I shit you not!) and a Backpackers (hostel). The bus system (Naked Bus) was inexpensive and efficient. This well-thought-out industry brings tourist money into the country and lets them showcase the incredible natural beauty that abounds there.

Wellington is where I begin, and I've landed softly. My hosts are U.S. expats, the uncle and aunt of a former coworker, living here now for 40+ years. Their hippie streak runs true, and their sweet hospitality helps me settle in. They have taken a local park under their charge, making it almost their life's work, now that they are in their retired years.

Volunteering for almost as long as they have lived here, they remove the strangling foreign species from the land to protect the fragile indigenous plants. The couple and their neighbors set traps to keep intrusive rats at bay, which brings more regional birds home to roost. My trail runs through this green sanctuary bode well for my commitment to continue exercising.

When I wake in the morning, an unfamiliar bird song fills my ears. I'm told they are tuis, riroriros (gray warblers), wood pigeons, and occasionally, screeching kakas. Familiar, yet different.

I begin to explore on my own. The Wellington wind will have none of it. I turn a corner, blithely skipping along, and it blasts me back a few steps. It is winter here in August. It's chilled and damp. Sweaters and warm socks are worn about the house. And I love it. It's the first foreign place I've known, and I'm more than satisfied. Blow, damn you, blow! I lash myself to the mast and set out to wander.

Canada (OK, I guess that's somewhat foreign) gave me a similar feel, where things seemed the same, yet weren't. I have moments of nervousness and anxiety. Will my host family like me? Will I like them (no worries there as they are a delight)? Will I understand how to get around? All that falls away as I begin to make my way around Wellington.

There are bookshops, tea shops, and shops with toast and pastries. Greetings of "How ya goin'?" in thick nasally accents confuse me and make me feel as if I speak another language. I feel ridiculous, but folks are patient with me. Back in the States, two of my dear, older friends, who had traveled through New Zealand some 20 years before, pressed their leftover New Zealand currency into my hands as they bid me bon voyage. This currency proves to be a curiosity when I attempt to use it. Most of the young baristas and counter help have never seen these bills and are unsure if they are still in circulation or of value. One excited young line cook scampers from the back to trade his new bills for my older ones so he can show them off as collector's items. I am, for a very brief moment in time, a minor celebrity. F-list at most.

Wellington is built upon the hills above the harbor, hills that I am itching to run. My running had been hit or miss this past year. My thoughts of run-

ning vastly outnumber the actual runs I go on. One of my caveats with running is the reward of eating after, so I find a dumpling house a short walk from the end

of my first run in my first foreign country. It's a cold, damp day, and the shop is tiny, doing mostly take-away business. The dumplings are being sold by the pair. Spinach, Tofu Bok Choy, and Japanese Six Mushroom crowd the cardboard container I am handed. In a sweet and savory broth, bob plump orbs that are heaven to eat. Dumplings have always made me happy. Running makes me happy. Enjoying both in the same day gives me reason to believe this trip is going to alter my patterns, for the better. Shift

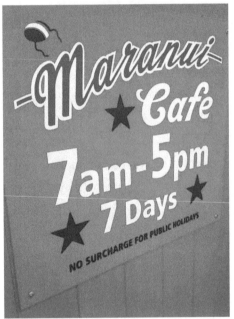

that shit! Move forward!

The wind whips the waves of Wellington Harbor into a spitting, swirling mild blue tempest. It seems incongruous to the warmth I've felt. This frenzied fury of the ocean defies the feeling of what I've only known, so far, to be a sweet and placid place.

My hosts, Bill and Marilyn, take me for brunch at a café where the surf swells and perfect waves lure surfers from around the world.

It's in an old lifeguard-training facility that's still used for training to this day. Colorful and with a hustling energy, the food is perfect, and the company welcome and warm.

A trip to the Weta Workshop has been recommended by Bill. This is where Peter Jackson and crew designed the special effects for his *The Lord of the Rings* films. I'm a longtime *The Hobbit/LOTR* nerd, so my geeking out is palpable. My hosts also take me to the location where the Rivendell scenes were filmed. Since I essentially eat like a hobbit (who doesn't love second breakfast?), it's only natural that I'd want to visit these sites.

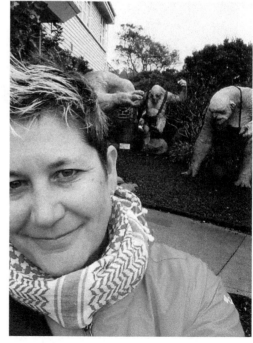

Auckland is the next stop via a nice bus outfitted with both Wi-Fi and electrical outlets. Green rolling hills, quick glimpses of the ocean, and winding mountain roads slip by. A connecting bus is late, causing worry and panic. The hostel I'm headed to in Auckland assures me someone will be at the desk after hours. Yet, I'm anxious and fearful. When I arrive, they are welcoming at the front desk as fellow visitors are uproariously drinking and playing pool in the lobby. Taking the elevator to the dorm many floors above this party relaxes my worry even more.

My first hostel experience resurrects my memories of college dorm living. The creaking bunk beds, whispers, and stumbles in the dark. There is always someone hunkered under their covers for what seems to be a whole day, at which I scoff. But it's warm, dry, cheap, and centrally located.

With only a day to explore, I find tea and toast. Dumplings are a 45-minute walk away, with a bustling Asian market found en route. By not taking the bus, I am stubbornly forcing myself to exercise and interact with my surroundings.

I head north of Auckland to Opua, where a friend of a friend and her partner have graciously offered me a place to stay. They're both tour guides, so I get an in-depth history lesson on the area, and the flora and fauna as well.

She took me tramping about for a day to historic whaling and trade spots. All somewhat reminiscent of Massachusetts, but with a strong Maori influence. The historic U.S. revolutionary landmarks that The Old Bird forced us to see for educational reasons when we were kids are so like these spots in Northern New Zealand that it's a bit eerie.

And then there are kiwis.

Not the fruit, the birds. That night, as the sun is about to set, a trip to Rangihoua Heritage Park and Marsden Cross to take in some local history and then onward to private land to hear the kiwi calls. These are calls that most New Zealanders have never heard. It's home to a good size group of birds. They are a nocturnal, vulnerable, and often endangered bird as they have no protection against non-native predators (dogs, rats, cats, stoats, and ferrets). Man brought danger to New Zealand, where there were no known predators for the birds prior to civilization. To get to hear or see them is a rare and wonderful thing.

We wrap our flashlights in red plastic wrap to filter the light, and then suddenly, there they are. The first we spot is a waddling pregnant mound of unusual fluff. Google "kiwi egg" and you'll find a startling image of an enormous egg filling a relatively tiny skeleton. The largest egg to body ratio of any bird, six times larger than normal! They're weird little things with gargantuan eggs. A male starts to scamper away, as he thinks he can't be seen in our red light. He freezes as if to say, "You can't see me!" These prehistoric remnants are oddly lovely.

The following day, my gracious host suggest a dolphin cruise, where, right out of the harbor, we spot a pod feeding. They swim alongside the boat and then in front for a bit. These are the moments I've been hoping for. The water is rough as we head to an island for another tramp about, enjoying panoramic ocean views and then some seals sunning themselves.

The ocean is so close and such a big part of the life here. Another day, I take a run down a trail that cuts just above the waves. Looking out over the sea helps to settle my mind. The

newness of every single day is starting to grow on me.

Onward I travel and yet another day, another bus, and I'm in Rotorua. Hot springs bubble and geysers blow. I find a trail to run up which leads me into their redwoods. Yep, they have them too. Not native, but magnificent to run through. As I ascend, I can see the steam drifting up from the hot springs in town. I take a dip later in the public hot springs pool as rain mists down upon

me. Warnings are posted to not wear your jewelry, which I don't. But apparently, even the minerals in the residual water left in your wet hair can discolor your jewelry. I find this out the hard way. Ah, well. ...

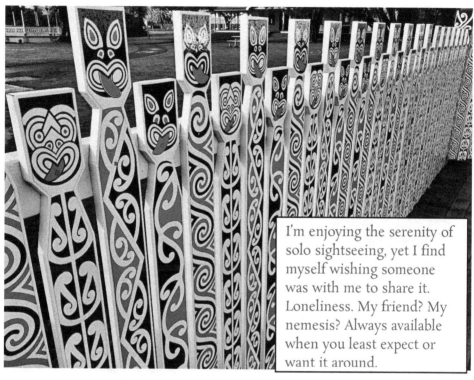

I'm enjoying the serenity of solo sightseeing, yet I find myself wishing someone was with me to share it. Loneliness. My friend? My nemesis? Always available when you least expect or want it around.

I remind myself that this adventure is still a fucking phenomenal thing for me to be doing. And begrudgingly, the loneliness backs off, for now.

My next stop is outside of Linton. Part of my budgeting has me volunteering to offset my room and board. I've found a position via WWOOF where I help on a rambling, animal-filled farm. It is, basically, an animal sanctuary. It's winter at the time, so my tasks are more up-keep oriented, but A-OK when you get to hang with this particular brood. The woman who has

taken these animals into her life is kind, a food lover, and a great resource for restaurants and markets.

There are six dogs; sweet, and a little damaged, but settled into a life of ball tossing, affection, and chases through paddocks. The goats and cows rarely turn their heads to their canine nonsense. Everyone fits. Two cats, one of whom sits up high, lording it over everyone, but no one minds.

Chickens, or "chooks" as they are called in New Zealand, wander about their coop and pen as a peacock protects them. Or at least he thinks he does. It seems the hens will have nothing of him. But still, he proudly struts about as if he holds sway.

My days are spent tidying up after the crew and cooking for the family. It's too cold for any real out-side work, though

one day I'm asked to work on a goat-proof fence. I'm out in the paddock on a blustery day, doing my best with my limited carpentry experience. It'll hold, for now. There will be other volunteers to follow me who will most assuredly do a tighter job.

I'm told head to Napier next. It's a bit similar to the Napa Valley in the U.S.

A gorgeous black sand beach is only 100 yards from my hostel. There are wineries and bike paths. As I'm all sorts of sober, it's the bike paths I head to, renting a bike for a day, winding my way about the off-season, quiet countryside. More tea shops, toasts with Marmite, pastries, and books to burrow into. A large cat holds court in a large

schlumpy chair. I eat a Canadian Nanaimo bar and read an old Andy Capp comic. I've found a comfortable and easy rhythm.

Back to Wellington I go to finish up my New Zealand travels. I fall back into the hospitable home of my hosts. A few more wanderings about town, time spent with a childhood friend, and eating, cooking for/with my hosts, more eating, and many more cups of tea. Now, to Australia.

Landed in Perth on a Monday and it's go, go, go! Perfect for me as I hate sitting still.

Australia feels very familiar as well. So far, I keep finding these comfortable places to be. Denise and her husband, John, are fantastic hosts/tour guides. We have known one another for over 16 years, as we met at a cooking school in Boulder, Colorado, where she was one of my assistants.

When I arrive, we head right over to a Monday market half a block from

their house, because...food! I eat martabak, which is a Middle Eastern or Southeast Asian flatbread filled with lentils and spinach, and had to have some roasted corn as well.

Their neighborhood is a bit outside downtown Perth but very easily reached via bus. And I decide to start getting in a bit of walking. I know that I'll need to get my legs into walking shape for the other countries I'll be visiting.

So I am starting to push myself.

Denise and John have lived and raised their family in several countries and have strong ties in many expat communities around the world. A morning run/walk along the Swan River with a bunch of expat ladies brings me more tea and toast, topped with Vegemite. What is really amazing to see is how open and welcoming the expats are. Their lifestyle isn't one that most Americans would understand. But they have found a way to raise families, pursue

careers, learn, and get involved in their local cultures all the while living a world away from their home countries.

Cooking with/for Denise is always a pleasure; sarcasm, laughter, and that easy kitchen ballet that only those who have cooked together before can know. John is always a willing eater, which makes the table a friendly and comfortable place.

Denise has lined up a few adventures for us. More expat ladies gathered for a bike ride along the coast. The Indian Ocean behind us is a light blue with white caps. Absolutely stunning! Trails are civilized and easy; no real hills. Biking isn't my strong suit, but I know I can see more of a place if I'm on a bike, so I pedal furiously to keep up.

Then more tea, with a caramel slice, which, by the way, may now be my favorite thing ever. ...

Another day, another tea shop, where with tea and a book, I enjoy what has become my favorite way to spend an afternoon.

I am taken to dim sum (because of course I am) by some of the ladies. We are eager to share our favorite dishes and try new ones, like yam cakes with XO sauce. Which, it turns out, is not vegan. Tasted damn good though—maybe I'll develop a veg version.

As it's starting to be spring here, I wander Kings Park with my buddy Gavin (from my hometown) to explore the strange, to us, flowers. Kangaroo paw pops out with its bright red color and curious shape. The park is a floral-filled central Perth getaway. It's a very civilized way to get close to nature. Not the Rocky Mountain National Park wildness in Colorado I'm used to, but quite nice.

I am extremely lucky to have Gavin to drag about for food adventures as well. He's the fifth kid in a crew of four I babysat about some 20-odd years ago. Since he didn't get Clarke time with me then, as he wasn't even born yet, I feel he deserves it now. Not sure he'd agree, but I'm exploring and feeding him, so that's a plus. He's doing a semester at "Uni" here and was open to trying new things.

Like a variety of grilled cheese sandwiches at Ghost Face Thrilla, a tiny storefront down an alley. It is relaxed, with just the right amount of variety in the sandwiches, without going overboard. The concept sparks my interest.

This I could do, but would I? Is this what I want to do when I'm back in the U.S.? I want to stretch myself and my abilities, but here I am in only the second country I've visited on my trip, and I'm already trying to pigeonhole myself. *Relax*, I think, *slow your fucking roll, you've a long way to go yet.*

More dim sum is had with Gavin, Denise, John, and their friends. The communal nature of the dishes brings that sense of comradery to the table that

I so enjoy. "Eat this, have you tried that?" And on and on.

Another time, Denise, Gavin, and I try handmade noodles at Noodle Forum, a small place in a mini mall, right across from a store selling American food, of all things. (Fruit Loops, Kraft Mac & Cheese, etc.) The noodle dough is kneaded the traditional way; using a bamboo rod riding noodle chef. The mound of dough is poured onto a work table, and then the chef rides the rod up and down on the dough to work the gluten, to knead it. Now...that's not something you see every day.

Denise and John make sure to take me to the Saturday farmers' markets.

There I find varieties of both cooked food and fresh vegetables. A Middle Eastern shakshuka, eggs in spicy tomato sauce, becomes breakfast. Not vegan, but when the eggs are this fresh and farm-raised, I partake occasionally.

I'm loving that the farmers' markets here are as popular as they were back in Colorado. But something is off, just like it is in Boulder. There is more diversity in the fruits and vegetables than there is in the clientele. It's whitewashed. Everyone shopping here and back in the States, is, for the most part, white and middle class. I'm a populist when it comes to food. It should be for everyone. One of the things I wanted to look for was a place not like where I have been. Seems I'm still looking.

Hidden corners and spaces camouflaged in seemingly monotonous neighborhoods delight me, and Denise shows me a secret garden that is weird and wonderful. Someone has taken it into their head to fill a tiny area under some trees and bushes with toys, mosaics, and other oddities. If you didn't know it was here, you would walk right by.

Our next adventure is a run/walk through John Forrest National Park. Closer to the wild open spaces I used to play around in back in Colorado. Denise and John both grew up there, so they understand what I'm seeking. John spies a red-tailed black cockatoo ignoring us as it tears into a gum nut. That beak really does a job on the super hard nut, which smell like limes.

I've been hearing from my good friends Ann and Gene about how wonderful Margaret River in South Western Australia is for years now. For almost 10 years, they spent four months out of year there. As I was in Western Australia, I had to go see for myself.

I was lucky enough to stay at Karibu Cottage just outside of town. Libby and Robb, my hosts, are wonderful, gracious, and very knowledgeable about where to go and what to do. They rent the cottage to visitors, like Ann and Gene, for all those years. And I in turn, am able to stay with them through this connection.

A group of kangaroos were hanging out in the paddock throughout my stay. They're like deer that wander about in your backyard. It's surreal to see. If a koala walked up and shook hands with me I wouldn't be surprised at this point. No such luck though.

Libby and Robb have twin girls and a teenage son. The girls attend school locally, while their son is off at uni. One evening the girls lend a hand as we put together tortellini filled with roasted cauliflower and then served topped with arugula pesto and a green veg-filled salad.

I find more avocado toast and cup of tea, or as I like to call it, a cuppa. I have it as often I can when I'm out and about. A major benefit of traveling solo is being able to eat what I want, when I want.

A supposed short jaunt to Prevelly, a surfer's paradise, turns into a good long walking trek, due to my goddamned inborn directional idiocy. The sea is such a blue and storming a bit. It is awe inspiring. I keep having to remind myself that this is the Indian Ocean I'm looking at. Reminding myself that I'm out in a foreign place.

A small café tucked up a hill, looking out over the ocean offers me lunch.

Surfers lounge about here and at the tiny general store next door. What would it take to just live in a place like this? No cares, basic needs met? Why am I thinking this way? I must explore more.

A rental bike and a Rails to Trails path give me another view of the area.

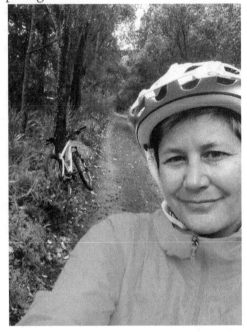

Rain pours down, kangaroos hop across my path, and cows barely register as I shoot by. It is lovely. Messy, wet, muddy, sweaty—every inch of me soaked through and with a big shit-ass grin on my face.

Libby had a recipe for Moroccan Fish, so we served it up with couscous and sides of roasted potatoes and asparagus, both straight from her garden. To finish, a very traditional Aussie and New Zealand dessert, pavlova, that Libby whipped up and served with cream and blueberries. Both countries lay claim to it, as countries will.

Other friends of friends, Lynn and Shirley, hosted us for morning tea surrounded by flowers, guinea fowl, and a friendly golden retriever at their place. The area is remote yet near town. Familiar again; similar to where I grew up,

And let's not forget Molly, Libby, and Robb's poodle. She is a two-time venomous snake bite survivor and very loving. This is the first moment I realize that the dangerous animals of Australia are actually a thing, not just a myth.

Back to Perth I go, where most folks don't, as it is on the western side, the forgotten step sister side, of Australia. Forgotten it may be, but it shouldn't be. It's lively, lovely, filled with amazing restaurants and people.

One morning John pulls out the backup waffle iron—yes, the backup—to make breakfast. He whips up a family recipe of soft, fluffy waffles, and I appreciate not only the food but this amazing couple who have not one but two waffle irons for just such occasions.

I teach a "Mexico in Perth" cooking class to the ex-pat ladies. Denise and I fall into our cooking school rhythm. Some of the students profess to not being fans of Mexican food. Their opinions change as we make Guacamole, Pico de Gallo, fresh Corn Tortillas, Refritos, and a Zacatecas Lamb Mole, which I truly believe is my best recipe...so far.

Did I mention Churros and Chile Spiked Mexican Hot Chocolate for dessert? Yeah, we did.

There is a lot to love in Australia.

- Great public transportation: Bus, train, or even ferry get you just about everywhere easily.

- Caramel slices: I've never seen them in the States, but holy hell they are good! A shortbread-like base, caramel middle (made from sweetened, condensed milk) and chocolate on top. Soooo not vegan, damn them.

- GST: The sales tax is included in the price of everything (again, like New Zealand). If the menu or price tag says $20, you pay $20. Genius!

- No Tipping: Waitstaff are paid a fare and decent wage. Not that crazy of an idea.

- Cafés: Coffee/tea shops with toast, brekky, and baked goods, like the aforementioned and ever loved, caramel slice.

- Footy: I don't understand it all, but two West Coast teams are favored in the Grand Finals and athletic strong men play it. Yes, please.

But...there are just a few things that just aren't right.

30

- Target: Their version is tiny and doesn't carry everything anyone could possibly want ever, so that is just wrong.
- Pharmacy (chemist in Aussie): Same as Target.
- Cafés: They close at 5 p.m. and often aren't open on the weekend. So what do you do on the weekend?

- Chocolate chip cookie: Nope, nope, nope...just stop it now. America is the only place that knows how to do it, chocolate chips and brown sugar are not to be found here.

- Milkshakes: Chocolate milk does not a milkshake make.
- Chips: They taste wonderful, but they're fries to us, so confused I was.

Australia and New Zealand were like travel-lite. Familiar but not. Friends guided me. But now it's time I really went out on my own, shitty sense of direction and all.

31

The antipodes don't boast a cuisine so dissimilar to the U.S. For me, the differences were in the comfort food and sweets, because that's where I tend to gravitate the most.

Beans on Toast
Serves 4

Laugh if you will at this comfort food, but we eat mac 'n' cheese like it's our job in the US. I don't see anything different here. It's simple and comforting, what more do you need? You could go all legit and use a can of Heinz Baked Beanz that you might be able to find in international markets, or you could pull out your dried beans and do what I've done here. Oh, and I used whole-wheat toast, as opposed to the white bread you usually find. Once again, you do you.

Ingredients:

3½ cups *White Navy Beans, covered with boiling water and allowed to sit for 1 hour or cover with cold water and let sit overnight*

4 cups *Whole Canned Tomatoes, crushed with your hands*

2 TBS *Olive Oil*

3 TBS	Dried mix of Thyme, Rosemary and Sage or Marjoram (any combination will do)
2 cloves	Garlic, minced
2 cups	Onion, peeled and diced small
4 TBS	Vegan or regular Worcestershire sauce
2 tsp	Hot sauce, or to taste
¼ cup	Brown or Maple sugar
3 each	Whole Cloves
	Salt and Pepper, to taste

Method:

• Drain the beans and set aside.

• Heat the oil over medium-high heat in a large, heavy pot until heated through.

• Add in the onion and sauté for about 5 minutes, stirring occasionally.

• Toss in the herbs and garlic. Sauté, stirring, until the onions are soft.

• Add in the tomatoes, Worcestershire sauce, hot sauce, cloves, sugar, salt, and pepper.

• Stir to mix, bring to a boil, turn to a simmer, and cook for about 20 minutes.

• Remove the cloves and puree the sauce with a stick blender or with a regular blender in batches, until it becomes a smooth sauce.

• Return to the pot and add in the beans.

• Cover bring to a boil again and then turn to a simmer and cook for about an hour or so until the beans are cooked through.

• Letting the beans cool after cooking and rest for a day in the fridge melds the flavor and is preferred to eating them right away. They will also freeze well and can be pulled out and heated as needed.

• Serve over whole-grain or white toast that has been spread with vegan margarine or butter.

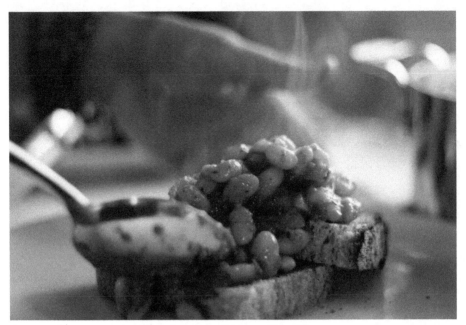

- *Tastes great with a hot cup of tea on the side.*

Chips (French Fries)
Serves 4-6

Because I will eat my weight in chips/fries if left to my own devices.

Ingredients:

2 lbs. Russet or similarly floury potatoes scrubbed and cut into thick batons. Think smaller than a steak fry and bigger than a shoestring.

4-6 cups Canola oil, for frying

Sea salt, to taste

Cooling Rack on a Sheet Pan (for draining the fried chips, this way they stay crisp and don't get soggy sitting in their own oil drippings)

Method:

- Rinse in the potato batons in a bowl of cold water. Stirring them about with your hands to remove starch. This will help the chips become crispy when fried. Drain and cover again, stirring, until the water runs clear. Drain, then spread the potatoes out in an even layer on paper towels and dry thoroughly. Let the potatoes air-dry for 10 minutes.

- Place in a pot and cover with plenty of cold water then bring to the boil in unsalted water and boil for five minutes. Leave to dry completely on a tea towel, patting dry.

- Once cool, place in the fridge on a clean tray for an hour, uncovered, to dry out a little more.

- Heat the oil to 300°F and place some of the chips in, cooking fewer chips at a time prevents the oil from dropping in temperature too quickly. Cook for 5-8

minutes, until softened and slightly colored, but not golden. Using a slotted spoon, transfer the fries to the rack over the sheet pan to drain and cook the rest this way in batches.

- Finally, turn the oil up to 360°F to fry the chips a second time. Fry in batches, until golden and crisp. Using a slotted spoon, transfer the fries to the rack over the sheet pan to drain and sprinkle with flaky sea salt and always eat hot.

Lamingtons

Makes about 16

These sweet little cupcake-like chunks can be looked down upon as "pedestrian" and "everyone does them" in New Zealand and Australia. But I don't live there, so I think they are fabulous!

Ingredients:

Cake:

1 cup minus 1 TBS Non-Dairy or Regular Milk

1 TBS	Apple Cider Vinegar
1 ½ cups	Unbleached Cake Flour
½ tsp	Fine Sea Salt
¾ tsp	Baking Powder
½ tsp	Baking Soda
¾ cup	Sugar
6 TBS	Canola Oil
1 ½ tsp	Vanilla Extract

Frosting:

1 cup	Vegan Margarine or Butter at room temperature
1 cup	Non-Dairy or Regular Milk
3 cups	Powdered Sugar
½ cup	Cacao Powder
6 cups	Shredded unsweetened coconut

Method:

• Preheat oven to 350°F. Line one 8- by 9- by 3-inch cake pan with parchment paper; set aside.

37

- In a small mixing bowl, stir together the milk and vinegar to make buttermilk; set aside for 10 minutes. In another small mixing bowl, sift together the flour, salt, baking powder, and baking soda; set aside.

- In a large mixing bowl, combine the oil, sugar, and vanilla. When the buttermilk has formed, alternate between mixing the flour and buttermilk into the sugar mixture in halves. Add the flour first, then the buttermilk.

- Once all the flour has been added (but you're still left with 1/2 of the buttermilk), whisk the crap out of the mixture, just until most of the clumps have disappeared. (Don't whisk too much or else you'll overwork the gluten.) Whisk in the remaining buttermilk.

- Pour the batter into the prepared pan and bake at 350°F for 24-26 minutes, or until a toothpick comes out clean. Allow the cake to cool in the pan for about 15 minutes, then transfer to a wire rack. Once the cake has cooled, wrap with aluminum foil and refrigerate until you're ready to frost (cold cakes are easier to frost).

- To prepare the frosting: Sift the powdered sugar and cocoa powder into two different bowls. In a large saucepan, melt the margarine, then mix in the milk.

- Next, using a whisk to stir, start to add the cocoa powder. Once the cocoa powder is completely dissolved, add the powdered sugar about a cup at a time, whisking constantly to prevent lumps. When all the powdered sugar is combined, pour the chocolate mix into two separate bowls—that way when one mix gets full of crumbs you can switch to the next one.

- Cut cake into even 1.5- to 2-inch bite-sized pieces.

• To ice the lamingtons: Working quickly, using a fork, dip the cake cubes into the chocolate mix and roll them around with the tines of the fork to completely coat. Drain any excess mixture off the cakes then drop them in the coconut and roll

 them around lightly to coat evenly with coconut. Set the cake cubes on the cooling rack placed over parchment paper to drain. You can re-frigerate the cakes to help set the icing, then bring them to room temperature before serving.

Vegan Pavlova

Makes a Shit Ton of Meringue

(Enough to feed 8-12 people who love sweets!)

It's a meringue and yet so much more. I don't care which country invented it, I'm just happy we now know that aquafaba (the water from a can of chickpeas) will make it vegan.

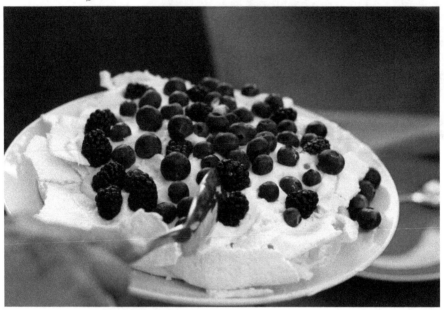

Ingredients:

1 can Coconut Cream

1 can Chickpeas, drained, the liquid saved (approximately 1 cup) and beans put aside for another use

2 tsp Vanilla Extract, divided

1 TBS Arrowroot or 1 tsp Cream of Tartar

 A pinch of fine salt

1 cup Powdered Sugar

2 TBS Maple Syrup

 Assorted fresh berries

Method:

- Put the coconut cream in the fridge to chill for 3 hours or overnight.

- The chickpea liquid (aquafaba) should be room temperature.

- Preheat the oven to 275°F.

- Line two (or more) sheet pans with parchment paper.

- Mix the sugar, salt, and arrowroot together and set aside.

- Pour the aquafaba into a mixing bowl or a bowl of a standing mixer.

- Using the whisk attachment, whisk for 8 minutes or until soft peaks form.

- Add the powdered sugar mixture slowly, a tablespoon at a time. Scrape down the sides from time to time.

- Add in the vanilla extract.

- Whisk for 7-10 minutes more until very stiff, shiny peaks form. Again, scrape down the sides from time to time, so that all the mixture is incorporated into the stiff peaks.

- The shapes of the meringues are up to you. You can form a few large circles, to use layered once you are ready to serve, filled between with the coconut cream. Or you can make many little ones. It doesn't matter; you do what makes you happy.

- Place the sheet pans in the oven and reduce temperature to 215°F.

- Bake for 1-2 hours or until outside of meringue is firm and crisp. Turn off oven and leave the meringues in to dry out for 4 hours or overnight.

- Later or the next day put the chilled coconut cream into a chilled mixing bowl or a chilled bowl of a standing mixer and again use the whisk attachment.

- Whisk to stiff peaks then fold through the maple syrup and vanilla.

- Spread dollops of the whipped coconut cream over the meringues, top with fresh berries and serve.

..

SINGAPORE AND MALAYSIA

Singapore Dream

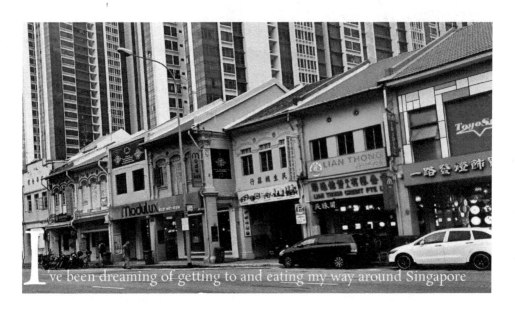

I've been dreaming of getting to and eating my way around Singapore

for over 15 years. And I made it, finally fucking-a-right, made it. It intrigues me because of the food—food I've heard of on travel shows, in fancy food magazines, and from Malaysian sushi workers at one of my jobs.

First thing I did after checking into my Singapore hostel was run out to find the nearest hawker stand to fill my gob with noodle soup.

The hawker stalls were developed to take the street food off the street without losing any of the street cachet. You can be assured you're eating in

an area that is regulated, but it's not airbrushed. Dishes are usually washed in a bucket behind the stall. Walls are nonexistent. And you get what you get.

And I wanted noodle soup, bad. Well...at first, I thought the soup I tried may have been pig's blood soup. And for those of you wanting to say, "But you're vegan!?" Don't get your knickers in a twist, I'm mostly vegan. I'm on this trip to have adventures after all. And that soup is an adventure I need never have again. The veg were great, but I was turned off by the metallic taste, which I took for blood. Turns out it's "Spicy and Sour Soup," all vegetables after all. The spice was incredible! Szechuan peppercorns perhaps? It seems I have a sensitivity to them which fucks me up for a few days after having them. I really did want to enjoy that soup.

Most hawker centers are mini malls for food stalls. They have something for everyone, including cut fruit and agar agar jelly (vegan Jell-o). It's cheap, and it's fruit, readily available everywhere. This is mind blowing for me. I can get a fresh vegetable juice at a stall for about $1 USD. At Whole Foods Market, it would be around $10. Something is starting to stir within me. And it isn't the hit of nutrients from the fresh juice. It's awareness. Fresh fruit and vegetables abound. Whether in the hawker stalls or at markets. Easily at hand. Everywhere. Cheap. How is this not replicated in the U.S.?

I spend a day wandering the Singapore Botanical Gardens, the orchid garden in particular. The Old Bird is keen on botany, so I take pics for her. And I find myself interested as well. Every two steps is another shape, size, color of orchid. Breathtaking and overwhelming.

In my first tentative wanderings, I worry about safety. I have heard how safe Singapore is, but is that true? Then I realize that I am taller and much

heavier than most everyone around me. My worries disappear, and I forget that I ever wondered.

My last name may not seem that unique but spelling Clarke with an "e" on the end isn't that popular. (A great uncle of mine actually removed the "e" so, according to him, it would cost less to paint his name on the door of any business he started...he never did start that business.) Not only Clarke Street here in Singapore, but Clarke Quay (pronounced key). Relatives of mine perhaps? I'd like to think so, but my family wasn't lace curtain Irish (as in coming from money), so probably not.

Sometimes my hunger to try as much food as I can means some fish happens...fish happens. ... I know that the freshness this close to the ocean can't be beat. I don't give myself too much grief for it. The sheer variety of food made my head spin, but I was determined to try all I could.

I mostly I ate vegan, like tofu skin balls with veg. Or the tiniest, tastiest pineapples I'd ever had.

The city is a crazy mix of old and new architecture, temples, and alleys. I prefer the old parts of town personally. Their colors sometimes bright, but more often faded. Sad in some ways, but still beautiful, if you look close enough.

There are several different cultures living comfortably together here. The native Malay, Chinese, Indian, and Western cultures brought their religions and foods that meld into a diverse and peaceful whole.

I find cheap breakfasts, in the Indian neighborhoods, of Idli plates, less than .75 cents USD to get my days started. The metal platters they are served on will become very familiar to me over the next few months. Spice and soft bread, lentils and comfort in an unfamiliar place.

The haze/smog that greeted me here was so thick you can almost chew it. The sights aren't as glorious since the view was completely cut off by it. Also, sweating gallons in this humidity is the norm.

46

My hair needs cutting, bad. The Old Bird always gets on me that it's too short. Years of drinking clouded my sense of self. After sobering up, I finally found that when my hair is cut into a short pixie and I look into a mirror, I see me. The outside me matches the me I feel inside. In one of the air-conditioned major malls, down below street level, I find a cosmetology school offering $5 haircuts. I'm in. The gal is young and tiny and a bit flummoxed to be cutting my hair. But she dives in and soon I'm seeing the me I like to see. Perfect.

One morning at the hostel, I am greeted by a familiar American accent. She and I chat for a bit, and it turns out she's a Boulder native, but of course. We agree to meet for a spontaneous dim sum lunch. Although it's nice to meet someone from the U.S., and receive an invitation to visit her in Cambodia, where she works, her traveling companion isn't my cup of tea. Pun intended. I am starting to assert my will when it comes to where I go and what I do. I don't want to acquiesce in order to keep peace. It may sound uncivil and even juvenile, but why the hell should I endure when I can enjoy?

What a long hazy trip it's been...

Hazy Malaysia

Off to Kuala Lumpur I go. I've found my latest accommodations on AirBnB.

By not taking my time and rushing into it, I find myself staying well out of the city center, heading out 45 minutes by train. This is typical for me, to not look at the details and just see the big picture. I must learn to slow down and assess situations. Or am I too old to learn new tricks?

In the bathroom is the first squat toilet I have met up with on my travels. That, more than anything else, shows me how out of my comfort zone I have wandered. This is how a large portion of the world's population does its business. If they can, I can.

Oh, this heat and haze.

The low visibility is due, I read, to burning of rainforests in Indonesia for palm oil harvesting. That godawful haze has followed me all the way here. It's depressing and painful to see. An almost chewable reminder that there is no perfect place in the world.

And yet, my hostess is kind, and covered. She's Muslim and wears a hijab. I worry, as a mosque is just across the street. What should I wear? I don't want to offend, but I also don't want to wilt from the humidity. How will I assimilate? The calls to prayer start to emanate, and I am a world away from all that I know.

I venture forth, covered to my wrists in a long-sleeved shirt, covered to my ankles in pants and with a scarf wrapped around my neck to use, if need be, to cover my head. Men walk by and...and...then I notice. Women shoot by driving scooters, some covered, some in shorts. The men I pass barely register me. I breathe a sigh of relief and return to the house to change.

There is a hawker stall less than 50 yards from my place. The train line is a 15-minute walk. I've got this.

Our family vacations when I was a kid centered around many educational museums and historical monuments that I have a deep-seated aversion to most of them. Yet, I decide to try out the

Islamic Art Museum and was filled with awe at the exhibits.

The artwork of the Quran, the architecture of the mosques and the intri-

cate Muslim art give me a glimpse of a world I have never seen. My Irish-Italian Catholic childhood, with the church's pageantry, didn't prepare me for this. And the fact that I have now lapsed so far out of Catholicism into Atheism probably adds to it. I learn that the mosque serves as a place where Muslims can come together for prayer, as well as a center for information, education, social welfare, and dispute settlement. This goes against all the hateful rhetoric that has been filling the U.S. news recently.

As I wander about the cool museum, other tourists and visitors quietly contemplate as I do. Of all the things that feel the most recognizable to me, it's a museum. Exhibits, informational signs, they are all familiar and unlike the usual discomfort I feel, from the forced marches we endured when kids, this is a known experience.

There are hawker stands all over the city, morning, noon, and night. The vendors are selling so many different interesting items that I fear I'll never be able to taste them all. There are triangle pancakes that are oddly filled with corn and peanuts, and yet so easy to love. I sit eating Puti Piring—rice flour dough forming a

cake around a filling of coconut that they've cooked in bamboo rings. Light, sweet, and lovely. A tourist family is watching me eat, so I let them know how fantastic it is and they dive in to buy their own.

The choices of eats and sweets are overwhelming me in a very pleasant way. If it seems as if I spend most of my time wandering hawker stalls, it's because I am. The smog/smoke haze is too thick for me to safely run, so I'm hiking my ass to and fro to taste and see all that I can.

For tea time one day I try kaya toast, which is egg, coconut, and a sugar mixture slathered on toast. It's not vegan but a perfect example of the mix of European and Asian cultures.

I was, however, able to find vegan sushi. It may go against all you believe in, but damn, it was good. Eating vegan here isn't hard at all. Most signs have

English translations or pictures, and most hawker stalls have at least one person who understands me. I have no trouble finding food to fill my food hole. When I am in doubt, I try anyway. More often than not, I am happy with what I get.

There are restaurants called "Veg Rice" that serve up buffets of predominantly vegetable dishes served over a scoop of rice. There are greens aplenty, tofu, curried potatoes, and so much more. You are charged according to the discretion of the cashier. They look over your plate and declare the price to you. Never all that much money, so I dig in unabashedly.

I spend one early morning at my AirBnB accommodations in a video chat with friends from college who are at my 25th college reunion back in Buffalo. They carry the phone around so that I can chat with folks and then carry me into a photo

booth, so I can be in the picture with them. Their sweetness brings me to tears. This amazes them, because that's not who I am. Or am I?

On another day, I take yet another train to visit the Batu Caves, a Hindu shrine. There are over 270 steps to the visually stunning top. The world's tallest statue of Hindu deity Murugan, at 140 feet high, greets you as you begin to ascend. Monkeys reach for flower strands that the tourists have bought for them. The inside of the caves are carved with more deities, and the walls extend into dizzying heights. Tourists and pilgrims make their way here, most from India, with a rainbow of saris and selfie sticks.

Lunch is found just outside the temple at an Indian banana leaf restaurant. You choose the dishes you want, and it is all brought on the aforementioned leaf for you. Male waiters hover to bring drinks and bread.

My new favorite breakfast—and it's vegan—roti canai with dhal. That and

a cup of sweet tea will set you back $.78 U.S. It's light and fluffy, with just a bit of oily texture and crunch. Very yin and yang or wabi-sabi. I love it. The dhal is served on the side or poured over the top. Slight spice and warm flavor combine into a perfect mélange. Another dish developed from a melding of cultures.

I meet up with new friends Helen and Mark (via old Perth friends Denise and John). They are more of the wonderful expat folks I've been meeting along the way. They give me a good dose of American hospitality and much-needed conversation.

I am confused when they take me to a complex of high-end restaurants within a mall and wonder why we are eating this glorious Italian food. Until I realize that Malaysian food is almost everyday to them. They are treating me to something they don't often have.

The malls, I hate to say, which are filled with their Louis Vuitton and Italian or French restaurants, are starting to be my midday sanctuaries. The air con (air conditioning) saves me from wilting out in the haze and heat. And I am given a glimpse again into a world I don't know. The women in their camel-hump hijabs, piled high on their heads, or totally covered in their chador, are better dressed than I will ever be. Coordinated and colorful outfits, shoes and nails, make-up so on point—I feel frumpy and frazzled in comparison.

On another hazy day, Mark and Helen take me out for afternoon high tea. The venue is an old plantation, harking back to the country's colonial past. The view from the porch where we sit, they assure me, is spectacular when it isn't so hazy. Although the view is limited, the pastries piled on at tea time are numerous and the company brings me to laughing tears. Good people this.

It's morning, and I'm on a train heading north from Kuala Lumpur to Georgetown, Penang. An island in the northwest of Malaysia that's well-known for its food and a beach tourist mecca in season.

I'm being seduced by this place.

Glimpses of tattered alleys and vibrant temples appear out of the haze, hawker stalls fill the air with tempting smells and yells of mind-boggling food choices, captivating Muslim calls to prayer throughout the day.... But the haze.... Damn this haze. Damn that palm oil. Here is yet another environmental lesson. It's not just that me, a ridiculous tourist, is losing a view, it's the people living here in the path of this smoke, day in and day out, must endure it and probably suffer health problems. I'm hoping to soon look past the haze and find what's hidden from me out there.

Studiously I find an all-female pod hostel to stay in for a few days. The pods are simple and comfortable, with plugs, lights, and a shade to shut out the outside world. I'm alone. Rain pours down, and I find myself holed up in my pod, much like those I sneered at from my first hostel experience in Auckland. The haze, the humidity, the rain all conspire to hit me with a low of lows. There is no escaping it. I embrace it instead. I read, I drink tea, I snooze. I fucking hate feeling like this, but I know fighting it won't work, one of the advantages of having gotten to this age, I know what depressed me is like and needs.

And the following day, after taking the time to search and research I visit Kapitan Keling Mosque. My first time in a mosque.

Not sure what it is that I expect to find. There are courteous signs letting the visitor know that out of respect robes will be given to those not wearing suitable attire. A robed gentleman with a flowing white beard and sweet smile hands me one and mimes a head covering. I use my scarf and he nods his assent. I leave my shoes on a rack and wander, barefoot, on the cool marble floors.

There is no one here, as it isn't the time for prayer. No praying, no kneeling, just silence. Soaring marble ceilings, whirring ceiling fans, trickling water in the ablution fountains, and silence. Very serene. I am not religious at all anymore. And yet I believe in kindness, respect, and serenity. Here I feel it. This is a lovely feeling to have after my depression the day before.

More map and blog searching finds me on a bus in the rain heading two hours southwest of Georgetown for a bowl of Mee Udang in Teluk Kumbar. It's prawn noodle, a sourish broth, endemic to Penang, with noodles and shrimp. The place I'm heading, it is written, is unlike any other with this dish. I wander the side streets in the rain, Google map guiding me, and stumble inside. A woman is sweeping and setting up the dining area. Someone comes from the back to tell

me they don't open until 1 p.m. and it's 12:30 p.m. now. "May I stay, and read, until you're open?" I inquire. That's sorted, and I wait and read. The owner chats with me as he continues to prepare the room. He's lived in the states, so his English makes it easy for me to relay the tale of my journey and the dish I've come to try. He places the plate in front of me, and I swoon.

It's like a breath of prawn emanating from the bowl, redolent of shrimp. The noodles have just the right toothsomeness, the broth is warm and slightly sour, the shrimp perfectly cooked, and the hardboiled egg served with it adds another layer of texture and umami. This, I believe, is heaven.

More conversation with the owner and he asks if I had taken the bus from Georgetown and if that is how I will be getting back. I nod as I keep eating, not letting any of this bowl go to waste, a glass of fresh mango juice on the side to refresh me between bites. "I can drive you to the bus stop," he says, as we look out at the continuing rain. I agree, and he takes me the 5 minutes through the showers, to the bus shelter. I am grateful. For the noodles and the kindness of strangers.

On the bus ride back, I stop at a large market to again wander. This is where I most like to be. Folks ignore me, unless it's to shoo me away from

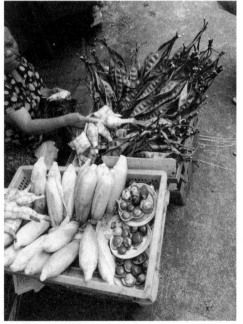

picture taking, which does happen from time to time. I've made the conscious decision to not photograph faces unless they allow it or I'm so compelled by a situation that I feel I must. It feels like such an intrusion for me, this bulking, lumbering, sweaty, white tourist, to take pictures of them going about their day-to-day lives. One of my goals is to find a life somewhere out here in the world—I don't want to be just an observer.

I use my time wandering as an education. What is the everyday like here? The produce, the cooked foods, why do people line up at that stall in mobs every afternoon? I see butchers with processed, headless chickens resting on blood smeared boards in the heat of the day.

A tall, teenaged Indian gal with large brown steamer baskets filled with steaming rice noodles slaps them into a newspaper in her hand, adding shredded coconut and jaggery (cane sugar) for a perfect mid-afternoon snack. It's called putu mayam and is usually made by mixing rice flour with water and/or coconut milk and pressing the dough through a sieve to make vermicelli-like noodles. The noodles are then steamed, often with the addition of juice from the aromatic pandan leaf as flavoring. The hot noodles are then served up with the accompanying coconut and jaggery.

Chinese tourists are lining up at another stall that is selling plastic cups of cendol, a snack made from rice flour, then mixed with palm sugar, coconut milk, and swollen green worm-like rice flour jelly. Either a tour guide or a guidebook has set this stall up as the #1 in Georgetown, which is why the line gets longer and longer. I'm trying not to get any more sugar into my system, so I only wander by.

Research pulls up that more than 64% of Malaysians eat at least one meal per day out. This shows why the stalls are so busy all-day long. The food is really good, inexpensive, and it keeps your house from heating up in this unbearable humidity. The wisdom of this is not lost on me. More thoughts are fermenting.

Back at the hostel on another morning, other female travelers have started to arrive, so I'm alone no more. One, a tiny lady from China, talks to me in English that is worlds better than any Chinese I could ever hope of knowing. She tells me her name is Chow Duah (which I've spelled here phonetically as I would be hopeless if trying to spell it correctly). After digging deep into my Google translator, we share tales of our travels, and I am able to convey to her

my love of dim sum. Comprehension brightens her face and we make a date to meet at 9 a.m. the next morning.

The next day, I'm ready to hike about the streets with her, but we cross the street from our hostel, and there it is. A huge dim sum parlor that is open this early in the a.m. and filled with bustling workers getting their breakfast.

It's a steamy, loud, clanking, buffet-type place, and she orders for me to assure that most of what we have is vegetarian.

She tells me she works in a bank in China and usually travels with her sister, who has just become a mom. How kind she is to chat with me and share this meal. I am embarrassed and pleased when she compliments my use of chopsticks. Must thank The Old Bird for that, as she taught us to use them when we were young with chopsticks she would bring back from trips to Chinatown in New York City.

One of the necessities for travel is shots and malaria pills for the specific places you'll be visiting. I had some done in the U.S., some in Perth and the rest I'm having done here in Georgetown. It's a bit of a hike to get there, but the clinic is quick, efficient, and at least $300 less than it would have been in the States.

The sheer quantity of quality food choices here in Malaysia has endeared this country to my heart, stomach, and taste buds. I could probably eat something different for lunch every day of the week for a year. Delving more into this mixture of cuisines and cultures intrigues me. Returning isn't a maybe, it is a must.

My Malaysia plan had been to trek my way from the west side here to the east. But U.S. State Department alerts of kidnappings on the east side have me altering my plans. After some chatting with Denise in Perth (who lived in Bangkok for several years with her family), a new plan to head to Bangkok and meet up with her and her expat friend Meg is hatched. Onward!

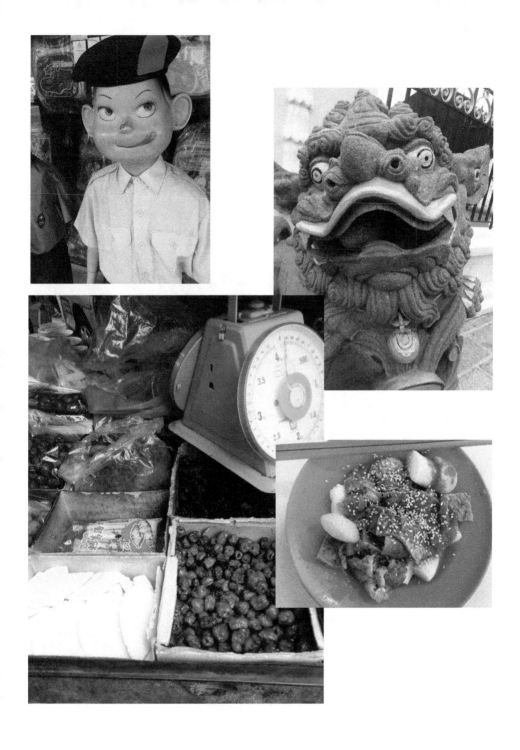

Singapore and Malaysian Recipes

Eating vegan in these areas was not a problem. The dishes listed here are easy and filled with familiar flavors but served in fresh and creative ways.

Malaysian Peanut Pancake (Apam Balik)

Serves 6-8

Apam Balik is a soft, fluffy, and moist, sweet, Malaysian peanut pancake turnover stuffed with a myriad of fillings. Here I've used peanuts and palm sugar. This was a truly wonderful street find. And easy enough to make at home, I promise.

Ingredients:

Batter:

2 cups	All-Purpose Flour
5 TBS	Sugar
1 tsp	Instant Yeast
¼ tsp	Baking Powder
⅛ tsp	Baking Soda
½ tsp	Salt
1½ cup	Coconut Milk, warm (115°F)
2 TBS	Canola Oil
2 each	Egg Replacer (as in mix up enough of the egg replacer to replace 2 eggs) or 2 Eggs

Filling:

1½ cups	Peanuts, toasted and chopped (coarse or fine is up to you)
3-4 TBS	Palm Sugar, grated
¼ cup	Vegan Margarine or Butter

Method:

62

- In a bowl, add all the ingredients for the batter and whisk until smooth.
- Cover the bowl and let proof (sit) in a warm place, for 2-3 hours (or overnight in the refrigerator). Batter will increase in volume and the surface will start to bubble.
- If you chill the batter overnight, let it sit at room temperature for 1 hour.
- Heat a 12-inch sauté pan over medium-low heat.
- Pour some of the canola oil in and use a paper towel to wipe off any excess.
- Give the batter a stir.
- Once the oil is heated through, pour about 1 cup of the batter in, depending on how thick or thick you want the pancake to be, and spread it evenly.
- If you like your pancake edges a little crusty, swivel the pan so that the batter coats the side of the pan.
- Cover with a lid and let the pancake cook until you see bubbles appearing on the surface and the pancake has started to set.
- Once the surface has start to set, add small dollops of margarine all around the surface.
- Sprinkle some of the peanuts and sugar over the top as well.
- Let it continue to cook; cover to speed up the process
- When the bottom has a golden-brown color to it and the pancake has completely set, fold the pancake in half like a moon shape and remove from the pan.

- Repeat with the remaining batter to make more pancakes.
- Slice and serve immediately.

Roti Canai

Serves 4

This dish became a personal favorite for many reasons. It's cheap, tastes amazing, and although working the dough takes a minute to get the hang of, it really isn't that hard to make.

Ingredients:

2 cups	All-Purpose Flour
2 tsp.	Salt
1 cup	Warm Water
1 cup	Vegetable Oil

Method:

- Mix the salt in the water.

- Put the flour in a mixing bowl and add the salted water gradually, stirring continuously with your fingers or a wooden spoon. Mix the flour into a dough then knead until smooth and not sticky or gooey.

- Generously oil your hands and form the dough into palm-sized balls, similarly sized, about 6 balls total.

- Pour the rest of the oil into a bowl put in the balls, coating it with oil as you place them. Leave the dough to rest in a refrigerator overnight.

- Remove from the fridge and allow to sit out at room temperature for 1 hour.

- Generously oil your kneading space with a pastry brush or a paper towel. Take a dough ball and flatten it out into with your palms until about 9 inches in diameter.

- Flip it, to stretch the dough even more, by placing one hand under and one hand over the dough and stretching. Work the dough this way a couple of times until it spread it out and paper thin.

- Hold the dough up high over the work surface so it hangs down and stretches more. Start to lower it into a circle, like a cinnamon roll, letting it get as flat as possible.

- Heat a griddle or flat skillet over medium heat and grease gently. Cook the roti until golden brown and then flip to cook on the other side, pressing down with a spatula when flipped to spread the roti even more.

- When serving, shred the circle into pieces, so that it is light and fluffy, and serve with dhal.

Dhal Curry

Serves 4

This lentil dish isn't just for roti, you can have it with rice, idli, naan— any way you like it.

Ingredients:

1/4 cup	Coconut Oil
2 each	Shallots, chopped small
1-2 cloves	Garlic, chopped small
1 inch	Ginger, peeled and chopped small
1 tsp	Mustard Seeds
1 tsp	Cumin Seeds
1 TBS	Turmeric Powder
1/8 tsp	Cayenne Pepper (or to taste)
2 TBS	Curry Powder or two Curry Leaves
1 cup	Yellow Lentils or Chana Dhal, that has been soaked in water for 1 hour
1 each	Tomato, sliced
1 each	Carrot, peeled and sliced
	Water as needed
	Salt, to taste
2 TBS	Cilantro, chopped
2 each	Green Onions, chopped
2 TBS	Coconut Flakes, toasted

Method:

- Heat a saucepan over medium-high heat.
- Add in the coconut oil to melt.
- Toss in the shallots, garlic, and ginger and sauté until fragrant. Stir in the mustard and cumin seeds, and sauté for one minute. Add in the cayenne, curry, and turmeric then mix to combine.

66

- Add tomato slices, carrots, and potatoes to the other ingredients. Mix in the dhal and 2 cups of water, and bring to a boil.
- Turn the heat to a simmer and cook for about 30 minutes or until dhal softens, stirring from time to time. Add a little more water, 1/4 cup at a time, if the dhal seems too thick.
- Season with salt to taste.
- Mix the cilantro, green onion, and coconut together and serve the dhal with this mixture as a garnish and with the roti canai.

Curry Laksa (Curry Mee)

Serves: 4 to 6 servings

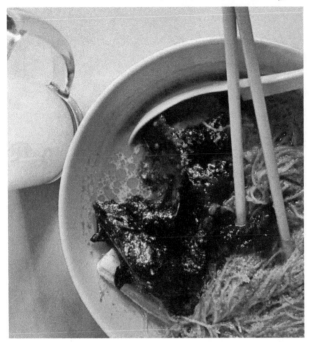

Yeah, I know, look at that list of ingredients! This will take some shopping to find them, but honestly, once you do and then make the Spice Paste, this is so worth it.

Just look at that picture there, right?

Ingredients:

Spice Paste:

5 each	Shallots, peeled and roughly chopped
3 cloves	Garlic, peeled, and halved
3 each	Dried Chilies, seeded and soaked in hot water (more or less to your taste)
1 stalk	Lemongrass, slice bottom third into rings
½ inch	Ginger, peeled and thickly sliced
½ cup	Curry Powder
2 pieces	Dried Tamarind or 3 TBS Tamarind Paste

Soup:

3 TBS	Canola Oil
2 cups	Oyster Mushrooms

3 each	Pandan leaves, shredded and knotted (found frozen in Asian Markets)
6 cups	Vegetable Stock
2 cups	Mung Bean Sprouts
6 oz	Beehoon (Dried Rice Vermicelli),
12 oz	Fresh or Dried Yellow Noodles
1 cup	Seaweed, toasted and shredded
1 14 oz can	Coconut Milk
1 cup	Deep Fried Tofu, sliced (make your own, or again found conveniently at an Asian Market near you)
	Salt, to taste

Garnish:

½ each	Cucumber, julienned
3 to 4 sprigs	Mint Leaves, stems removed
1 each	Lime, cut into wedges
4 to 6 tsp.	Fried Chili Paste (from what you make above)

Method:

• Blend all spice paste ingredients with ¼ cup water until smooth. Pour mixture into a bowl and set aside.

• Heat 2 tablespoons of the oil in a large pot over medium heat. Add mushrooms and cook about 3 minutes until golden. Remove with a slotted spoon and set aside.

• Add 1 tablespoon of the oil and heat through. And in the spice paste and stir fry until fragrant, about 5 minutes.

• Pour in the vegetable broth. Add in the pandan leaves. Cover and bring the soup to a boil.

• Reduce the heat and allow the soup to simmer for 20 minutes.

• In the meantime, fill a separate pot half full of water. Bring to a boil. Scald bean sprouts for about 20 seconds. Remove with a metal strainer or slotted spoon.

- Add the bee hoon and cook for 2 minutes. Remove with metal strainer or slotted spoon.

- Cook the fresh yellow noodles in the boiling water for 2 to 3 minutes or the dried yellow noodles for 3 to 5 minutes. Remove with a metal strainer or slotted spoon and set aside.

- Pour the coconut milk into soup. Add the fried tofu and season with salt. Bring it up to a boil and allow the coconut milk to heat through. Turn off the heat.

- Place a portion of noodles, bean sprouts, some mushrooms, and seaweed strips into a bowl. Pour curry soup over noodles and vegetables. Garnish with cucumber and mint leaves.

- Serve immediately with fried chili paste and lime wedges on the side.

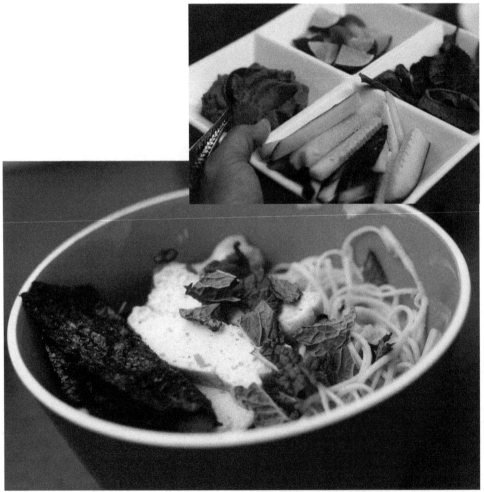

Mee Rebus

Serves 4-6

Mee Rebus is one of the most popular noodles dishes in Malaysia. Here, I have replicated the prawn fritters that come with it with my own vegan version. If you can find the Hokkien noodles, you have found the holy grail of this dish.

Ingredients:

10 oz Thin Yellow Noodles, (Hokkien noodles if you can find them), cooked and drained

1 TBS	Red Curry Paste
1 TBS	Miso Paste
1 TBS	Pickled Plums, mashed
2 cups	Red Potatoes, peeled and cut into large chunks
6 cups	Vegetable Broth
1 TBS	Tamarind Paste, seeds removed and mixed with 3 TBS Water
1 TBS	Palm Sugar
	Salt, to taste

Garnish:

1 cup	Fried Tofu, chopped
2 TBS	Green Onions, sliced
2 TBS	Fried Shallots (Fry your own or, yet again, find them at an Asian market)
¼ cup	Bean Sprouts
	Sambal Oolek, or your favorite chili paste, to taste

Mushroom & Onion Fritters:

1 TBS	*Canola Oil plus 4 cups for frying*
1 cup	*Oyster Mushroom, chopped small*
¾ cup	*Miso Paste*
¾ cup	*Onions, chopped small*
¼ cup	*Green Onions, minced*
2 cups	*All-Purpose flour, sifted*
3 tsp.	*Baking Powder*
1 tsp	*Salt*
1 cup	*Water*
½ cup	*Vegetable Broth*
½ tsp	*White Pepper, ground*
½ tsp	*Sugar*

Method:

- *Boil potatoes until tender in a large pot of salted water. Drain and mash until smooth.*
- *Mix together curry and miso pastes, pickled plums, and the potato puree.*
- *Slowly add in the veg broth until a desired soup consistency is obtained.*
- *Stir in tamarind juice.*
- *Place back on the heat and simmer for about 30 minutes.*
- *Season with salt and sugar.*

- Heat the canola oil in a sauté pan over medium-high heat.

- Place chopped mushrooms, onions, and green onions in the pan and sauté about 5 minutes to soften the mushrooms.
- Pour them into a large mixing bowl.
- Add in the flour, water, and veg broth, and mix until a smooth paste forms. Season with salt, pepper, and sugar.
- Heat up the fry oil in a large pot for deep frying.
- Drop a spoonful of batter into the oil and deep fry until golden brown.
- Do this in batches to avoid overcrowding the pan.
- Remove with a slotted spoon and drain on a cooling rack over a sheet pan.
- To serves, put a portion of the noodles into a bowl, pour some of the broth over the top and garnish with fried tofu, green onions, fried shallots, bean sprouts, and chili paste.

FOUR

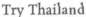

Thailand and Cambodia

Try Thailand

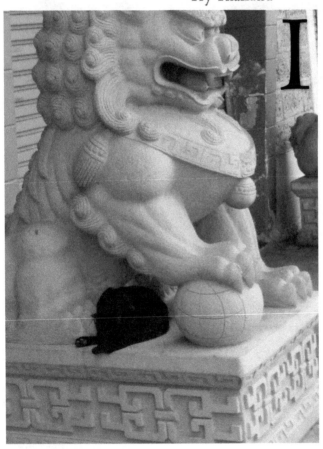

Itake the night train from Georgetown, Penang, to Bangkok. "The Night Train to Bangkok" sounds like a great movie title. I tweet for several minutes about it and realize I'm tweeting on my cell phone ON THE NIGHT TRAIN TO BANGKOK. Life is weird and wonderful.

The train is set up accommodatingly stiff seats to sit in during the day, then stiff beds are pulled down at night. The bunks have curtains, which help just a little as the lights are on all night. And the bathrooms...well, let's just say don't go walking along the train tracks in Malaysia or Thailand, got it?

It's crowded but not overwhelmingly so. I worry about my bag. Should I keep constant vigilance? A friend has lent me a wire mesh net I could use to cover and lock it up. Sneaking peaks of fellow travelers reveal middle-aged Indian couples, mid-twenties males, possibly Japanese tourists, rumpled businessmen, and the like. There is less worry after I realize they are just like me. Just wanting to get to where they're headed.

The border stop into Thailand goes slower than I had hoped, lines of grumpy, sleepy travelers who just want it to be over. I'll get used this, I hope.

At certain stops vendors come aboard and sell sweets and treats. I buy rice packets, sugared and wrapped in banana leaves, which come in groups of four for less than $1. My phone, my life line, is starting to lose its charge and I frantically search for an outlet. Fellow travelers (Japanese?) have an extension cord with several outlets. I ask if I can plug in and they graciously nod their OK. I share some sweet rice with them. Because, I am finding, travelers look out for one another.

Bangkok, Thailand, is a smooth transition from Malaysia. Buddhist temples are much more prevalent, as it is the predominate religion. Again, I stay with very kind expats (Meg and her husband Frank), and I'm a bit apart from the everyday here. They graciously offer up their driver to get me into the city from the gated community they live in. This hasn't been my mode of travel before this, but I don't know the culture yet and as I've only just arrived, I take them up on it.

Denise arrives and we three go for dim sum, because that is what you do. It is, again, inside a large mall. I'm finding this to be the norm. It throws off my street food vibe for a moment, until the dumplings start arriving, then my brain shuts the fuck up and my mouth gets stuffed full.

Meg suggests we go to an island off Phuket called Kao Yao Noi for a few days of beach, biking, and a cooking class. I'm so happy to be in with these ladies, as they are seasoned travelers, love to bike about and eat anything. This is like a vacation from my usual mucking about, somewhat directionless.

We take a plane from Bangkok to Phuket, then a taxi from the airport to the dock, then a boat over to the island, then a truck/bus to the hotel/resort. It's a bit gray skies, as it's off season, but that means we touristy folk are few and far between.

Bikes are rented, and we set off. They are bikers, belonging to bike clubs who go on 30- to 50-mile rides on a weekend. I am a toodler. As in I toodle on a bike on a bike path from time to time.

We wind along the roads, they have worked out where there might be a beach on the map and away we go. The pavement ends, the road reaches up, and I hop off the bike to hike it. It's hot and sticky, my bike unfamiliar. And I am in Thailand, on an island, biking to a hidden beach. This is what I wanted.

The beach is discovered, deserted, and a bit dilapidated. We park our bikes ironically next to a no parking sign. The water is warm, the sky hazy, the company adventurous. We decide we'll open the shack on the beach to serve tourists cold beverages and snacks. Our plans change as we discuss how horrid it would be to mess with this secluded of the spot. Miniscule water lice nip at me causing me to howl and laugh.

The ride back is just as hilly and sweaty, but we wind our way around the island, scouting where tomorrow's cooking class will be. Lunch is found at a small roadside restaurant where the outdoor kitchen is a burner with a wok. We spot a road crew working on some construction. The tools are rudimentary, picks and baskets. And then I realize the entire crew is comprised of women! Amazing.

Afternoon brings a shared idea of a boat ride. We find a longtail boatman willing to take us, even though dark clouds are gathering. Once we are out and well away from the dock, the boat is flying along over the waves. It's warm, but those clouds are starting to worry our pilot. He starts to berate us and tell us we must pay him more. Meg handles him well, asking why would we do that? And no we don't. He pulls into the dock of an island that is Ao Phang Nga National Park. We didn't ask him to take us here, and he explains that we must wait out the storm that is about to hit. The extra money is for the entrance fee to the park. Comprehension hits us. We all agree that we'll wait out the storm under a pavilion with other visitors, then leave once it's over, no payment needed. And we do.

There is a photo crew here, possibly taking pictures to use to market the area for destination weddings. At least that is what I surmise from the tuxedoed man and wedding dress–garbed gal lounging by the tables under the roof as the rain pours down. There are also other tourists who are reprimanded for trying to remove shells and rocks from the island. It's a stern reminder that these ecosystems are fragile.

Rain gone, back on the boat, and we are away. He takes us by James Bond Island (Khao Phing Kan), which was featured in *The Man with the Golden Gun* and to a cave where bird nests are taken to make the very expensive, environmentally hazardous, and just plain gross (the nests are made with bird spit, so you're eating bird spit soup people) much sought-after dish.

We are returned, safely, dry and exhilarated, to the dock and thank our pilot. It's a lesson, we thought we were being fleeced, he was thinking of our safety. Not speaking the language lent itself to the confusion.

The next day, we're at Mina's Thai Cookery class. Mina is a sassy bit of a thing who teaches small groups traditional techniques and flavors so that you can develop a true appreciation for the recipes. Her kitchen is small but well-appointed, and she has several ladies who assist so the class flows along smoothly.

She shows us an elephant-shaped stool that you crouch-sit on, and it's a coconut shredder. The coconut is ripe and used to make coconut cream and milk once it is shaved. We all take a turn, giggling at the weirdness of crouching to do this prep. It's not at all the back straight and at your boards that a U.S. cooking school would instill in you. Yet it is very effective, as the coconut shreds perfectly and falls into light mounds below the grater. Add a bit of water to the shredded coconut, knead it and then squeeze out the coconut cream. A bit more water added to the shredded coconut and you have coconut milk. Unbelievable. Its taste is fresh and light.

The different flavor profiles for the dishes we are making are arranged (mise en place) as we prepared them to show us

how they worked within the dish. Our teacher instructs us in traditional flavors and the twists she adds to a dish because she likes the texture or flavor. A personal instruction that speaks to me. Full and happy, we thank her for everything.

It's then a rush to catch our boat to our taxi, then to our plane, and back to Bangkok.

Denise takes me to catch up with a Thai friend of hers, and they take me to The Nine Emperor Gods Festival. This is a period of nine days, where those who are participating in the festival abstain from eating meat, poultry, seafood, and dairy products, among other things. Restaurants and stalls indicate that jeh (festival) food is for sale by hanging a yellow flag out with the word เจ

(jeh) written on it in red. Yeah that's right, a whole pavilion filled with tons of vegan eats. I do not know which way to turn. I realize that my stomach and budget won't allow me to try everything, but I soldier on, doing the best I can.

A few days later, there is a surreal dinner at an Israeli falafel place in Bangkok. But I trust Denise's food instincts. And she is right, it's great falafel—in Bangkok. You just never know. She talks me into a Thai massage that is very relaxing, if a bit crowded since it's on a pallet next to six other pallets, stuffed in the back room of a store front.

Traveling with these two adventurous ladies has given me yet another perspective on my journey. I'm not that far in, relatively speaking, and the loneliness has been kept at bay due to their presence. I'm starting to realize that I can take control of that when solo. Just start talking Clarke, you're good at that.

Meg sends me out my last day with a command that I must see the Reclining Buddha. It's within a temple complex and again, though not Hindu, I am asked to don respectful dress and I put on the skirt they lend me. Tourists flood the place, cameras and selfies abound. By turning my mind from that to the intricate carvings, gold-gilt touches, and seemingly endless beauty, I try and remove myself from the touristy atmosphere to one of contemplation. The Buddha is massive, and down the hallway at the back is a line of bowls where you drop in coins to donate to the temple. The sound of them ringing

as they fall in is tranquil, and I follow the line in front of me, slowly letting it all sink in.

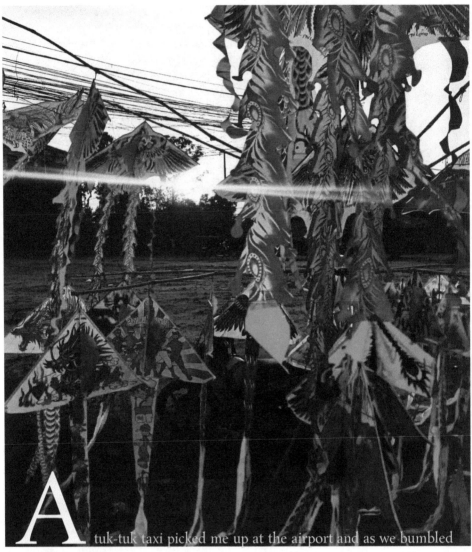

A tuk-tuk taxi picked me up at the airport and as we bumbled along, the air feels softer, water buffalo, brightly lit soccer games, and roadside restaurants emerge into view then fall away as evening sets.

My hotel is on an unpaved, pothole-pitted road, off another of the same. Yet behind its unassuming entrance is a pool, a room for me with cool marble floors, and a king-sized bed. A breakfast buffet included in the price of $18 a

night. I'm unsure, as traveler's guilt sets in. Shouldn't I be immersing myself in the experience?

I am here because a new acquaintance in a hostel in Singapore recommended I visit her. Turns out, she lives so far from Siem Riep that it would eat up two days of travel for me. I decide to stay here in Siem Reap for my entire visit to Cambodia.

My first day is spent wandering. I peer down a shop and see it opens on a hidden market where women are buying and selling. They sit atop low platforms that showcase their offerings, whether animal or vegetable. The variety is, again, astounding. Reinforcing my thoughts of fresh fruits and vegetables for all can't be that hard to come by back home. So why are they?

Small stands with tiny plastic stools offer up food to take away or eat in. I opt to eat at a one where the gal makes me a panzanella-like salad. She spreads a fish paste on half a demi baguette then fries it and some green colored seitan rolls. She chops this fried mass of flavor and serves it all up on a plastic-

bag covered plate accompanied by cabbage, cucumber, and a sweet chili dipping sauce. And it all cost 50 cents!

I chat with the hotel concierge to see what I should do with my time here. Hiring a tour guide would be $20 a day. That would be a big hit to my budget. He shows me the bike rental brochure, and I'm in. Only $4 a day plus a $7 pass for three days into the temple complexes.

The next three days are spent riding the rental bike to explore the temples of Angkor Wat and its neighbors. Elephants lumber by, monkeys wander about, and chickens literally cross the road. The temples do not disappoint. I'm not one for a tour, so instead I wander on my own. Taking note and pictures of the details on the numerous carvings. The sheer size of the temples, the engineering, and artistry are awe inspiring. From time to time, I overhear a tour guide giving snippets to his tour. I learn some things, but mostly I just wander and wonder.

The freedom the bike gives me to explore where I will, is exhilarating. I've taken to wrapping my head in a scarf as I ride to block the sun and absorb some of sweat running off me in gallons. The traffic filled streets are a worry, but I remember what my friend Denise told me about surviving the flow of cars. Just enter in and keep

going at your pace, don't stop or slow down, just keep going, like water they will flow around you. And they do. Once I'm off the main thoroughfares, the tiny side streets and country lanes show me a side of this place that I wouldn't have seen otherwise. There are hammocks hanging on trees further out from the temple complex and I realize that this is where the drivers go to rest while they wait for the tourists to finish their tours. They laze about eating, reading or sleeping, sometimes joined by their families.

My time in New Zealand got me watching their national rugby team, The All Blacks. Here in Cambodia, I find a bar to watch the team play South Africa in the Rugby World Cup. Next to me peacefully sit two fellas, one from New Zealand, one from South Africa. Because of course they are.

As I wander home I find a night market. There are stalls and carts, with lights glaring in the soft dark. At one, a vendor seems to have sweets of some kind, with a line of customers. I get into line and study them, hoping to understand what it is they are ordering, but I am none the wiser when I get to the front of the line. The women who ordered ahead of me understands me as I ask in English, but what are they? She laughs and explains, sweet rice flavored with banana and others. I take three and bring them back to the hotel to eat as the AC whirrs.

My last day here, and I ride another rental, this time a mountain bike, along the Siem Reap River. Men and boys toss nets into the river where it isn't clogged by garbage. The road isn't paved and pitted with even more potholes. The mountain bike takes this in stride.

Temples and mosques fill the air with calls to prayer, bells and music. Small boys, much too small for the bikes they ride, peddle along on spindly legs. Even smaller children yell "Hello! Hello!" and wave as I ride by. I send a hello right back and return their smiles.

I stopped because I couldn't ride any more. The stench of garbage and sewage overwhelms me. Shaking off the sadness I find a café in a tourist stop for a final roadside meal. As I watch, young boys are playing pool, barely able to reach with the long cues. There are about eight to 10 of them. Barefoot, with loose T-shirts, laughing, and slapping cards down in some unknown variation of billiards. Their giggles and laughs help me to realize that what I see and what they live, are two different things. I eat my bowl of vegetables and rice, drink my iced tea, and I'm grateful that I'm here.

There is so much to see and absorb that I don't take as many pictures and or write about it, until much later. I just want to take it all in. Cambodia is a beautiful, heartbreaking dream.

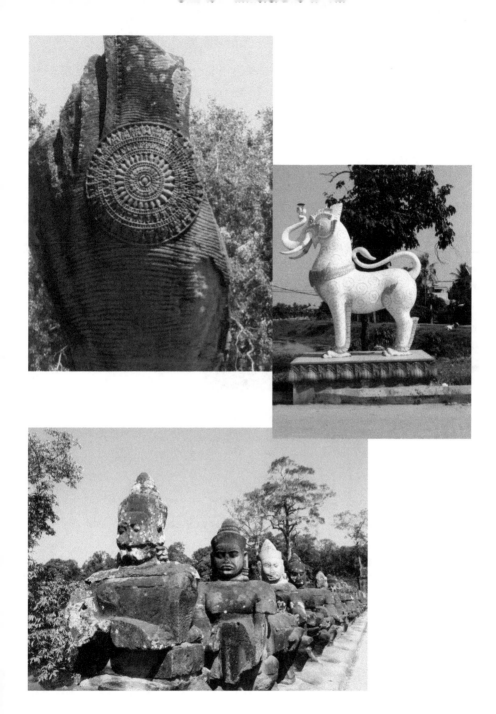

Thailand and Cambodia Recipes

Eating vegan in these areas was not a problem. The dishes listed here are easy and filled with familiar flavors but served in fresh and creative ways.

Thai Corn Fritters
Serves 4-6

My new ex-pat friend Meg took me down the street from her house in Bangkok to a little outdoor stand to eat some of these. They were hot, spicy, sweet from the corn, and fabulous.

Ingredients:

¾ lb.	Corn, either fresh cut from the cob, or frozen
1-quart	Canola Oil, for deep-frying
1 TBS	Thai Red Curry Paste, or to taste
1 TBS	Egg Replacer with 2 TBS Water, or 1 large Egg (you do you)
¾ cup	Rice Flour
1 tsp	Baking Powder
½ TBS	Salt
¼ cup	Thai or regular Basil leaves, minced
	Thai Sweet Chili Sauce for dipping

Method:

- Remove corn kernels from cobs or defrost the frozen corn.
- Heat the oil to 300°F in a heavy, large wide-mouth pot.
- Line a sheet pan with a cooling rack to drain the fritters when they come out of the fryer.

- Reserve half of corn kernels and place the other half in the blender or food processor along with red curry paste, egg replacer, rice flour, baking powder, and salt; blend until smooth and transfer mixture to a bowl.
- Fold the basil and reserved corn into the batter.
- Use a spoon to drop the corn batter very gently into the oil. Do not overcrowd the pot.
- Once the fritters float to the top, flip them around to make sure they're browned evenly.
- Once they're golden brown and they start to darken around the edges, scoop them out onto the cooling rack with a slotted spoon. Repeat until all the fritters are cooked.
- Allow them to cool slightly.
- Serve them with Thai sweet chili sauce on the side for dipping.

Sweet and Sour Eggplant

Serves 4-6

The sweet-sour sauce we had in Thailand was served over a fried fish. Here, I've fried up some eggplant slices to take its place. Honestly, it's so fresh and refreshing it is good over just about anything.

Ingredients:

3 TBS	Canola Oil, or more if needed
3 each	Baby Eggplants, cubed into bite-sized chunks
1 cup	Rice Flour
	A pinch of Salt
½ to 1 tsp.	Crushed Red Pepper Flakes, or to taste
1 each	Onion, cubed into bite-sized chunks
1 each	Red Bell Pepper, cubed into bite-sized chunks
1 each	Tomato, cubed into bite-sized chunks
1 cup	Pineapple, fresh, cubed into bite-sized chunks
4 cloves	Garlic, finely chopped
3 TBS	Rice Vinegar
2 TBS	Palm Sugar
20 leaves	Fresh Basil, shredded

Method:

- Mix the rice flour with the salt.
- Toss the eggplant slices with the rice flour to coat.
- Heat a deep skillet or wok-shaped pan over high heat.
- Add 1 tablespoon of oil and heat through.

- *Toss in the eggplant and brown. You may need to work in batches if your pan isn't big enough. Use another tablespoon of oil between batches. Don't crowd the pan. Remove and set aside on a cooling rack over a sheet pan.*

- *Add 2 tablespoons of the oil and crushed red pepper, and let sizzle for 10 to 15 seconds, then add in the garlic and cook, stirring, for a minute more.*

- *Toss in the onion, bell pepper, tomato, cucumber, and pineapple, and stir-fry for 3 minutes more.*

- *Mix in the vinegar. Sprinkle with sugar, and toss for 1 or 2 minutes longer.*

- *Toss in the reserved eggplant, and mix to combine.*

- *Remove pan from heat, add basil leaves, and toss to combine with eggplant.*

- *Serve over hot, cooked jasmine rice.*

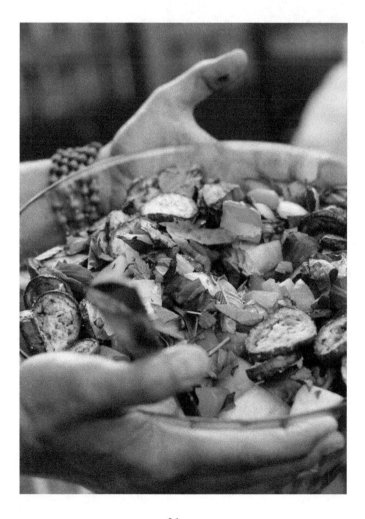

Stir-fried Morning Glory (Water Spinach)

Serves 6-8

Water Spinach is also known as "Ong Choi" or "Ong Choy" when you're looking for it at an Asian Market. It has fibrous, hollow stems, and here you can cut and then either smash with the dull side of your knife or crunch in your hands before preparing.

Ingredients:

4 TBS	Canola Oil
2 cloves	Garlic
1 bunch	Morning Glory, chopped and smashed
1 cup	Vegetable Broth
2 tsp	Palm Sugar
2 TBS	Vegan Oyster or Hoisin Sauce

Method:

- Heat a large sauté pan or wok over medium-high heat then add the oil to heat through.
- Toss in the garlic and cook, stirring until golden.
- Add in the morning glory and broth.
- Cook 1 minute and then add the palm sugar and oyster or hoisin sauce.

- *Cook for another few minutes more, stirring to combine and so the greens wilt, then serve.*

Cambodian Bread Salad

Serves 6-8

I don't know what to call it. The woman making and selling it didn't speak English, and I sure as hell can't speak any Cambodian. But I liked it. It had fermented fish paste spread on fried pieces of baguette. I've replicated that umami funk here in a very vegan way.

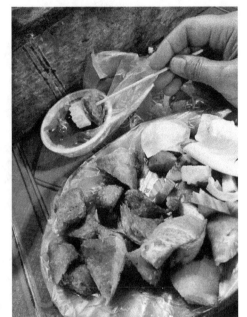

Ingredients:

3 TBS	Brown Rice Miso (make sure it has no Bonito if you want it full-on Vegan)
12 each	Pickled Plums, pits removed
1 each	Baguette, I prefer the softer ones that you'll find at Asian markets for this
1 cup	Fresh Tofu Skin, sliced (or you can use seiten, your choice)
1½ cups	Cucumber, cut in half and sliced
2 cups	White Cabbage, chopped somewhat small
6 cups	Canola Oil, for frying
3 TBS	Soy Sauce, more or less, depending upon your salt preference
2 tsp.	Palm Sugar
2 each	Limes, juiced
1 tsp.	Chili Garlic Paste, or to taste
1 each	Green Onion, minced

Method:

- Preheat the fry oil in a large wide-mouth pot to 360°F.
- Put the plums and miso into a blender and blend until smooth.

94

- Slice the bread in half lengthwise, and into 12 slices, about ½-inch thick.
- Spread evenly with the miso/plum mixture.
- Mix the soy sauce, palm sugar, lime juice, chili-garlic paste, and green onion together and set aside.
- Fry the slices of bread in the fry oil, in batches so as not to overcrowd the pot, until golden. Remove and let cool slightly.
- Fry the tofu skin until golden.
- Cut the bread slices and tofu skin into bite-size pieces.
- Assemble the salad with a base of cabbage, topped with the cucumber, tofu skin, and bread pieces.
- Serve with the soy mixture on the side for dipping. On its own the toasted bread can be a bit much, but when you have a bit of everything together in the perfect bite, it works really, really well.

FIVE

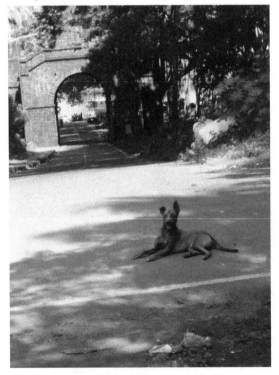

India, Tanzania, and Zanzibar

India Broke Me

A few days in Singapore, as a bookend to my Southeast Asia travels, and then I'm off to India, flying into Mumbai to transfer to a flight to Goa. The Mumbai airport is architecturally impressive. A soaring airy counterpoint to the repetitive aggressive yelling I am greeted with at ticketing desks and security.

Why Goa? Glad you asked. ...

I knew nothing of Goa except obscure references in books I've read. Then in January of 2015 I found myself in Detroit, Michigan, trying to rally coworkers into a celebratory dinner. One wanted Indian food. Two weren't fans of it. And one jackass bitched out completely. A few Google and Yelp searches later, I find a Portuguese-Indian place that made everybody happy. It was Goan.

After that, I did some more researching and when planning my round the world journey thought, why not Goa!? It's a beach destination for much of India, a good portion of Russia, and some Germans and English as well. It's also an easy way to ease myself and my buddy Skees into the chaos of India.

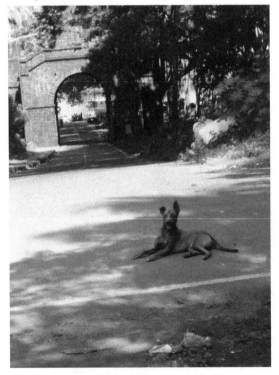

He wanted to visit India as his best friend when he was young was Indian. Skees met up with me in Goa having never really gone anywhere outside the U.S. as an adult. It was, understandably, quite the culture shock and sensory overload for him. But he caught onto some of the rhythms of it soon enough. He was the one to find a tuk-tuk driver (motorcycle rickshaws) who would give us a tour of the area the following day to explore.

The Portuguese ruled in Goa for 450 years, until 1961. Their influence is strong in the architecture. Old Goa is good for that, cathedrals and markets. Our driver leaves us to wander. Greeted as a curiosity by some fellow tourists, being the only white people around, we are asked to have our picture taken with them and laughingly agree.

We find sugarcane juice sellers who greet the tour buses with their frothy, cool cups of sweetness. No ice needed we tell them, doing what we can to keep any water-based substance out of our systems. The juice isn't as sweet as you might think, and after researching, I find that is filled with a higher percentage of nutrients per volume than unrefined sugar. It's a powerhouse.

We visit an old market in Goa, and Skees (a produce buyer in his U.S. life) is blown away by the

choice and freshness in this winding, open building. We hunt out a place for lunch and have a simple, traditional fried fish with fluffy light white rolls. It's tiny, busy and you can feel the Portuguese influence.

We eat in a "tourist" restaurant one night. We are settling in as we realize there is karaoke that evening. German tourists take the stage to sing as a feral cow wanders in off the street. Because of course it does. The food doesn't delight us as much as this does. #karaokeandcows is our new mantra.

After a day or two of beach time, we fly up to visit Mumbai. It's a city of well over 12 million people. Taxis and motorcycles honk their horns all day and night. The cacophony is fucking mind boggling. The heat and humidity are beyond oppressive.

We take an afternoon to try and purchase train tickets that will take us south to Fort Kochi in a few days. There are no discernible lines or queues in the loud, hot bustling, crowded train office. We find a teller who is specifically for the English-speaking traveler, and she pecks away at the computer, hunting for us. Finding nothing as all trains are reserved by folks heading home for Diwali, the Hindu festival of lights, which goes on for five days. Just our luck that we happen to be here at the same time.

I drag him along for the stalls and trays of snacks and the tree-lined streets, for the telltale a banner, calling out you're wanting!" I we dig in to vegetable topped with cheese

As we wander, turn to us, and we are

as I scour the streets markets selling tin meals. We walk along and my eyes search umbrellas that act as to me, "Here is what find a grouping, and and rice dishes, mine of all things.

buses pass, heads stared at as

curiosities. Both often the only non-Indians about, he is over 6 feet tall, and I'm, at 5 feet 5 inches, usually taller than most of the men. We stick out and they notice.

Skees again finds a friendly taxi driver who can take us around to show us the sights. He gives us a history lesson, shows us incredible views and takes us down near the Gateway of India stone arch. Neither of us wants to do the tourist thing and become one with the ever-increasing crowd to go out to see it. We snap a few photos, grab a famous, glorious, multi-layered fruit juice and head out on our way.

It is loud, hot, and frankly I'm not at all surprised when Skees starts to shut down. It's so very overwhelming for him that he sleeps most of the day. Venturing out for just few short hours to explore with me.

Flights to Fort Kochi are procured, another hotel found, and we are on our way a day or so later.

Rain falls, and Skees sleeps. He's finally succumbed to the most common complaint that travelers in India encounter. We are unsure what caused it, but as he's eating somewhat differently than I am, and I haven't had any problems, we're 98% sure it's the food.

I wanted him to join me in India, in part so I would feel safe as I explore. But his system isn't complying with what I want, so I venture out on my own. I find a ferry to take me to Jew Town. I did not make that up—that is what it is called. Honestly.

It's mostly tourist traps of knickknacks and gewgaws. Unessentials hawked by aggressive sellers wanting to earn a living. Sometimes practically demanding it.

Occasionally there are moments that seem less pushy and more serene. There are Chinese fishermen lifting their nets for the tourists. A bit hokey, but still interesting. A tiny bookstore is found, giving a welcome boost to my sanity-saving book needs. Whiling away the time, when I'm unable to explore as much as I would like at night as Skees dozes, means books are needed to keep me going.

Rain falls as I disembark the ferry back on the other side. There are vendors selling street food, so I naturally gravitate there for lunch. Small schoolgirls gawk and giggle at me as I eat paratha hot from the griddle with, what I take to be, chana masala, but in a sauce much darker than I've seen in the U.S. It settles me, comforts me. As food does.

That night, in the pouring rain, I venture forth and find a roadside stall selling masala dosa and grab two, wrapped in newspaper. I return to the hotel and we eat at the ends of our beds. Skees starting to slowly come back to life.

He's able to venture forth the next day, following in my footsteps as I show him the sights from my earlier recon. He's cornered more than once, by the assertive vendors, pulling him in to chat. Unable to just give them a cursory no thank you, his American is showing.

Back to Goa we go, for Skees to fly out the next day. He's wrung out by it

all. Although he does get quite the laugh out of the feral cow that plants itself down behind us when we're on the beach. I take a selfie with it, just to prove such things do happen.

I've one more day here in Goa, and I need, yet again, a haircut. It is that time again, and I wonder, can I make this happen? As I wander from my new hotel toward the beach, I'm approached by a barber: "Madam, do you need a haircut?" I do! Please come in, he gestures. I settle myself into his chair, he drapes the cape around me, I explain what I'm looking for, and he begins. In the other chair in his tiny shop, sits a young man whiling away his time, looking out onto the street or into the mirrors that line the far wall. I am checking my phone, so I don't notice that this young man is ogling me. The kind barber pulls my cape down over my knees and shoos the young man out of the shop. I smile at this kind gesture, at how even my 40-something body being a curiosity and smile even wider as the hair falls away making me feel more and more me.

November 13, 2015

I wake early unable to sleep as often happens. I start scrolling through the news on my phone and I see it, there's been a bombing, a series of bombings in Paris. I'm in Goa nowhere near where this is happening. A friend of mine is, and fear strikes me. I message him panicking, "Are you OK?" I start to cry, sobbing, weeping curled in a ball in my hotel. A few hours go by, and my brain cannot wrap itself around the possibility of losing this once close friend with whom I now have the thinnest of connections. A message comes through: "Am OK". He is and he isn't, as he was at the stadium when the bomb went off during a soccer game, but he is unharmed and I feel relief and shame because this has nothing to do with me. Yet it tore me open with fear. Is that what the terrorists are trying to do to all of us, no matter where we are in the world? Make us fear them even as we have no real connection to them?

For the day, and a small time after, my friend forgets that he and I are no longer as close as we were. And I'm pulled in briefly to see his worry and panic. My romantic life has always been a shambles, so I try to lend an ear without being pulled into something that I know will eventually be disappointing for me.

I had to stop and wonder, with the crazy terrifying events in Paris, if I should continue writing my blog. I'm more *Eat, Fuck, Run* than *Eat, Pray, Love*, but I found myself questioning the blogs' worth. I truly believe that each plate or meal we share brings us closer together. I'll continue. And thankfully so, as it was the basis for the book you are reading.

A friend has mentioned Hampi, which is in country east of Goa, as a perfect, much needed, quiet getaway. The bus station in Goa is made up of benches and a tented tarp, where families and fellow travelers wait for their bus to arrive. On this night bus, I share a bunk with a young gal from England. Dreadlocked and elephant-panted, she's a stereotype, yet kind and sweet. As the bus winds the streets out of Goa, we see a wedding procession out a window. Turbaned males sing and play instruments, crowding around as the groom rides above them on a white horse.

I settle in and sleep better than I expect too. I am awakened in the early morning hours, to a stopped bus. My phone's Google Map shows we have yet to make it to Hampi. I look forward to see the bus crowded from the outside as people yell and gesture. Then I notice that the windshield is missing. Gone. Just fucking vanished. I don't know why or care, as the bus driver continues merrily along, sans glass.

We are greeted at the bus station in Hampi by shouting, pushing tuk-tuk drivers. They outnumber the bus passengers by two to one. I fight my way through them as they thrust maps into my face. One of them, standing a bit away from the mob, leans toward me and says "Madam, I await you here," and steps off to the side standing quietly. I hire him to take me to the ferry to my guesthouse.

Hampi turns out to be a quiet respite from what India has been so far. I stay at a guesthouse in a hut surrounded by trees and with a couch for lounging on a small patio. The restaurants serving falafel and pizza and the young beer-guzzling international hippies and tourists paying to bathe an elephant don't dampen my spirits as I find other avenues to explore, sometimes quite literally.

A message sent to my U.S. friend who recommended this oasis is responded to with the news that a friend of theirs happens to be in Hampi as well. Would I be open to meeting up with him? Sure thing! As I lay on my patio, reading in the shade, a voice calls out, "Chris Clarke?" That's me! We chat and catch up on our connections from Boulder. There is also another night of travel stories, and a meal shared.

There is a ferry that transport travelers from one side of Tungabhadra River to the other here in Hampi. Underwhelming is the size of the river, yet the ferry is the only conveyance for many kilometers. At one point I try to board the boat that just arrived from the north side, until he informs me that no, I must wait for the boat that journeys from the south side to take me. It's less than 30 yards, and I have to wait for the one-way trip to commence. That is India's frustrations in a nutshell.

The southern side is where the temples, bookstore, and street food are located, so I make the journey several times with families, travelers, and costumed dancers offering to take a picture with you in their colorful regalia.

On the northern side, where I am staying, the lure of falafel captures me for a meal. But once I find a cart on the southern side, where I'm the only non-Indian partaking, I am much happier.

I inquire at the guesthouse where the nearest ATM is located, as I am running low on rupees, and cash is the primary payment here. It is 6 km away and the bike rental store is just across the street. Off I ride, winding along the road to the seemingly even smaller town of Anegundi. I spend 30 minutes riding about the town in search of the familiar ATM sign. Monkeys chase my bike as I shoot past a temple and finally, after questions to and pointing from various vendors, I finally find it. A lone ATM, inside a card-accessed vestibule, no bank attached. A guard is located outside to help those who are unsure how it all works. Surreal and wonderful all at the same time

Back in Hampi, I take a few walks here and there to check out the scenery and get to know the area. On one, a motorbike flies past me with a family of six on board. Two tourists riding bikes come up behind me, chatting with one another and questioning if that was really six people on a motorbike? I laugh and let them know their eyes did not deceive them.

A gentle rain starts to fall, so I head back. I see a small coffee shop, or restaurant, well it's more of a glorified shack on the side of the road. I duck in and am greeted by a smiling man, seemingly the owner. There are Israeli hippies drinking beers at another table, and I order a chai, sit, on the cushions, read my book, and wait out the rain. The owner pulls out a guitar and starts to play a tune that turns out to be an Israeli folk song, sung with gentle enjoyment by my fellow patrons. They thank him and head on their way. A woman from the back, his wife perhaps, ask if I'd like to eat. I don't see a menu, I ask what she has. "What do you want?" "Veg biriyani?" "OK, it will take a few minutes." About 30 minutes later, set before me is a steaming, literally made from scratch, veg biriyani. You are slowly redeeming yourself, India.

My final afternoon is spent in the restaurant of the guesthouse, waiting for the time my bus leaves. Rice paddies are the view as I lounge on yet more cushions. I wonder what a comparable view in the U.S. would be? Corn fields? Amber waves of grain?

The end of my journey through India is indicative of my whole stay here. I catch a bus from Hampi to Hospet. In the bus station there, I am approached by a family and questioned about where I am from, how old am I, how many children do I have. They're are as amazed at my childlessness as I am by the 19-year-old telling me that she has been married for two years and that her younger brother is 10, and not the 7 years old that I took him to be.

Onto the night bus to Goa I go. There is one stop along the way for bathroom and food. The ladies on the bus line up outside a foul, stinking, three-sided structure that is just a tiny hole in the ground where you squat to do your business. We hand out tissues and hand sanitizer, because this is what you do.

At 6 a.m., the bus arrives in Goa, and I don't have a flight out until 6 p.m. I hurriedly search the map for a hotel nearby. I wander for an hour through the growing heat of the morning, dragging my bag behind, wilting and worried, until I find a place that can take me in. I only need it for few hours I let him know. I am assured of a car to take me to the airport, a shower, and a place to nap. That works. I even find a perfect lunch around the corner with more masala dosa. I am handling it.

The flight takes me to Mumbai, where again I am greeted at the airport with more of the rudeness that I have come to realize is the cultural norm here. I get through it and finally onto the plane. Only one more stopover in Ethiopia then on to Dar es Salaam in Tanzania.

After 10 days in Tanzania, India catches up with me. A head cold muddles my brain, and a dry cough rattles my chest. India broke me.

It's my way—to have stress get to me long after the fact. When I worked retail over the holidays, pulling double shifts, overtime, closing then coming in to open six hours later, I'd feel the stress of all that by mid-January, with a weeklong malingering flu or bronchitis. And now I'm feeling it. India broke me.

I was ready for it, or so I thought. It was going to be loud, smelly, and dirty at times, I knew that. But I was sure the beauty of the place, the kindness of the people, and the food (oh, that glorious food!) would more than balance out. But India broke me.

First, the beeping. The motorbikes, tuk tuks, cars, buses, and trucks beep their horns incessantly. I'm pulling up next to you where there is no lane, beeep! I'm behind you and do not care that there are feral cows slowing you down, beeeeep!! The light has turned green, and we five cars behind you want to make sure you know it, beeeeeeeep!!! It is endless.

Secondly, the in-your face commercialism, for lack of a better phrase. Everywhere I went, "Madame you like?" Getting off the night bus in Hampi, we travelers were mobbed by tuk-tuk drivers, about 30 of them, thrusting maps in our faces. The one gentleman who stepped to the side and gently told me,

"Madam, I wait for you here," got my business due to his calm demeanor and understanding of how overwhelming his fellow drivers' sales tactics were.

Most stores or restaurants have a hawker out front insisting you enter. The tourist restaurants were heartbreaking for me, with their multicultural menus, extolling Russian, Israeli, Chinese, pizza, and pasta selections. Finding Indian food in those areas was like searching for the fucking Holy Grail. When I did eventually discover a street vendor in Hampi or an all-veg place down an alley in Goa, I returned again and again out of sheer relief. Mumbai was, thankfully, flush with cheap, interesting and delicious street food. Fresh fruit and sugarcane juices, fruit plates, pressed sandwiches, idli, parantha, masala dosa, biryani, and so much more were thick on the ground.

Third and lastly, the poverty. I'm no Pollyanna, skipping along whistling a happy tune and throwing rose petals about. I know it exists worldwide. For me what was overwhelming was the myriad of ways it presented itself everywhere I went in India.

The mounds of garbage on the side of city streets, country roads and beaches.

The begging children and cripples.,

As I woke in the morning on the night bus to Hampi, I looked out the window to see picturesque rice paddies with men defecating in them.

An elderly woman selling roasted peanuts as I waited for a ferry in Hampi, stood and walked over to the side of the road, lifted her sari, crouched, and urinated.

Plastic water bottles, which are almost always the only access people have to clean water, litter the countryside.

Big glamorous houses surrounded by shacks and squalor.

It was not all depressing. There were moments of beauty and joy throughout my month there.

Finding a kind tuk-tuk driver who showed us the temples and markets of Old Goa.

Becoming a familiar face to

the Superman-hatted sandwich vendor down the street from the hotel in Mumbai.

Finding tiny used bookstore oases in Goa and Fort Kochi.

Listening to Israeli hippies pick up a tune strummed by the owner of a tiny roadside café as I read a book, drank a spicy chai, and waited out the rain outside of Hampi.

Meeting a curious family in a bus station in Hospet.

Those moments sustain me. They will, with the passage of time, help to soften the harshness and sorrow that India wrenched from me.

I love you India, and yet I do not always like you.

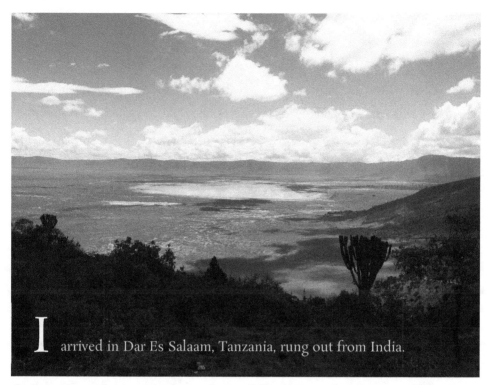

I arrived in Dar Es Salaam, Tanzania, rung out from India.

body and mind so weary that I almost fall asleep in the interminable wait for my passport to pass through customs. I am not alone. Others stand or squat around the glass-lined offices until a large lady comes out and yells out our names, mispronouncing them wildly. It is the beginning of my immersion into the life in Tanzania. Inefficient doesn't even begin to explain it. But as no one is shouting in my face or shoving as they would have been in India, I'm doing just fine.

My phone, which has worked in all the countries I have been in so far, via T-Mobile, will only work in East Africa for exorbitant prices. So I hop on the Wi-Fi at the airport and frantically message my friend and soon-to-be host, Lisa. She calms me and explains buying a SIM card here is easy and cheap. And I find one right outside the exit of the airport. For $1 U.S. The shop person even sets it up for me. Now to get to the hotel.

I've gone off script here and found one as near to the airport as I can find. I'm not looking to explore. I'm too exhausted for that. I just want to sleep and

maybe eat something. And it's costing me more than twice my usual budget for accommodations. I also don't want to spend money on taxis. I could walk, I think, as it's just across the street.

Then I notice there is a set price for the taxi service and so I give in. The streets are potholed and crowded. There are smoke-spouting food stalls, shops, careening cars, and motorcycles. The taxi driver gives me his card when he finds out I'm leaving in less than 24 hours to again fly out of the airport. I thankfully schedule my return trip with him.

My check-in is fraught with anxiety as my credit cards won't work. Come back in 10 minutes, I'm assured. I check out my accommodations (oh, toilet paper and bath towels, I have never been so happy to see you), unpack the few things I'll need for my short stay, and I'm back at the desk to try again. Turns out the hotel's machine goes on the fritz every so often, so my card passes through with no problem now. After returning to my room, relief pours through me and exhausts me even more. It is time to break down and cry. I need it, and I shall have it. My usual emotional and physical demand for food is overcome by my fatigue. Once the sobbing stops, I fall into a deep, untroubled 12-hour slumber.

Breakfast is easy and familiar, checkout is a breeze, and my taxi on time. So far, so good. The domestic side of the airport is tiny and seemingly run by only one desk, shared by several airlines. The luggage check is just to "Leave your bag over there," as they point to the side of the desk. I sit as close to the nearest AC as I can. Then I notice it's the only AC. I'm starting to see a theme here.

My flight to Arusha is on a local airline, inside a small prop plane that makes the stunning views even easier to enjoy. (I'm starting to get my optimism back, thanks to the good cry and deep sleep.) Once I'm out of the airport in Arusha, there is Lisa and her all-terrain vehicle. Welcoming and familiar.

She and her family give me a much-needed dose of friends, kids, dogs, and Mamma Jackie to bring me back to myself after India beat me up.

The family has lived in Tanzania for 6 years, setting down their ex-pat roots for husband Matt to work for The Nature Conservancy in Africa. She

explains the usually daily power outages and hot showers should be scheduled before or after those times. The grounds around the house have banana and avocado trees. Quite possibly a dream come true for many Americans.

Lisa informs me that that a Serengeti safari is planned for the coming weekend. "Who's going?" I ask, as I mentally start to plan for my time alone in the house. "All of us. Including you!" I have no problem agreeing, also mentally chucking my usual budgetary worries out the window for a once in a lifetime experience before finding out the whole thing is free. They have friends with a safari company who want folks along for a photo shoot to use for marketing their business.

On the drive there, I get much needed kid time with two of their brood, playing car games and keeping track of the multitude of wildlife we see along the way. A new banana variety, red skinned and very thick, is purchased from a roadside seller. I have a new banana to love. I'll come to eat these from breakfast most mornings as they are so filling and not overly sweet.

 The caravan stops for a moment at the overlook to the Ngorongoro Crater. We search through binoculars and see, far off and as little dots, a few elephants wandering through. It's the closest I'll get to them, sadly. There are so few now as their numbers are dwindling due to poachers.

As we take pictures of the breathtaking landscape, we have become the center of attention for a group of fellow tourists. There is a young girl, who is giggling uncontrollably as she takes pics of us with her phone. We are clearly not from around here. Her father

urges, "Go on, Deborah, talk with them," but she just continues to giggle. "OK," I say, laughing, "you can take my pic but I want one of you." A selfie of the two of us laughing is taken, and I have a picture to remind me that no matter how different we may seem, laughter is a common denominator.

Once we arrive at the camp, well within the Serengeti, our site looks out onto the savannah with a clear view of the wildebeest migration thundering through the horizon. It is the largest terrestrial mammal migration on the planet. Over 1.5 million wildebeest, countless Thomson gazelles, zebras, and more. It is mind-boggling and a solace. That the natural world keeps doing what it was meant to do, these many millennia along, gives me hope.

We are given an unforgettable glamping experience. Tents outfitted with 5-star hotel rooms inside. Electricity, queen-sized beds and towels so soft that I whispered to Lisa that I wish we could steal them. When we are ready for showers, the camp crew bring hot water to fill the showers that are installed in each of the tents. It's the kind of safari camping I imagine Hemingway would have loved, but with more photos taken and no shots fired. The experience of sitting in a chair, wrapped in a Masai shuka (blanket) against the evening chill, watching the African light wane, is an exceptional experience. At night, we hear lions calling as they wander by camp. There are plenty of safari guides keeping an eye on us, so I have no fear as I fall asleep.

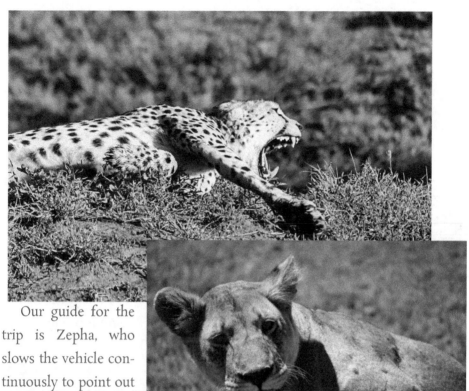

Our guide for the trip is Zepha, who slows the vehicle continuously to point out the animals that stroll into view. Marabou Stork, giraffes, zebras, baboons, wildebeest, hartebeest, cheetahs, water buffalo, warthogs, ostriches, golden jackals, the Thomson's gazelles, elands, hyenas (one who stole a frying pan from the camp), lions, hippos, black-backed jackals, African wild cats, lesser spotted eagle, tawny eagle, and over 80 types of other birds were just a few that were caught by his expert eye. His knowledge is so encyclopedic that there are times I feel he must be making it up. Until we stop for lunch, and I see him reading a book off to the side, learning even more about the Serengeti inhabitants. He's been working here for years and even he is still learning all he can. (The Old Bird will appreciate that he's a lifelong learner!)

More and more on this amazing journey, I am realizing that it isn't luck that is responsible for these incredible experiences, as it is cultivating a tribe of like-minded, kind and generous people.

One of the most generous I meet here in Tanz is Mamma Jackie, the former nanny, who cooks for the family, and me, a lunch every day, set out on the table with a simple beauty that would make any restaurant proud. She is kind and inquisitive with a smile and laugh that go a long way in healing my

exhaustion, When India catches ups with me for real, sending me to bed for a day of sleep while I fight off a cough, I let her know that I'll be out of commission. She coos and clucks telling me to go, go to sleep, shooing me away with a wave of her hand. And later, as the sun sifts through the curtains, I hear a light tap and that same lovely Black hand reaches through a slightly opened door to leave a hot cup of tea for me on the side table. There are tears of gratitude that I let fall as I slip back into a deep sleep.

She also teaches me about Ugali, the national dish of Tanzania. It's dense and filling. Not everyone's cup of tea. I like it, but I don't have to eat it every day. The sad/wonderful thing about the national cuisine here is that it is based upon a subsistence diet. The Maasai and other tribes are nomadic, and their food reflects that. It was meant to nourish and give you energy. More fat is used in the cooking than we in America are used to because of this. And

a sign of wealth here is for you to be fat. This shows that you eat well and work less. I get it. It's wonderful and heartbreaking, as more and more the nomadic tribes are becoming domesticated and their traditional ways of life are disappearing.

A few days after recovering, I'm able to get out and run on the roads around the house. They are unpaved and with a majestic view of Mt. Meru, behind which Kilimanjaro hides. Every morning, when I step through the gate, there is a dog outside, seemingly waiting for me. I nickname him Buddy. He runs along with me, sometimes at my heels. Other times he bounds through the tall grass as if he's a puppy. He seems well-fed and unlike a stray. But he also doesn't seem to belong to anyone. I throw him numerous sticks, although he doesn't seem to understand the concept of return.

Matt invites me to visit him at his offices to meet the woman who cooks for them every day. I am delighted. He wants me to teach her a few more western dishes and I want to pick her brain about the local food. Lisa lends me her car and explains that it is only a 10-minute drive away and I am terrified. First, the driving is on the left side of the road here. Second, the police will pull you over indiscriminately. This happened once when Lisa was driving, and she pays the "fine" (read bribe) right there on the side of the road. I am driving as if I'm sixteen again and taking my driver's test, white knuckling the steering wheel and leaning forward, almost nose to windshield.

Once there, I shake off the anxiety and have a wonderful time with the cook, Nazrah. She's young, a graduate of a cooking program, speaks perfect English, and is eager to learn from me and teach me as I am for her. She

laughs as I eagerly take down the recipe for her pepper sauce. It is not only fiery and delicious, but unique.

Teaching is something I most enjoy. Perhaps it's my mother's occupation coming through in my blood. One afternoon is spent teaching the children and a few of their friends a dumpling class. They are all involved and excited. Almost as excited to eat it all as they are to make it.

At least one day a week as I travel, I take time to plot and plan for the weeks ahead. Scouring the Internet for places to stay, work, and travel. I'll be heading to Zanzibar per Lisa's instructions after leaving Arusha for a week, and then I'll be on to Turkey. It's winter time there, and I don't have a coat. My favorite, waterproof, Columbia shell is lost in the cabinet of the hotel in India after hanging it up to dry from the onslaught of rain when searching out masala dosa for me and my travel buddy. Losing things is something I am well versed in. I can't even be upset about it anymore, it's become so standard in my life.

Matt assures me we'll find something at the Mitumba Market. Kilimanjaro brings people the world over to attempt its heights. They outfit themselves

with the latest and greatest gear, only to leave much of it behind when they are done as they have no call for it in their home countries. This is where the entrepreneurs of the market come in. They pick up the coats, boots, hats, and gloves and sell them off at a largely discounted rate.

We arrive, and I am almost immediately surrounded by men with coats in their hands, shouting "Mamma here, here, this is what you want." Laughing at their sales pitch, I try a few on and find what I need. Matt and I haggle the seller down and it costs me only $14 U.S. Once back at the house, an Internet search shows that this same jacket retails for over $100 U.S. A damm good bargain. Mamma Jackie and her daughter Elizabeth take it in hand and clean it up so that it looks better than new.

My trip in Arusha comes to an end, and I say goodbye to my friends, knowing we will catch up again, whether out in the world or stateside.

I'm in Stone Town, Zanzibar, now. More heat and humidity. But wandering through the alley like streets and discovering the street food makes me happy.

The son of the proprietress of my guesthouse offered to give me a tour. Abdulla has lived here all his life and is adept at finding the out of the way places. And his cell phone ring tone is Justin Bieber's "Sorry," so that's perfect.

My directional dysfunction, oddly enough, isn't a problem on the streets here. There seems to be enough visual clues, doors, alleys, store signs that I'm able to find my way through the maze almost easily. Yeah, me! Many of the doors here intricately carved, colorful and eye catching. They reflect the Swahili, Indian, and Arab influences that have melded so nicely.

Abdullah has given me as a point of reference for my wanderings, the town center. It about the size of the coffee shop I sit in now. Small and cozy. There are benches lining the walls, with a small tier of seats on one side. A black board backs this with items written in chalk in both English and Swahili. They are topics of discussion for the Stone Town men to discuss each day.

Although I don't agree with the women being left out of the conversation, it is heartening to see the inhabitants involved in their community.

I request a tour of a bakery and I'm quickly led to a seemingly small one.

Until you enter the back where hundreds of pounds of dough are proofing in troughs, where they bake thousands of loaves daily in wood-fired ovens, as well as roasting some peanuts. The loaves are long and white. Later, I try one and find it dry

and boring. Yet they have been making them at this bakery for hundreds of years. Maybe they are popular because they last, are hearty and make a great base for stews and things. Maybe?

They are also sold at the Darajani Market where Abdullah takes me next. This is THE market in Stone Town. Packed, loud, smelly—my kind of place.

Warning for my veg head friends: This is where you will find graphic meat photos. Before any of you get up on your soap box and lecture me about how "Meat is Murder," etc., I'm in another country, wandering through another culture. I will not be yet another rude, culturally insensitive, and imperialistic American. Do I believe that in America we should practice more humane animal practices? Yes. Do I believe that we Americans should be eating more vegetables and less animal proteins? Yes. I am not in America. I am in Stone Town, Zanzibar, where the average monthly wage is around $50 U.S. a month.

The market is a wonder, sectioned off for the meat seller (halal), poultry areas, fish, vegetables and fruits, and spices mounded

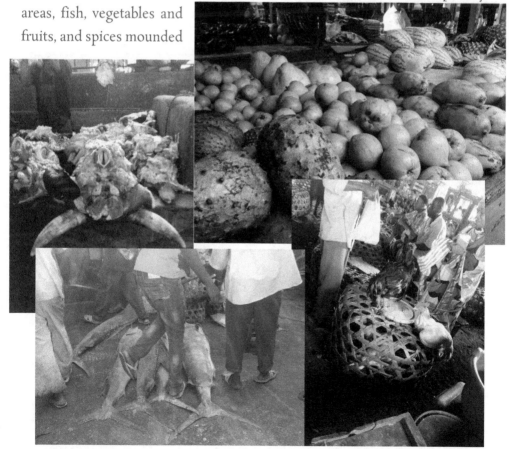

high. Glorious. Yet another banana variety is piled on the ground. They are gigantic! Used for cooking as they are starchier and less sweet then what we are used to, they are called "elephant fingers" in Swahili.

We sit to rest after wandering and a parade goes by, men and covered women. I ask him what is going on, and he informs me that is for the Prophet Muhammad's birthday. He says it with a touch of surprise in his voice, as if to say, "How could you not know this?" Much the same way we would look at a visitor to the U.S. who was asking about a Fourth of July parade.

Abdullah also informs me that I must try a restaurant just down the street called Lukmaan. Their spice tea, reminiscent of an Indian chai, is so spicy my tongue tingles. I like it. I work my way down the cafeteria line, asking for okra and chapati, that are both Arab and Indian influenced. Another meal there is made of an injera like pancake, with collards, beans and peas. That was breakfast. Damn good.

I leave stone town to head to the east. The beaches here on the west, Stone Town side of Zanzibar are OK, but I have heard that the east is where the real views are.

It's hard living in paradise. "Pole, pole" the say when I arrive at Paje Beach on Zanzibar. It means "slowly, slowly." That's how life moves there—no need for speed.

Paje beach was a last-minute decision, which seems to fit the lifestyle as well. The beach is white sand and the water a light blue that is astonishingly beautiful.

I found a guesthouse on AirBnB that fit my budget and was a two-minute walk from the beach. Arriving by taxi, I am unable to find it. A few phone calls placed from another guesthouse/hotel, which graciously let me use their phone, and I'm told someone will come gather me.

Saloum, the caretaker, and his pup Sela (I may or may not be spelling their names right) greet me and show me around.

It's rustic and with the beach so close, a truly perfect find. I cannot even fathom the blue of this water. It is light and warm. There are housemates who are Dutch and Estonian. As the days slide by, pole pole, we find a German to wander with as well.

I cook for them, simply. Fresh fish tucked with lime and garlic, wrapped in foil, and tossed in the coals of the fire. As we eat, the Dutchman I think, exclaims, "It's hard living in paradise. ..." We lay on rope beds outside and watch the night sky as shooting stars put on a show. There are so many, as there are no streetlights here, that we lose count.

Most days the water is luke-warm, and your swimming is

held captive by the tides. A hammock at a local coffee shop, the only Wi-Fi available, becomes my perch. I read, rock and relax.

I wander around the village, checking out the area. I see at one roadside restaurant, a young man pounding and scrubbing an octopus on the pavement to tenderize it. Not the way I would have done it, but I understand why.

I am in need of more cash, and my housemate from Holland and I find a money changer at a hardware store. Yep, you heard that right. We give him our American dollars, and he changes them, at a very competitive rate, into Tanzanian shillings, out of a drawer in his desk. Who needs a bank.

One night and day, it pours rain, so we walk up the beach to visit another guesthouse for lunch. Along the way, women are working their seaweed beds while the tide is out. They have found a sustainable way to make money for themselves and their families. Most of it is sold for soaps. I wonder about the edible uses.

The following morning, I catch the tide before it goes out, and the water is refreshingly cool, whereas during the day the water becomes bathwater. Not all that invigorating.

I cook once more, my last night. We shop in the village. As we walk through, children play and giggle with us.

I cook fish the same as before and make bananas in a curry sauce. The bananas are called elephant fingers due to their size. They are starchy and unsweet, so best for cooking in the sauce and melding well with the salty delicacy of the fish.

My last night, I jump in the ocean as the stars fill the sky above me. There is no one on the beach or in the water. I am alone, lost in my own wonder at where I have gotten myself to.

It sure is hard to live in paradise.

India, Tanzania and Zanzibar Recipes

There is some overlap in spices and bread as there was a considerable Indian influence in Tanzania and Zanzibar. Find the nearest Indian market and get to know the proprietor. They'll head you in the right ingredient direction.

Chana Masala

Serves 6-8

The dish I had when I got off the ferry in Fort Kochi was much darker than any Chana Masala I had eaten in the U.S. The trick, I found, was using a tea bag to spice and color the dish. Mystery solved.

Ingredients:

Chickpeas:

1 cup	Dried Chickpeas
1 each	Teabag
3 cups	Water
½ tsp	Salt

Channa Spices:

2 pods	Cardamom
1 inch	Cinnamon Stick
3 each	Black Peppercorns
2 each	Cloves
1 each	Bay Leaf
¼ tsp	Fenugreek Seeds
1 tsp	Cumin Seeds
1 tsp	Coriander Seeds
1 tsp F	Fennel Seeds
1 each	Dried Chili

Gravy:

3 cloves	Garlic, chopped
1/2 inch	Ginger, chopped
2 TBS	Canola Oil
1 each	Onion, peeled and chopped
1 each	Tomato, chopped
1/4 tsp	Turmeric
	A pinch of Cayenne
1/4 tsp	Garam Masala
2 each	Jalapenos, cut in two and seeds removed
1 1/4 cups	Water from the cooked Chickpeas, as needed
	Salt, to taste

Garnish:

1/4 cup	Cilantro, roughly chopped
1/4 cup	Red Onion, minced
1/4 cup	Tomato, chopped small
2 each	Limes, quartered

Method:

- Pour boiling water over the chickpeas to cover. Let sit for one hour and then drain.
- Place the chickpeas, tea bag, and 3 cups of cold water in a pot, cover and bring to a boil over high heat. Turn to a simmer, and cook until the chickpeas are cooked through, about 30-40 minutes. Remove the tea bag and drain, saving the liquid.
- Place the chana spices in a dry sauté pan over low heat. Heat, stirring to release the flavors until fragrant, about 5 minutes. Remove and let cool. Grind the spices in a coffee or spice grinder to make a spice powder.
- Mash the garlic and ginger together in a mortar and pestle or with a knife.
- In a pot, heat the 2 tablespoons of canola oil over medium-high heat. Add in the garlic-ginger mixture and sauté until fragrant, about 1 minute.

- Add in the onion, and sauté until the onions are softened, about 3 minutes.
- Add in the tomato and cook until the tomatoes are breaking down, about 3 minutes more.
- Mix in the channa spices, turmeric, cayenne, garam masala, and jalapeños.
- Season with salt and add in the chickpeas. Pour in about 1½ cups of the liquid from the cooked chickpeas.
- Stir and bring to a boil over high heat, turn to a simmer, and cook, uncovered until the sauce starts to thicken. Mash a ¼ cup of the chickpeas to help thicken the sauce.
- Serve with the cilantro, chopped red onion, tomato, and lime on the side for folks to garnish their own. Works great with rice or paratha.

Idli

Serves 4

Your nearest Indian grocery or Amazon.com will have all you need to make this dish. I found my microwaveable idli cooker on Amazon! It's just some, soaking, blending, and fermenting, and your batter is ready. It really is that easy to make these truly enjoyable soft, gluten-free breads. They are perfect for sponging up different dhals, chutneys, and sambals.

Ingredients:

2 cups	Idli Rava (also called rice rava or creamed rice)
½ cup	Urad Dhal (black lentils that have been split and skinned)
¼ cup	Poha (flattened rice)
8 each	Fenugreek seeds
	Salt, to taste
	Water (for soaking)
	Canola Oil (for greasing the idli steamer)

Method:

- Place the idli rava in a bowl, and cover with water. Soak for 4-5 hours.
- Mix the urad dhal, poha, and fenugreek in a bowl and cover with water. Soak for 4-5 hours as well
- Drain the urad dhal, and save the water on the side.
- Drain the idli rava, and discard the water.

- *Put the two mixtures together in a blender, and blend until smooth. Use some of the reserved urad dhal water if the mixture seems too thick. You are looking for a pancake batter consistency.*

- *Pour the mixture in a large non-reactive bowl, and mix in the salt. Cover and place in a warm place to ferment for 7-8 hours.*

- *Grease the idli steamer bowls with a little oil.*

- *Pour some batter into each of the bowls, and steam in the microwave for 3-5 minutes, or until the idlis are cooked through.*

- *Serve hot with chutneys or sambars.*

Vegetable Sambar

Serves 4

You can cut up the veg for this or you can just go to an Indian grocery and look for the frozen Sambar vegetable mix. It is that easy. It even has curry leaves in it, which you can use for other recipes as well.

Ingredients:

⅓ cup	Toor Dhal (yellow split peas or lentils)
¼ tsp	Turmeric
1 cup	Sambar Vegetables (I found this mix frozen at the Indian grocery, see above)
1-2 each	Dry Red Chilies, or to taste
½ tsp	Mustard Seeds
A pinch	Asafetida
⅓ cup	Red Onion
1 TBS	Sambal Powder (or grind 1 tsp coriander seeds, 1 tsp cumin seeds, 1 tsp mustard seeds, 6 each black peppercorns, 1 dry red chili, 1 tsp fenugreek seeds, ½ tsp ground cinnamon, and 1 TBS dry coconut together to make the mix)
1 TBS	Tamarind Paste mixed with 3 TBS hot water to make a juice
1 each	Tomato, finely chopped
1 TBS	Canola Oil
2½ cups	Water
1 TBS	Cilantro, finely chopped
	Salt to taste

Method:

- Put the dhal, 1 cup of water, and turmeric into a pot. Bring to a boil then simmer until cooked through, about 20-30 minutes.
- Rinse the frozen sambar vegetables until just defrosted.
- Heat a sauté pan over medium-high heat.
- Pour in 1 tablespoon of the oil and heat through.

- *Toss in the mustard seeds, dried chili, and asafetida and cook until fragrant, about 15 seconds.*
- *Toss in the onion, and sauté until softened, about 3 minutes.*
- *Add in the tamarind juice, and cook for about 3 minutes more.*
- *Mix in the tomatoes, and cook until they are soft.*
- *Stir in 1 tablespoon of the sambar powder.*
- *Cook for about a minute.*
- *Add in the cooked dhal, cooked vegetables, and 1 ½ cups water.*
- *Stir to combine, and bring to a boil for about 5-7 minutes. Season with salt.*
- *Remove from the heat.*
- *Garnish with the cilantro, and serve*

Coconut Chutney

Serves 4

As good as this is with idli, you don't have to reserve it for just that dish. Enjoy it with naan, paratha, on sandwiches—anywhere bread is involved.

Ingredients:

1 cup	Fresh Coconut, chopped (or 1 ½ cups dried, unsweetened coconut)
1 tsp.	Fresh Ginger, grated
1 small	Jalapeno, chopped
1 TBS	Yellow Lentils or Toasted Chickpeas
1 cup	Coconut Milk
1 TBS	Lemon Juice
	Salt, to taste
1 tsp.	Canola Oil
½ tsp.	Cumin Seeds
¼ tsp	Mustard Seeds
4-5 each	Curry Leaves (can be found in the mix of frozen Sambar Vegetables)
1 each	Dried Red Chili

Method:

- Use a coffee or spice grinder to grind up the coconut, a bit at a time.
- Then grind the ginger, jalapeño, and lentils or chickpeas. Mix the coconut and ginger mixture together.
- Mix in the coconut milk and stir to combine.

- Heat a sauté pan over medium-high heat.
- Add in the oil to heat through.
- Toss in the cumin seeds, mustard seeds, curry leaves, and dried chili. Cook until fragrant and mix into the coconut mixture. Season with salt.
- Allow the mixture to sit and the flavors to meld for 20 minutes then serve.

Mumbai Grilled Veg Sandwich

Serves 4

This was my late-night snack as I carefully ventured from the hotel room at night. The vendor was located just around the corner from my hotel. I must have eaten at least three of these sandwiches and became a familiar face to the guys at the stand.

Ingredients:

8 slices	Wheat or your Favorite Sandwich bread
1 each	Idaho Potato, peeled, boiled and sliced thin
1 small	Cucumber, thinly sliced
½ each	Red Onion, thinly sliced
1 medium	Tomato, sliced thin
1 each	Beet, peeled and boiled, sliced thin (optional)
	Vegan Margarine or Butter, room temperature
	Curry Powder, to taste
	Salt and Pepper, to taste

Cilantro Chutney:

1 cup	Fresh Cilantro Leaves
2 cloves	Garlic
1 small	Jalapeno, seeds removed and roughly chopped
¾ tsp.	Lime Juice
½ tsp.	Ground Cumin
	Salt, to taste

Method:

- Put all the chutney ingredients into a blender, and blend until smooth. Let sit at room temp for 20 minutes to meld the flavors.
- Preheat a grill press to medium-high heat.
- Spread each slice of bread with vegan margarine, and turn over, margarine-side down.

- *Spread each slice of bread with some of the chutney.*
- *Then, on 4 of the slices, layer potato slices, cucumber slices, red onion slices, tomato slices, and beet slices (if using). Sprinkle with some of the curry powder. Top with the other slice of bread, margarine-side out.*
- *Place the sandwiches into the grill pan and close. Cook, pressing down, until golden brown, about 5 minutes.*
- *Cut in half, and serve hot with some more of the chutney on the side for dipping.*

Nazrah's Spicy Pepper Sauce

Makes about 1½ to 2 cups

This condiment would be good with rice dishes, grilled proteins, and well, just about anything. It has some spice, but you can make it to your taste.

Ingredients:

1 tsp	Canola Oil
2 each	Yellow Onions, peeled and chopped
1-2 each	Red chili Peppers, chopped
2 small	Tomatoes, chopped
2 each	Lemons, juiced
1 TBS	Dried Rosemary
1 TBS	Tomato Paste
3 cloves	Garlic, minced
¼ cup	Cucumber, peeled, seeded, and chopped

Method:

- Heat the oil in a saucepan over medium heat.
- Toss in all the ingredients, except the cucumber, then turn to low, and sauté for 20 minutes.

- Toss in the cucumber, and remove from the heat.
- Puree, and chill.
- Serve at room temperature.

Mama Jackie's Braised Cabbage

Serves 6-8

Mamma Jackie made this for me for lunch more than once. I did not mind the repetition at all.

Ingredients:

3 TBS	Canola Oil
2 lbs.	White Cabbage, shredded
½ cup	Red Onion, peeled and sliced
1 tsp	Salt
¼ tsp	Crushed Red Pepper Flakes or to taste
½ cup	Vegetable Broth

Method:

- Heat the oil over medium-high heat.
- Sauté the onions, cabbage, and seasonings until the cabbage just loses its crispness.
- Add in the broth, and simmer for 5 minutes.
- Serve.

Ugali

Serves 4-6

This is a dense vehicle to get the food into your face. It isn't fancy, but it is sustaining. And that is why it is what it is.

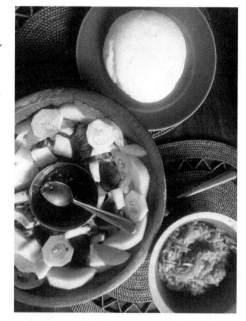

Ingredients:

2 cup	White Cornmeal
4 cups	Water
1 tsp.	Salt
2 tsp.	Canola Oil

Method:

- Bring the water and salt to a boil in a heavy-bottomed saucepan.
- Slowly stir in the cornmeal.
- Reduce heat to medium-low, and continue stirring, the ugali pulls away from the sides of the pot and becomes very thick.
- Remove from heat, and allow to cool somewhat.
- Grease a serving bowl with the oil. Pour the hot ugali in and flatten

the top. Place a plate over the bowl, and turn the ugali out onto the plate to serve.

Zanzibar Spiced Tea

Serves 4-6

Hot or iced, this spiced tea is refreshing. I like it to have a little kick, so I add more peppercorns. You do you.

Ingredients:

8 cups	Water
4 each	Black Tea Teabags
10	Cardamom pods, gently smashed
1 tsp	Coriander Seeds
1 large piece	Lemongrass, smashed
1 inch	Ginger, peeled and smashed
4 pieces	Star Anise
6 each	Black Peppercorns
A splash	Non-Dairy or Regular Milk, if you are so inclined
A touch	Sweetener of your choice, if needed

Method:

- Place the cardamom, coriander, lemongrass, ginger, star anise, and black peppercorns in cheesecloth or tie up in a coffee filter. Toss into a pot full of the water and bring to a boil.
- Pull the pot from the heat, and add in the teabags and cover.
- Let it steep for about 2 minutes, then remove the tea bags and spices.
- Serve iced or hot with a splash of milk or sweetener.

··

Turkey and Greece

My Turkish Heart

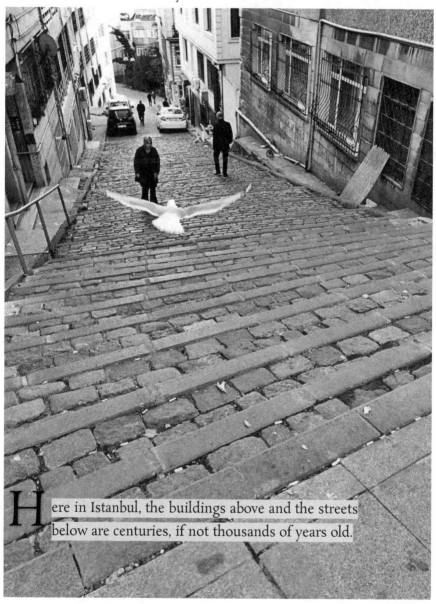

Here in Istanbul, the buildings above and the streets below are centuries, if not thousands of years old.

They are selling cell phones in markets that have been in existence since before 600 BC. Wrap your brain around that. These cobblestones wind their way through markets and neighborhoods where the domes and spires of mosques soar overhead. Turkey is predominantly a Muslim country, which is reflected in the architecture.

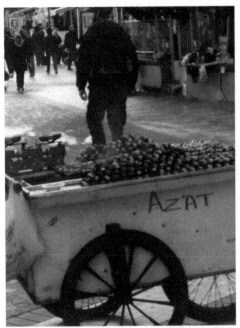

The European side doesn't draw me in as much as the Asian side, the Kadıköy neighborhood in particular. It's less touristy, more real to me. Parks, street art, and the sights and sounds of everyday life. I've found an AirBnB here, a room in an apartment that a young couple is offering up. They speak excellent English, after spending time in the states, and give me advice and recommendations. Incredibly hospitable.

The streets bustle with people, no

Christmas overload in sight, as it would be in the U.S. during the last few weeks in December. Almost everyone I see looks like my relatives from the Italian side of my family. Glimpses in their faces of my aunts, grandfather and great uncles. I'm sure it is because the Mediterranean, for thousands of years, encouraged through sea voyages, people to travel all throughout. We are all related somehow.

The tea culture is seductive. A glass is cheap, about some 60 cents. I drink it in shops where low stools are the seating and men chat and animatedly argue. Turkish coffee is regretfully tried as well, because friends have recommended it. But I'm no coffee drinker and this strong bitter sludge is not for me. I try the accompanying Turkish Delight, a nibble of it with each sip, hoping the overwhelming sweetness will balance the cringe-worthy sweetness. But nope, as I shake my head with a sour look on my face, not for me.

My hosts push me to wander the Moda neighborhood, where food markets abound. The displays are dazzling. Fruits, vegetables, olives, pickles, cheeses, dried fruits and nuts, and Turkish Delight as far as the eye can see. I find a bakery 100 yards from the house, where I become a regular. Each day I buy freshly baked whole-grain rolls and a sweet or two, holding my hand out with lira for the big-eared, doe-eyed smiling and welcoming counterman who gently retrieves what is required to pay. "Teşekkür ederim," thank you I say, my

tongue stumbling over the new words. He smiles encouragingly. I have never in my life known breads this wonderful. Honestly. Every day, I go back.

I spend one afternoon wandering through the Üsküdar neighborhood, along the Bosporus, stopping to drink tea and watch the life on and around the water. Simit sellers carry trays piled high with their bagel shaped snacks. Cheap and filling, they work as a perfect accompaniment to the glasses of tea.

Later, after I hike up stairs and more winding streets, I stumble upon a gigantic farmers' market, which I told my guesthouse host I have a knack for. The sheer abundance of produce is staggering. And the size of things! Cabbages larger than basketballs! Softball sized black radishes! Leeks a yard long! Mind-blowing—I am in awe.

One of the major downsides of living here is that everyone smokes. Everyone, everywhere. My lungs burn from it. But the sunshine and the cool, mild winter air (mid 40s to high 50s) make me happy. The Grand Bazaar and

the Blue Mosque take up a day of wandering. Tea sellers fly by in the bazaar, with glasses and small plates precariously balanced on trays. Anything you could think of being sold by over 4,000 shops. The mosque is a triumph of architecture, and though I don't go inside, instead wandering the parks outside munching on simit and people watching. The variety of tourists from all over the world, visiting here is astounding.

Feral cats and dogs roam the streets of the city, well-fed and happy. They lounge about in the sun, napping their afternoons away. I see piles of food left out for them everywhere I go. My hosts inform me that most of them have been captured, spayed or neutered, given vaccinations, and tagged. Then they are released back onto the street as the country doesn't believe in euthanizing them. All the animals I encountered were easy-going and content.

Christmas isn't as in your face and all-encompassing here as it is back home. I spend my eve and day catching up with family and friends in the States, eating whatever the hell I want (Merry Christmas to me!) and taking pics of the moments of holiday cheer I happen to stumble upon.

My holiday wish for you all: Peace!

After the holiday, it's time to head to a farm in northeastern Turkey, about 2½ hours east of Istanbul. In exchange for daily work, 6 days a week, 4 to 5 hours a day, I will receive room and board. A friendly lift is given by the daughter of the farm's owner and her fiancé. They fill me in on more things Turkish as we fly along the highway.

I arrive and am brought to the burlap-sided tent that makes up the dining hall. The farm also has a fine hotel and restaurant where guests can pay more to stay and learn about organic farming and dine on the spoils of the plantings.

Fellow volunteers—German, French, and Japanese—show me the bunk-house. The beds are comfortable and laden with blankets, as the heat is from a stove in the middle fueled by hazelnut shells. We are all sharing the room, and as cozy as it is, it isn't anywhere near a hardship. I learn that recently a fellow American woman volunteer spent only one night on the farm, unable

to resign herself to the accommodations. I promise myself I'll make a better showing for the U.S.A.

I head back to the dining hall, where lunch is being served. A strong farm table is set for almost 20. Tea is heating on the wood stove

here, the traditional double pot, with hot water on the bottom and strong black tea on the top. You pour some tea then add water to achieve your desired strength, the glass cups allowing you to see the color/strength you want. Many also add in some sugar.

The food is amazing. Fresh bread, some toasted on the wood stove, fresh green salad, redolent with herbs, pickled beans, and a soothing soup. Breakfast the next morning is just as wonderful. Fresh bread, again, fresh cheese, olives, tahini to spread on toast, and a grape molasses to top the tahini. It's perfect.

Every day the food, breakfast, lunch, and dinner, changes slightly, so that I am always asking what is that? And trying new things. They accommodate my no meat needs easily, but the vegan goes out the window as cheese and yogurt are made fresh here from the cow's milk. Chickpeas show up, greens aplenty, soups, cabbage, bulgur pilav, buttered noodles, vegetable fritters—the variety soothes me and fuels my daily physical labor.

We volunteers are put into the capable hands of a head man who speaks exemplary English and a head woman who doesn't but quickly becomes a friend to us all. She is strong, easily laughs, and is very curious. She also covers her head in a hijab. I like her and find myself gravitating to her daily. We call one another Big and Little Sister, although she informs me she has 7 sisters already.

The work is easy, planting or picking vegetables either outside or in a greenhouse. Cleaning stalls in the horse and cow barn. Easy and invigorating. When the weather turns cold and snowy, we are relegated to the dining tent or inside the house to do busy work. Picking through bulgur grains or breaking up hazelnuts. This time gives us a chance to get to know one another better, we foreigners and the Turkish coworkers.

My second week, I'm invited to work at the hotel restaurant. The kitchen is run by a chef with only rudimentary English, who is rarely seen as he has just become a new father. I'm put in the hands of a capable young lady, Merve, who speaks fantastic English. I'm a bit unsettled first when she responds to my questions when she doesn't hear them, with a loud shout of "What?" But I soon realize that is just the way; she's not angry, she's just asking. I'm relegated to KP duties, peeling potatoes, washing dishes, but I don't mind. It gives me a chance to watch the cook-

ing and learn what and how they make their dishes. And I realize I they have no idea what my abilities are, so I do what I can to help them without getting in the way of their well-oiled machine.

One day she informs me "Today we make Börek!" It's the traditional layered pastry, here filled with cheese, greens, and green onions—similar to a Greek spanakopita. The guests will eat this at lunch and we will see it at dinner. It's lovely, flakey and slightly sour from the use of yogurt to moisten the

pastry, which is more like a sheet of thin tortilla then filo dough.

The kitchen ladies are found often rolling out the pastry, called yufka, with thin dowels in the dining room between sittings. Their sleeves rolled up to their elbows, heads hijab covered, gossiping, tea drinking, and laughing as they roll.

Another day, we make manti, which are Turkish ravioli, often topped with yogurt, garlic, and a dash of paprika. I help make them but don't eat them as they are filled with meat. I'm sure I'll be

eating the occasional seafood, dairy, and maybe even meat along my way, but when I can hold out I will for the sake of my cholesterol.

Every afternoon a tea break happens, sometimes up at the hotel or in the dining tent. In the tent, cats force themselves onto my lap to purr and warm me. They are respected as well as their counterparts in Istanbul. Their mouse- and rodent-hunting abilities are utilized here on the farm, and the dogs are kept for their ability to scare off the wildlife from the crops.

Many of the other volunteers have moved on to continue their travels and it's just a Japanese woman and myself left. The cold weather also brings about a freeze, which incapacitates the bathrooms and showers. I wonder if I should stay. If I should leave like the other American who lasted one night. But then I realize I'm only here for two weeks. And I can hack it. A few days without a shower is nothing compared to other places in the world. Alternate bathroom facilities are offered up in the house and in a bathroom attached to another bunkhouse. We are also allowed to move in there, as it is warmer and cleaner.

We two volunteers also decide to get ourselves into a nearby town on our day off, to visit the hammam, which is a Turkish bath. We hitchhike and then grab a bus, cheap and easy.

The hammam has a side for male and another for the female bathers. There is a large heated pool, steaming away, everyone in bathing suits. Smaller rooms hold seats and fountains where you can scrub or be scrubbed down for a fee and pour the warm water over yourself to rinse. We chat with a friendly few ladies who speak English, but the rest of the bathers leave us be.

Families go to the hammam throughout the week, as heating water in the house is expensive and in most homes water heating is done by a solar-pow-ered water heater on the roof. Note to self: Don't be the first one in the morn-ing to shower, as the water hasn't heated up yet.

The houses out here, away from the beauty of Istanbul, are utilitarian. There is a monotony and sameness that seems drab and nowhere near as lively as the people living in them.

Another day on the farm, we are warming ourselves by the fire when someone puts on some Turkish folk music. Little Sister, the woman who tends the goats, and a young Turkish male farm worker excitedly begin a dance while humming or singing along to the tune. The enlist me to dance with them and teach me the steps. It is a moment of pure human interaction that will stay with me for all my life. Dancing in the heat of the wood stove, cats lazing about, tea steaming from cups, music played on a cell phone, and my new Turkish friends laughing at my attempts to match their steps.

Little Sister and I use other English-speaking workers or the Google Translate on my phone to learn more about one another. I tell her I don't think an unmarried, childless, non-religious woman such as myself would be welcome in Turkey. She looks at me in amazement, wondering, *Why?* She has family who cover, and others who don't marry or don't. "We don't care," she says, "we are family."

The day I leave, we take a picture together where we look a bit, in the eyes, like the sisters we have been acting like. My forever friend, my always little sister.

Back to Istanbul via bus I head. There is tea service, sandwiches, and cookies, not exactly gourmet, but the bus steward is efficient and kind. Never before have I seen such service on a bus. I love it.

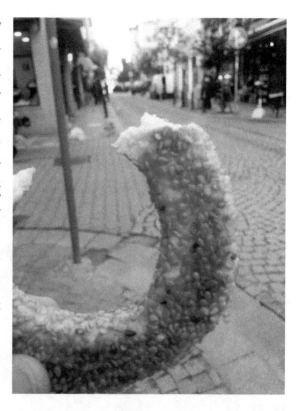

I go to stay again with my friendly AirBnB hosts in Istanbul, it's become home. They are encouraging of my expanding Turkish. Still woefully short in the general conversation category, but now I'm a bit bolder when heading to the bakery every single day to greet the counterman.

I find freshly squeezed orange and pomegranate juice on the streets that costs just pennies to buy. Again, why, oh why isn't this replicated in the U.S.?

High winds another day dash my hopes of taking a ferry to the European side, so I decide to head to a mall for a very specific reason. And there I sit, tucking into a 'shroom burger and fries at Shake Shack, as messages start to hit my phone asking if I'm OK. There has been a bombing on European side, and I'm doing possibly the most American thing I could be doing at that time. I'm safe and nowhere near the bombing. But I wonder, *If the winds hadn't had kept the ferries from sailing, would I have been?*

Shaking these thoughts away, I continue my travels. My hosts have suggested I fly to Izmir, where they are from. It's a "small" city, according to them, at only 3 million people. The flight is cheap, quick, and easy. I find another place to stay here, a room with another kind and friendly AirBnB host and

his cat. I wander about, eating and climbing up and down the stairs leading to the waterfront. There are city bikes for hire and only the chilly air keeps me from doing so. Instead I wander, walk, and admire this "little" city.

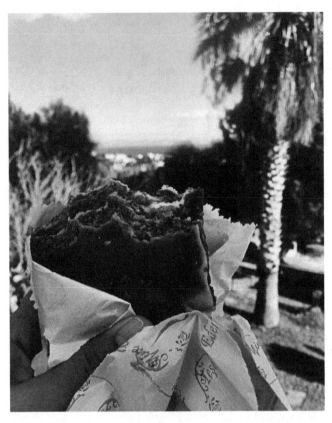

Another bus or two, and I'm off to Datça. It's located in the southwest along the coast. An off-season resort town where many expats have come to retire from England, Scotland, Germany, etc.

I'm working at a hotel where the manager speaks perfect English and is incredibly helpful. He's had many volunteers coming through and his curiosity and hospitality are genuine. Because it is off-season, we volunteers are set up in one of the apartments (apartment hotels in resort areas, quite alike to vacation condos in the U.S. with bedrooms, a kitchen, etc.) It's nighttime when I show up, and the two ladies sharing with me are from Argentina and the U.S. The American will be here for a few weeks more and the Argentinean is leaving in the morning.

As we chat, we find out that the American gal was the one who left the farm after one night—small world. I understand her reluctance after seeing the somewhat cushy accommodations we have here in Datça. My experience was so incredible that I can't help but gush as I tell her about it. Both of us

realize that no one's experiences are ever going to be the same as another's, and instead we celebrate and support the travels we've taken.

The view out of our apartment in the morning is glorious. Cloudy, looking down on the Aegean Sea. Yet another body of water in my wanders.

At the hotel, as there are no guests and its chilly outside, I am given busy work with two of the Turkish ladies working on staff. We sit cross-legged on the floor, with heaters warming us, picking through the natural filling for the numerous pillows. It's boring but again, it gives us a chance to chat and get to know one another. They teach me to count to ten in Turkish, and I tell them about my life in the U.S.

We are similar ages, which is a welcome change from the fellow travelers I've met who've all been around 15 to almost 30 years younger than I. Their young energy is wonderful, don't get me wrong, but sometimes having a contemporary to chat with is just as refreshing.

My housemate has made friends with a few of the restaurant owners in town, and we are invited to a dinner at one. The restaurant is closed for the night and our fellow diners are all older men. They show us how to make çiğ köfte. It's a version of a bulgur and lentil meatball-type dish. In Istanbul, I've had it where it is vegan, here they make it with raw beef. Turkey outlawed the street sale of the raw beef version for health and safety reasons, but I've got the vegan version down pat and will be making it often back in the States.

At a different place another day one of the twins who runs it translates for his father as he relays to us how to make yogurt from scratch, without a yogurt maker. The mother, overhearing our tutorial yells from across the room whenever she thinks he isn't giving us the right information. It's informative and hysterical. Yet another once in a lifetime experience.

Lunchtime at the hotel we workers gather to eat and chat, learning again, more about one another. One of the men, with paint spattered coveralls,

smoking a cigarette, asks me in halting English if I would like to see "my babies?" Sure! He pulls up a video on his phone of his arrival home each night and how his 10 cats rush to greet him. Someone who in the States I would assume to be gruff and macho, here is strong and loving of his animals. Beautiful.

A warm day arrives and once I'm off work I ask the manager if there is a basketball to use on the court across the way. He hands one off and I head over to shake the dust and rust off my jump shot. I'm reminded of the many strong ladies I've played with on basketball and soccer teams through the years. Sports have been an important personality and temperament building influence in my life. No matter how old I get, I'll always want to play.

On another day off, we take a hike to a place further down the peninsula that we find on the map. As we wander along and the road rises, the view of the sea becomes more and more majestic. We amble onto a path where we find a tied-up donkey blocking our way. I nervously share some of my peanuts with him so that he'll be kept busy as we sidle by. Further up a trail, high on the hill, we overlook the sea with not a single boat in sight. Perhaps it's because it's the off-season?

After we start to head back, we find a seaside restaurant where we seem to be the only guests. A table outside, facing the water, and plenty of mezze to eat make for a glorious lunchtime.

The recon my housemate has done in her time here results in her sharing her favorite breakfast spot. A tiny diner is in a house where the kitchen, seen

through the porch-converted dining area, is the house kitchen. Lovely. The numerous plates set before us hold olives, honey, tahini, olive oil, three different cheeses—one only hours old—eggs, spinach pastry, fresh bread, two kinds of fruit preserves, and a fresh salad. Our tea glasses are filled continuously as we work our way through the variety. Turkish Breakfast is no joke, and I must make this a thing in the U.S., if only to continue my own consumption of it.

One night, my housemate wants to go dancing. I'm game and let her know that as I'm sober, if I'm uncomfortable I'll just leave. It's not a problem for me so it shouldn't be for her. We have a great time dancing to late '80s/early '90s music. And when I find myself wanting to leave around 1 a.m., I do. Taking the 20-minute walk back up to the apartment to revel in the fact that I am walking through a beautifully starry night in Turkey, feeling safe in my travels and secure in my sobriety.

On our last night, our host takes us out for dinner. It's a well-known local place, with charming rustic Turkish musicians playing on a stage in the corner. Of course, our host knows the owner, and we are treated very kindly. Several mezze appear, and then the topper: octopus roasted so tender it melts in a beautiful charred symphony in my mouth. I have never had better.

After my two weeks working here are up, my housemate procures us a car ride to a bus station in a town north of Datça. The young Turks who drive us,

chat animatedly with us about music and travel. As we drive along the road from the Datça peninsula inland, we come to a spot where you can see both the Mediterranean and Aegean Seas. They tell us that in Turkish this spot is known as "The Fish Jumped Over." Very fitting.

Bodrum is a quick bus ride north, and we are again on the sea, in a resort town. The water here seems bluer and the town more bustling. We find a sweet guesthouse, when we see no one to take us in at the hostel, and take a leisurely walk along the water to discover a mezze restaurant. The pedestrian streets here are paved with marble. The kind of marble that back in the U.S. people would covet for their kitchens. And it paves the streets.

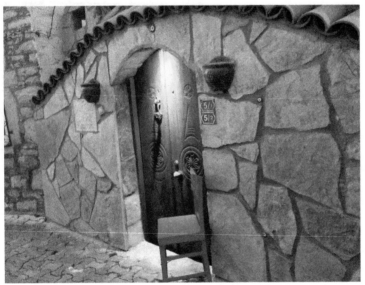

I've made my way here, so I can grab a ferry across to a Greek Island. A quick jump from one country to the other. I'll write of that in another chapter. Greece was very much a part of Bodrum at one point. The glass blue eyes that are sold as a tourist tchotchke to ward away the Evil Eye are in both places.

I bid my housemate goodbye as she is off for other adventures and I head out alone.

After Greece, I head back through Bodrum, Izmir, and back into Istanbul for my final days with my sweet hosts. I've waited until my time here in Turkey was ending to tell of it. I wanted to have a complete experience to relate.

In America, what do we know of this place? We see stories in the news of refugees, people rant against Muslims without ever having met one, and suspicion is the go-to emotion when talking about the country. Here is what I now know.

Turkey is Asian and European cultures combined, with Istanbul straddling both continents over the Bosphorus. The food, architecture, and culture reflect this meld of old and new.

Istanbul in the rain is beautiful to behold. The pedestrian streets paved with stone and ancient water drains, the mist along the river, the ferries, and the umbrellaed crowds.

Calls to prayer, hijab, blue jeans, and English spoken. The people are kind to the street cats and dogs, leaving out food and building them makeshift houses. I believe it says something strong and true when feral street animals are dealt with such kindness.

It feels familiar and foreign. Cities of millions, shopping, mountains, beaches, prairies, goats, fertile farms, cabbages the size of beach balls....

The food ... oh, the food....

Breads hearty and fresh.

Strong black tea served in small, delicate glasses.

Pastries, numerous and gorgeous.

Mezze spilling over the plate, showcasing the vegetables, olives, and cheeses, some only hours old.

And the Turkish breakfast, which seriously needs to be a thing. I was told that so many small plates are served with it because the Turks can't make up their minds. I'm OK with that.

The people have captured my heart.

Perhaps it's because those I met are connected in some way with the tourists and travelers that come through, but they were all open, warm and kind. Even when we couldn't speak the same language.

So now I have Turkish friends.

I spent two months here, and I could spend years, but it's time to move on to Spain.

Always in my heart, "Daima kalbimde."

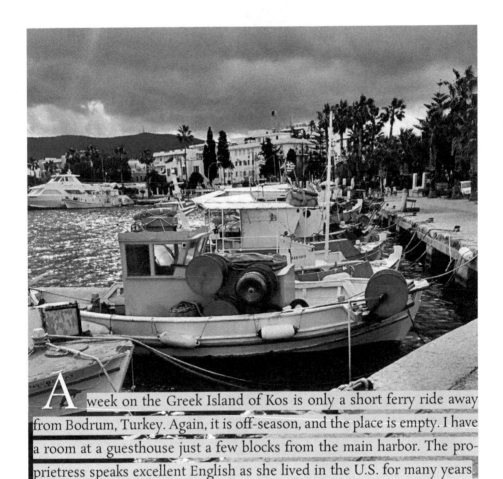

A week on the Greek Island of Kos is only a short ferry ride away from Bodrum, Turkey. Again, it is off-season, and the place is empty. I have a room at a guesthouse just a few blocks from the main harbor. The proprietress speaks excellent English as she lived in the U.S. for many years.

She tells me tales of the Syrian refugees who have come through only weeks before. How the government paid the locals to house them and how upset she was that many took advantage and charged more than was necessary. I see no signs of them and wonder how scared and unsure they must have felt, so unlike my leisurely visit.

She has a bike that I use for a few days to ride around the island. My Google map shows a hot spring a few kilometers down the road, so I head

that way. I find a dirt road with old signs pointing down to the beach, I lock the bike up and hike down. There is a rundown and abandoned bathhouse, locked and uninviting. A lone man, gray hair blowing in the wind, is sitting sunning himself in the warmth of the sun. He gestures to me and asks, "Hot spring?", "Yes!". I nod. Looking around I think maybe I'm missing something. I am waved over closer to the water's edge, "Here!" he says. I notice the rocks are a different color than the others along the beach, a rusty orange. I dip in my toe and the hot water shocks me. He wanders off to sun himself some more, and I settle into this impromptu beachfront spring. The ocean waves gently lap in with cold water to temper the heat bubbling up from below. I laugh at the exclusivity of it all.

My talkative guesthouse host recommends a small restaurant for me after I express my woe at all the tourist-centered places, some even closed, along the harbor. I meet the restaurateur and explain that I am from the U.S. and eat mostly just vegetables. Every afternoon, I show up to dine, after looking over many menus at other places and giving up because I know I'll be treated well here. He greets me with chants of "U.S.A., U.S.A.!" and then will tell me, "Today I have..." and I will have that. Sometimes it is fresh peas with potatoes, potatoes with fresh artichoke hearts, or stewed okra, all of which he picked that morning. Other times it's a bean soup, when the wind starts to pick up outside and soup is called for.

The wind has cancelled the ferry I was planning on taking back to Turkey, so my plans are adjusted for one more night here. There are ancient forts and open-air auditoriums to take up my wandering while I wait. The Old Bird is happy that I am being forced to get some history of the place and I grudgingly agree.

A perfect ending to a perfect visit.

Turkey and Greece Recipes

Turkish food comforted me. It was familiar and foreign all at the same time. And now that I think about it, so was the food in Greece. Goes to show that it's a small food world after all.

Mushroom Manti

Serves 4-6

Dumpling love is universal. In Turkey they are called Manti and are served with tomato sauce and a garlic yogurt on top. A little bit of work, and you can carry on this dumpling love.

Ingredients:

Filling:

2 cups White Button or Cremini Mushrooms, roughly chopped

1 each Onion, chopped small

2 cloves Garlic, minced

½ tsp Salt

¼ tsp Ground Black Pepper

1 TBS Olive Oil

Dough:

4 cups All-Purpose Flour, plus extra for rolling dough

3 cups Water, as needed

1 tsp Salt

Yogurt:

2/4 cups Plain Vegan or regular Yogurt (if it's not thick, strain it through cheesecloth or a coffee filter)

2 cloves Garlic, minced

Salt, to taste

For the Paprika Oil:

3 TBS Olive Oil

1/2 tsp Paprika

1/4 tsp Turkish Chili Pepper (Aleppo Pepper or Pul Biber)

Sauce:

1 TBS Turkish Mild Pepper Paste (Biber Salçası)

1/4 TBS Olive Oil

2 tsp. Dried Mint

1 tsp Ground Sumac (optional)

1 tsp. Turkish Chili Pepper (Aleppo Pepper or Pul Biber), or to taste

1-2 TBS Water

Method:

Filling:

- Put the filling ingredients into a food processor and pulse until finely chopped.
- In a pan over medium-high heat, heat the olive oil. Sauté the mushroom mixture for 5-7 minutes, or until the water from the mushrooms has completely evaporated.
- Season with salt and pepper, and set aside.

Yogurt:

- Mix the yogurt and garlic together, and season with salt. Set aside for the flavors to meld.

Paprika Oil:

- Make the paprika oil by mixing the olive oil, paprika, and pul biber in a small saucepan over medium heat. When it starts to bubble, remove from the heat, and set aside.

Dough:

- Combine the flour and salt in a mixing bowl.
- Pour in 1 cup of water.
- Knead the dough with your hands, and slowly add more water, by the ¼ cup, until the dough is smooth.
- Knead the dough in the bowl for about 10 minutes more until it is firm and smooth.
- Divide the dough into two round portions. Cover half the dough with a kitchen towel or plastic wrap.
- Lightly flour the counter. Roll out half the dough into a square, rolling the dough as thin as you can.
- Cut the larger square into 2-inch squares with a knife.
- Spoon a little of the filling, about the size of half a chickpea, into the middle of each square.
- Pinch the opposite corners to form a little a little pouch, and press the seams together to seal firmly.
- Transfer the manti to a lightly floured baking pan. Toss the manti gently in the flour to prevent them from sticking.
- If you want to freeze the manti at this point, place them close together on a sheet pan and place in the freezer. Once frozen through, place in, in sealed plastic bags and back into the freezer.
- Bring a large pot of salted water to a boil. Throw the manti into the rapidly boiling water, and cook for 5-7 minutes until they are cooked through.

Sauce:

- While manti are cooking, prepare the sauce.

- *Heat the oil in a wide pan, and add the biber salcasi.*
- *Mix in the Turkish chili pepper, dried mint, and sumac. Stir to combine and simmer for 1-2 minutes. Add a tablespoon or two of water to thin out the sauce.*

- *Arrange the manti on a warm serving dish, and spoon the garlic yogurt over them. Then drizzle the red pepper paste sauce and paprika oil over the garlic yoghurt. You can garnish with more Turkish chili pepper, dried mint, and sumac, and serve immediately.*

Vegan Çiğ Köfte

Serves 6-8

Traditionally, these are made with raw lamb or beef. Since that has been outlawed in restaurants for health reasons, they are now made with lentils and therefore, are VEGAN! They make a great, interesting, flavorful appetizer.

Ingredients:

2 cups	Red Lentils
2½ cups	Water
1 cup	Bulgur
1 each	Onion, finely chopped
2 cloves	Garlic, minced
1 bunch	Parsley, finely chopped
1 tsp	Sweet Paprika
1 TBS	Turkish Chili Pepper (Aleppo Pepper or Pul Biber)
1 TBS	Tomato Paste
1 TBS	Turkish Mild Pepper Paste (Biber Salçası)
1 tsp	Cumin
2 tsp	Salt
½ each	Lemon, juiced
1 TBS	Olive oil
6 each	Green Leaf Lettuce Leaves

Method:

- Bring the red lentils to a boil covered in the water for 15-20 minutes, or until soft.

- Mix in the bulgur, cover, and let sit for 30 minutes, allowing the mix to absorb the remaining water.

- *Mix in the onion, garlic, and parsley, and begin to massage the mixture with your hands to combine.*

- *Mix in the rest of the ingredients, except the lettuce, continuing to massage until a smooth mixture is obtained.*

- *Season to taste with salt.*

- *Form into cigar-shaped patties to serve on top of the lettuce leaves.*

Börek (Spinach and Cheese Pie)

Serves 4-8

I was relegated to mostly doing dishes when I worked in the restaurant kitchen on the farm. They didn't know what I could do. One day, Merve turned to me and said, "Today we make börek!" and we did. Like spanakopita in Greece, it is great for an appetizer or as the center of a meal.

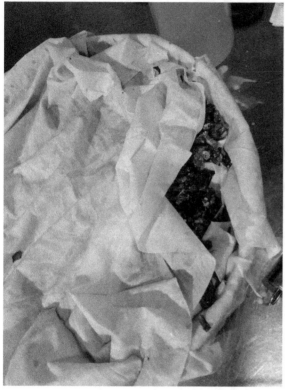

Ingredients:

2 TBS Olive Oil

2-3 each Leeks, mostly the white part, halved and sliced thin

1 lb. Greens, (I used chard and spinach) roughly chopped

1 cup Non-Dairy or Regular Milk

1 TBS Lemon Juice

¼ cup Nutritional Yeast

1 tsp Indian Black Salt

Salt and Pepper, to taste

3 TBS Vegan Margarine, or butter, melted

1 cup Non-Dairy Cheese, a crumbly one like feta works best, if you're a dairy eater (I used almond ricotta)

¼ cup Italian Parsley, chopped

1 lb Phyllo Dough pastry, defrosted and kept covered so they don't dry out

3 TBS White Sesame Seeds, toasted

Method:

- In a large sauté pan over medium-high heat, heat the olive oil through.
- Toss in the leeks and green onion, and cook until the leeks are soft and translucent.

- Add in the greens, season with salt, and sauté until all the spinach wilts down and is no longer wet.
- Pour out any excess liquid and set aside to cool down.
- In a medium bowl, combine the nondairy milk, lemon juice, nutritional yeast, salt, black salt, black pepper, and vegan margarine.
- When the spinach mixture has cooled, pour it into a towel, and squeeze out any extra liquid.
- Mix into it the crumbled almond cheese.
- Add in the parsley and ¼ cup of the nondairy milk mixture. Mix to incorporate.
- Preheat the oven to 400°F
- Grease a 12- to 14-inch round or square cake pan.
- Keep the phyllo under a damp towel as you work so it doesn't dry out.
- Remove 1 sheet of phyllo dough at a time, and drape it into the pan. Brush some of the milk mixture over the sheet as it sits in the bottom of the pan.
- Continue with ⅓ of the sheets, placing the sheets on top of one another, being sure to have some up over the sides of the pan and covering the entire bottom of the pan.
- Spread half of the spinach mixture over the bottom of the pan.
- Again, using ⅓ of the phyllo sheets, drape and brush with the milk mixture, to cover the spinach mixture and have some draping over the sides.

168

- Use the rest of the spinach mixture on top of this layer.
- Finish up with the rest of the phyllo, brushing the mixture on the whole time. The bits that were draped over the edge can now be folded over the top, brushing with the rest of the milk mixture.
- Sprinkle the sesame seeds over the top.
- Place the börek in the oven, and bake for 20 minutes.
- Turn the pan to ensure even cooking, and bake for another 20 minutes, or until a golden brown. Remove from oven, and let cool for 15-20 minutes before serving

Domatesli Bulgur Pilavı (Tomato Bulgur Pilaf)

Serves 4-6

This pilav/pilaf is great as a side dish, but I have to say I prefer it as a stuffing for Kumpir (recipe follows).

Ingredients:

1 TBS	Olive Oil
1 medium	Onion, peeled and finely chopped
1 each	Green or Red Pepper, deseeded and finely chopped
2 medium	Tomatoes roughly chopped, or 1 cup canned Tomatoes
1 cup	Coarse Bulgur Wheat
1½ cups	Vegetable Broth, hot
1 tsp.	Red Pepper Paste (biber salcasi)
	Salt and Pepper, to taste

Method:

- Heat a saucepan over medium-low heat. Add the olive oil to heat through.
- Toss in the onion and pepper, and sauté for a few minutes on a low heat until the vegetables start to sweat.
- Add in the tomatoes, and stir around for a couple of minutes until they start to soften.

- Stir in the pepper paste and the bulgur. Stir for a couple of minutes.
- Turn the heat to high, add your broth and season with the salt and pepper.
- Stir and bring to the boil. Cover and turn the heat to medium-low to simmer.
- Simmer for 8-10 minutes or until the liquid has been absorbed.
- Remove from the heat, and let sit, covered for 5 minutes.
- Remove the lid, stir, and serve.

Notes:

- If using canned tomatoes, the liquid may not be completely absorbed after the 8-10 minutes of cooking time. Let it simmer for another couple of minutes before removing from the heat.

Kumpir

Serves 4

Oh, good god, Kumpir. On the streets of Istanbul, it's the food that students get as it's filling and cheap. It fills every dream I have ever had for a potato. Stuffed to maximum capacity, you must eat all of one at least once in your life. Live a little, people!

Ingredients:

4 large	Idaho Roasting Potatoes
1-2 cups	Vegan or Regular Cheese, shredded
1 cup	Vegan Margarine or Butter

	Salt, to taste
1 cup	Dill Pickles, chopped small
1 cup	Black and Green Olives, sliced
1 cup	Fresh or defrosted Frozen Corn
1 cup	Frozen Peas, defrosted
2 each	Vegan or Regular Hot Dogs, cooked and sliced
½ cup	Pickled Cabbage
1 cup	Bulgur Pilavı (recipe above)

Method:

- Preheat the oven to 425°F.
- Poke all over the potato with a fork.
- Roast in the oven until they are soft and tender. The time depends on the size, approximately 40-50 minutes.
- Remove from the oven, cut the potatoes lengthwise in half. Season with salt, then add the shredded cheese and butter.
- With a spoon, smash the potato, and mix it all in.
- Top with any, or all, of the fillings you like.

Turkish Red Lentil Soup (Mercimek Çorbası)

Serves 4

What I adore about this soup is that it's comforting and spicy. It's like how I felt wandering about Turkey: a comforting adventure. Oh, and the recipe is easy. Yeah, you have to find some Biber Salçası and Pul Biber, but Amazon can hook you up, and it's worth it.

Ingredients:

For the Soup:

1 cup	Red Lentils
2 TBS	Olive Oil
1 large	Onion, finely diced
1 large	Carrot, diced
1 TBS	Turkish Mild Pepper Paste (Biber Salçası)
2 tsp	Ground Cumin
1 tsp	Paprika
½ tsp	Dried Mint
½ tsp	Dried Thyme or Oregano
¼ tsp	Ground Black Pepper
¼ tsp	Turkish Chili Pepper (Aleppo Pepper or Pul Biber)
4 cups	Vegetable Broth
4 cups	Water
	Salt, to taste

For the Paprika Oil:

3 TBS	Olive Oil
½ tsp	Paprika
¼ tsp	Turkish Chili Pepper (Aleppo Pepper or Pul Biber)

Garnish:

Paprika Oil, to taste

Dried Mint, to taste

Turkish Chili Pepper (Aleppo Pepper or Pul Biber), to taste

1 each Lemon, cut into quarters

Method:

- Pick over the lentils to remove any stones by rinsing them under cold water a few times. Drain and set aside.

- In a large pot, over medium-high heat, heat the olive oil through. Add the onion to sauté with a pinch of salt for a few minutes to soften. Toss in the carrots, and sauté for another few minutes.

- Add the biber salcasi and cook, stirring, for about a minute more.

- Add in the cumin, paprika, mint, thyme, black pepper, and pul biber, and sauté until fragrant, just about 10 seconds.

- Mix in the lentils, broth, water and season with the salt.

- Bring the soup to a boil then turn it to medium heat. Loosely cover the pot, allowing some steam to escape, and cook for 15-20 minutes or until the lentils fall apart and the carrots are completely cooked through.

- Make the paprika oil by mixing the olive oil, paprika, and pul biber in a small saucepan over medium heat. When it starts to bubble, remove from the heat and set aside.

- Blend the soup either in a blender or with a stick blender to reach a smooth consistency.

- Season with more salt to taste if need be.

- Serve with a drizzle of paprika oil, wedges of lemon, and extra mint and pul biber on the table.

Greek Potatoes and Peas

Serves 4

This is one of those simple dishes that will blow your mind. Fresh peas will work best, but frozen are OK. The peas I had in the dish in Greece had been picked only hours before.

Ingredients:

⅓ cup	Olive Oil
1 cup	Fresh Dill, chopped
½ cup	Onions, chopped small
3 cloves	Garlic, chopped
4 medium	Red Potatoes, peeled and cut into quarters
2 ½ cups	Water
1 ½ cups	Peas (fresh or frozen)
¼ cup	Lemon Juice, fresh squeezed
1 TBS	AllPurpose Flour
¼ cup	Vegetable Broth (if needed)
	Salt and Pepper, to taste

Method:

- Heat the olive oil in a larger saucepan over medium-low heat.
- Toss in the onions, and cook gently for about 3 minutes, until softened.
- Add the garlic and dill.

- Add the potatoes and peas. Turn the heat to low, and cook, stirring frequently.
- Add the 2½ cups of water, and simmer for about 25 minutes or until you can easily pierce the potatoes with a fork.
- In a small bowl, thoroughly mix the lemon juice with the flour.
- Add lemon-flour mixture to the pot, and stir well to incorporate.
- Continue to cook on low heat for another 5 minutes.
- If the sauce is thick, add in some of the vegetable broth, and cook for a few minutes more to heat through. Season with salt and pepper.
- Let the dish rest for 10-15 minutes before serving.
- Tastes just great at room temperature or even the next day.

Greek Broad Beans (Fava Beans)

Serves 4

No one understands more what a pain in the ass dried fava beans are than I. I tested these damm recipes, so I know. Please try them anyway. The time that it takes to remove the outer shell will be more than rewarded with the flavor and texture of the beans in the dish. But use shelled frozen beans if you just don't have the patience.

Ingredients:

3 TBS Greek Olive Oil

1 each Onion, chopped small

½ cup Carrot, sliced

½ cup Celery, sliced

2 cups Frozen Fava Beans or dried beans cooked until just soft and the outer shell removed and discarded

1 cup Water

2 TBS Tomato Paste

2 tsp Dried Oregano

 Salt and Pepper, to taste

Method:

- *Heat the olive oil in a large saucepan over medium heat. Add the onion, and sauté gently for 5 minutes, or until soft and translucent. Toss in the carrot and celery, and sauté for 3 minutes more.*
- *Toss the fava beans into the saucepan, and sauté gently for a minute or so. Raise the heat to medium-high and add the water and tomato paste.*
- *Mix in the oregano.*
- *Cover partially, and bring to a boil, turn to a simmer and cook for 20 to 25 minutes, or until the favas are soft and the liquid is reduced, leaving a rich tomato and olive oil sauce coating the beans.*
- *Season with salt and pepper.*

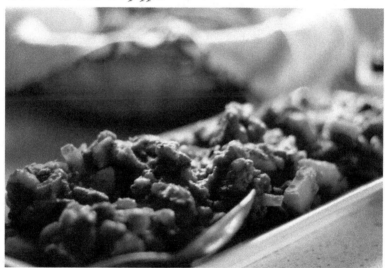

Wild Greens Salad

Serves 4

The restaurateur called this a "salad" so I will too. Truly, it's cooked, but I don't care. Do you?

Ingredients:

3 bunches Dandelion Greens, rinsed and trimmed, and chopped

8 cups Water

2 tsp Salt

Greek Olive Oil, as needed

2 each Lemons, halved

Method:

- In a large pot, bring salted water to a boil.
- Toss in the rinsed greens.
- Bring water back up to a rolling boil and cook for 10 minutes or until dandelion greens are soft and tender.

- Remove the greens and drain.
- Dress them with olive oil and fresh-squeezed lemon juice.

......................................

Morocco and Spain

Surprising Morocco

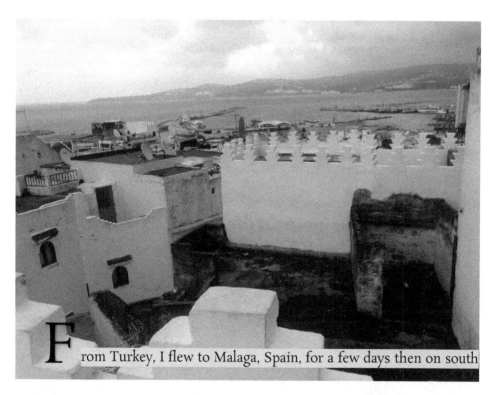

From Turkey, I flew to Malaga, Spain, for a few days then on south

to find my way to Morocco. Tangier is just across the water, just another short ferry ride from Spain and the Rock of Gibraltar. The view is stunning, the water calm, and the boat has visa and border control right on board. By the time we landed, I was through the line and disembarked straight onto Moroccan soil. The efficiency is very welcome.

My hotel is a short hike from the harbor. Taxi drivers vie for my attention, but I let them know no thanks and head out. The medina where it is located is full of winding streets where cars aren't allowed, so by foot works fine. I'll save some cash, get a better idea of the area, see more of the everyday life, and enjoy some exercise. I'm OK with all of that.

I find my place, clean, small and perfect. Literally right in the Kasbah. I joke that I feel like Ingrid Bergman fleeing to Tangier. Outside my window, as the cool evening starts to set in, I can hear the sounds of life and see the lights of the cafés and shops lighting up in the dusk. A short walk down the street, I find a vendor selling sandwiches on bread that I will come to know as typically Moroccan. It's round and cut into wedges for the sandwiches then covered in cornmeal. It's light with just enough of a crust to hold things together. He wraps it in paper for me, and I'm off to wander as I eat.

The young guy at the front desk is very helpful the next morning when I request a restaurant that serves a real B'sarra, which is a fava bean soup. He points me down the street, and I find it quickly. They've just opened (my American "up earlyness" is showing again) and have no problem understanding what it is I want. A few moments later, a steaming bowl of soup is set in front of me, colored red from the chili spice sprinkled over the top and accompanied by more of the wonderful bread. I dig in, nose running and tongue tingling from the spice. The flavor is unfamiliar and a bit earthy, but I like it. Very much.

Some more wandering through the streets and I find a bazaar, which is getting less and less surprising as they are literally all I search for. Mounds of multicolored and fragrant spices, intricate pastries, and hearty vegetables piled high at every turn.

Some of the vendors shoo me away when I start to take pictures. But another allows me to take a video of him as he adeptly makes thin large sheets of pastry called warka or Moroccan Feuilles De Brick. Made in a similar way to a crepe but with dough and not batter, they are also not as delicate or thin as phyllo. One hand continuously flips a dough ball in his hand as the other brushes oil on to the hot skillet. He winks at me as I thank him. A bit cheeky and talented!

The tea culture here is like the one in Turkey, only here the tea is fragrant with mint and sweetened. I enjoy several glasses sitting outside at this or that café, people watching, which is a favorite sport of mine.

Later that evening, I realize that I brushed my teeth with water from the tap rather than my sterile bottle water. It's not life threatening or anywhere as bad on my gastrointestinal system as I know other travelers have suffered, but I make sure to spend most of my night near to my hotel and head to bed early just in case.

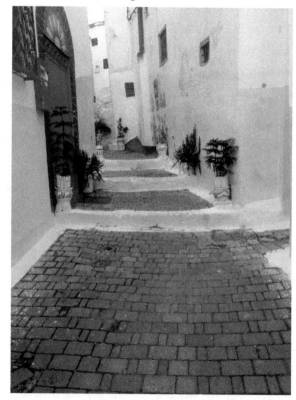

For breakfast, I find another street vendor selling a semolina flatbread called Msemen, with a choice of spread. When I realize he has almond butter, I'm elated! He wraps it in a piece of paper, and I'm off, happily munching away. Peanut butter, I've learned, is a rare sight around the world and often more expensive than almond butter is in the

States. Both nut butters have become a staple protein in my mostly vegan life, so finding them here and there is always welcome.

The next afternoon finds me leaving Tangiers to catch a train to Asilah, which is just 30 or so minutes south. I've found a soon-to-be hostel/farm to work on in this sleepy seaside town. I'm a little unsure as I enter a cabin on the car and seat myself. My fellow passenger allays my fears by telling me I'm headed the right way, and I settle in.

The countryside, as we leave the city, is green and lush with rolling hills. Not what I was expecting at all. Not a camel in sight.

My phone's SIM card doesn't work in this country, so I rely solely on Wi-Fi when I can find it to communicate and plan. I'm a little thrown off when I hop off the train at the station and find no one waiting for me and there is no Wi-Fi. A walk along a seemingly abandoned road, and I find a hotel with Wi-Fi. I send out some quick messages, and a few minutes later, my host is there to pick me up.

We drive through town, and he gives me a nickel tour. Then we're off to his homestead. It's remote from the town, about 45 minutes via walking, but the view is spectacular from up top of the hill. There are other volunteers here, a Russian couple and a sweet Japanese lady, Satomi. The Russians will be leaving in a few days. They've been busy, building a fireplace, fitting out the bathroom and kitchen, laying out a garden path and plantings. I'm asked to cook every day

for those who will be staying. I have no problem at all with that request, cooking for others is my jam.

As I'll be taking on this job, our host brings me to the market to grocery shop. It's a vast open-air market with stalls out in the open, under tarps or

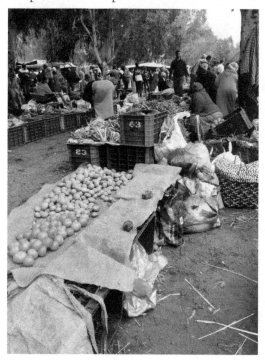

out of the back of trucks. Breads, vegetables, fruits, shoes, soap—you name it, you can find it. Want a donkey? You can test-drive one, and there is donkey-specific parking. Because of course there is.

If you find you're buying more than you can carry, you hire a teenaged boy to follow behind you with a wheelbarrow. It's like hiring shopping cart at the grocery store, but these

teens seem less sullen than American ones are apt to be.

Our host is also excited to show us a local cheese maker. The family is Italian, and the cheese is similar to ricotta salata. Finding the unexpected in unexpected surroundings always delights me.

On Fridays, our neighbor stops by with a gargantuan platter of Chicken Tagine and Couscous. He spends time visiting to work on his English, and we dig into the fragrant mounds. I eat around the poultry and am very grateful for his kindness.

At night, three of us sleep on pallet mattresses on the floor, piled high with blankets to keep off the surprising morning chill. The bathroom shower isn't quite set up but a bucket and cup work just fine. There is very limited Wi-Fi, a TV that gets only Moroccan channels, and I've forgotten to pick up some new books. It's rustic and very livable here. As in Turkey, I'm only here for two weeks. I can do this.

For a few days, I'm struck down by a chest cough. I spend some time recovering and watching the American TV show MASH, about the Korean War, on Moroccan TV dubbed in German, which is just surreal.

Satomi is very kind, and we get along very well. We share pots of mint tea and stories of our travels as she practices her already perfect English on me. Exploring with walks is also a shared interest. We go wandering through the tiny village where the hostel sits and through the hills. We even walk down into town to sip more tea and use the Wi-Fi at the cafés there.

Social media postings of friends show that an anger and fear of Muslims is growing back home. It comes to a head when I see a post that rails against Muslims building mosques in America as the turrets would be perfect for snipers to take us all out. I am stunned by their fear as I've been out of touch with the climate back home. Mulling it over, I decide to respond. Here is what I wrote.

Dear American Friends,

Yesterday, here in a tiny village outside Asilah, Morocco, I went for a walk. Along the way, we met up with a group of hijab-dressed Muslim

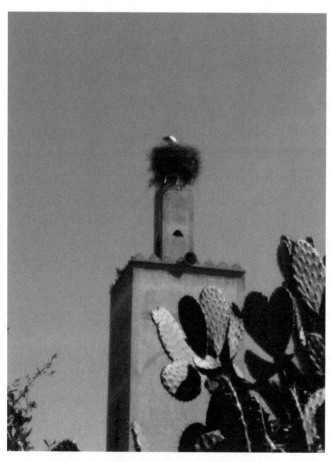

women. They were on their way to comfort friends who had a death in the family. They hailed us with "As-Salaam-Alaikum," the Arabic greeting, meaning "Peace be unto you." One woman even gently took my fellow volunteer's hand, smiled sweetly, and wished us well.

There are two mosques within sight distance. Their calls to prayer echo against one another through the valley. Atop the minaret of one, a family of storks is nesting and raising their young.

This, my friends, is the Muslim world.

So far on my journey, I have been to 13 countries. Six of them were predominantly Muslim, while three have a minority of Muslim adherents.

I've met peaceful smiles, nods, and hospitality wherever I've been. The number one question I'm asked? "How are you? Are you warm/cold/hungry?"

I am not religious or spiritual. I'm restless, ever questioning and questing.

There are radicals the world over who push forth anger, hatred, and subjugation of equal rights in the name of their "religion."

I believe that it isn't a religion we should be united against. Instead, we should be showing peace and acceptance to those who greet us with the same. "As-Salaam-Alaikum."

My time in Asilah comes to an end, and I'm off to Marrakesh. I take another night train, and this one is full—there isn't a compartment open where it is warm and quiet. I seat myself in the general seating and feel the cold start to creep in. The lights stay on all night and passengers disembark or get on throughout the night, with the door to the space between the cars open often letting in the cold air. I estimate that is about 45 degrees Fahrenheit. I rummage through my bag and find a sleep sheet that I wrap around myself, scarf wrapped around my neck, hat scrunched down on my head, and coat on. I hunker down, trying to sleep and stay warm at the same time.

Arriving in Marrakech the sun is gratefully shining, warming me. I shake off the chill and start walking the 40 minutes to my accommodations. I find my way to my riad in the medina after getting turned around and being shown the way by a friendly native.

The quiet and comfortable rooms are a haven. The central courtyard is probably a wonderful place to gather around the fountain during the

warmer seasons. This works.

Off I head to wander and see what I can see. Tourist tchotchkes spill out of the shops, lamps, rugs and so on. Nothing I need so I hunt out places to eat. Tea shops, bakeries with super sweet and floral scented pastries, and small cafés are plentiful.

I also find another hammam to enjoy. I pay more than my budget would usually allow, but after the bucket showers I have been partaking in I'm all in for a good scrubbing. The cucumber water, plush robes, and calming music sweep me up in a very abnormal atmosphere for me. I sit back and enjoy. The attendant scrubs me down in the steaming bath room as I sit in paper undies, lulled into a drowsy happiness.

An old friend from Boulder brings tours to Marrakech and the area throughout the year, and luckily, she is here now. After some preliminary back and forth, she invites me to join them at their hotel for dinner and sends a car to pick me up.

I'm greeted and led to a quiet library space in this sprawling 5-star hotel. I dust off my jeans, trying to make myself and my plaid Chuck Taylors presentable. My friend laughs at my unease. "You're fine." she tells me, and we head to cocktails and appetizers. I meet the owner of the hotel, who is lovely and gracious, as are the tour members.

Dinner is a 5-course meal with native musicians playing off to the side as waiters serve us a lamb tagine at a sweeping, candle-lit table. And yes, dear reader, I do partake. I am not going to put up a fuss when I have been invited to such a luxurious dinner. The company, food and atmosphere make for a glorious and very sweet experience.

On my last night in Marrakech, I head to the central souk or marketplace to find dinner. A steaming bowl of harira (bean and pasta soup), bread, and greens at a counter under a tarp are exactly what I wanted. What I didn't want was to leave my cherished plaid Chuck Taylors behind. Tucked under a bed I miss them as I pack to head to the airport. Argh! But that is my way.

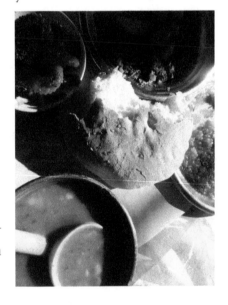

Oh, Morocco, there were things I expected from childhood perusals of *National Geographic*. Photos and stories I'd heard from friends who've spent years coming to Marrakesh to lead culinary tours. Hell, I once taught a class in tandem with a chef friend who spent his boyhood here.

I expected the Medina's winding streets in Tangier and Marrakech, men strolling by in djellabas (long, hooded robes), spices wafting through the

marketplaces, mint tea loaded down with sugar, and the eye-aching glory of the rugs, lights, pillows, glasses, and silver. I knew about all of it.

What I didn't know surprised and delighted me.

People were friendly and kind. Speaking in English, Spanish, or French, they gave me directions to my hotel or riad with a gentle smile or guided me through the maze of cobblestone streets. There were recommendations for B'sarra (fava bean soup) stalls, where to find free books, off-the-beaten path ricotta salata makers, and hearty, chewy whole-meal baked bread. Neighbors who brought steaming platters of couscous, more bread, and sweets in exchange for English pronunciation guidance.

I didn't expect the green, lush farm lands and rolling hills of Asilah. Where spring brought wildflowers popping up spots of color and huge snails/slugs leaving a mucous trail in their quest for your cabbages.

I didn't expect it to be so rainy and cold. Where a well-lit fire, hot sweet mint tea, and even sweeter, kinder Japanese fellow traveler housemates and our laughing half Moroccan, half Spanish host shared stories of their roads taken, worked in tandem to keep me warm.

The food fed my stomach, palate, and eyes. Intricate, toothachingly sweet pastries strong breads, hearty soups, abundant vegetables, salty peanuts, and fragrant couscous platters.

You surprised me, Morocco, pleasantly so.

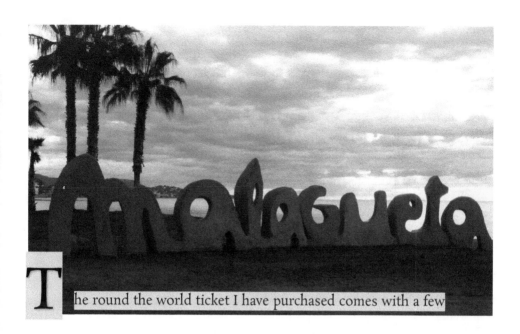

T he round the world ticket I have purchased comes with a few
caveats. I have to fly into and out of the same airports. I can travel all around
the area while I'm there, but have to return to the same airport I arrived at
to leave the country. Malaga is one such airport. It's on the southern coast
of Spain's Costa del Sol, my entry into Europe, and I spend only a few days
here as I balance my days in Europe according to the Schengen Agreement,
that allows me to travel to certain EU
countries that have abolished their inter-
nal borders, but gives me only 90 days in
6 months in Europe. As I've already been
to Greece and I want to get to Iceland
along the way, all part of Schengen, I di-
verted into Morocco for a month.

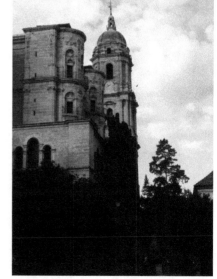

Before I go, I spend a few days
wandering in Malaga. I've found an
Airbnb guesthouse that is right in the
midst of the old city. The winding alley-

like streets of Europe are starting to become familiar, after Turkey. My wandering commences. I even have a few runs along the beach. Soaring churches, markets, and beaches. I see the allure of this resort coast.

Meals of tapas are easily found. I order the vegetarian salad at one place, and it comes with tuna, because of course it does. Granted this is the amazing canned Spanish tuna, but it is fish and I'm Mostly Vegan. I make do.

Salmorejo is also another regional specialty I find at a vegetarian restaurant. It's a smooth, chilled puréed soup consisting of stale bread, garlic, fresh tomato. and olive oil. And it is lovely. The recipes that come about from utilizing leftovers or about-to-go bad items are some of my favorite. That ingenuity brings about fabulous flavors is culinary innovation that I can get behind.

After my diversion to Morocco, I've flown back into Spain, landing in Madrid. It's hostel life for the next few days. After the loss of my beloved Chuck Taylors in Marrakesh, I waste more time than I probably should on finding a replacement pair.

I had a hard hit of culture shock when I got to Madrid. I had been spoiled by the previous countries and their inexpensive street food. I had to readjust my budgetary expectations. And then there was the language.

My Spanish is rudimentary at best, learned in kitchens, with lots of yelling and swearing. Good enough to get me knifed in Tijuana, but I wasn't sure that it would work for me in Spain. Ultimately it was OK. I didn't starve or get stabbed, so plusses all around.

It helps that I slowly get back into running regularly. I went for a run the first morning in Madrid. I haven't done that anywhere near as much as I've wanted on this trip. All the lame H-excuses—heat, humidity, haze, hijab (cultural differences), hacking cough, and hormonal issues. I've walked a lot, but I haven't been running. But today I went for a run in a city where running is normal. Very much like Colorado. All sexes, shapes, and speeds

run through the park. It hurt, it wasn't fast or far, but I ran. And it started to feel better. My mind easing into the rhythms, my legs aching but happy I went for a run on that first day in

Madrid. And next day, I ran again.

The park where I ran has a sizeable string of used bookshops along one of the avenues. Find what makes you happy and do that.

One of the best parts of traveling, besides the food, is meeting up with fellow travelers. I was truly lucky that I overheard James chatting in the hostel in Madrid. Although we are literally ages apart, we found a mutual appreciation for the unexpected moments and spontaneous companionship that wandering foreign cities toss your way. It helped that's he's not only a food lover, but also always hungry. That's my life right there. He's a freelance writer and has the amazing FreelanceWritersSchool.com with articles, advice, and awesomeness. Check him out.

I'm finding more and more as I travel that folks my age are not to be found embarking on similar journeys. But, it turns out, I have the conversational skills of a 25-year-old male, so I fit in with most of the folks I do meet.

One of our ventures was to a large flea market for vinyl album shopping and finding a tapas place afterwards. We decide to order the Menu of

the Day. It comes with a bottle of wine. James chats with the bartender about the wine as I won't be imbibing. The bartender laughs and says it's free, man drink what you can. Now that is what I call a gift with purchase.

He and I wander out another night with a fellow traveler, a New Zealander, to watch Scottish Rugby in an Irish Pub, in Madrid Spain. Because of course we do. This nighttime wander shows off the architecture of this ancient city. Buildings I never noticed as I went searching for new Chucks are now lit up and very impressive. A reminder to lift my head up from time to time.

Then I'm off on a bus heading north to Logano, in the La Rioja region, and then to another going just a touch south to the tiny mountain town of San Roman de Cameros. I've found a hostel online, and again I'm the only one there. I'm handed the keys by the proprietors and told to have fun.

All the cows wear bells around their necks. They clink hollowly as they wander about the hillsides. It's a comforting background noise as there is no traffic or busy streets here to overwhelm. One afternoon, I hear the noise close to home, I peer out the window and see a cow wandering through the steep streets of the village. That seems very right to me.

I go for a run up an unpaved road through the hills. I feel sluggish but then I remind myself that I am running in the mountains of Spain. Sure,

not very fast but running in the mountains of Spain! I realize that it's a very wabi-sabi moment as there's beauty in all the imperfections.

In order to balance the city life, I often spend time in more rural places when traveling. I am a small-town girl originally. For all my friends who are road/mountain bikers or trail runners, I strongly suggest that if you head to Spain to spend some time in San Román de Cameros. It's idyllic with mountains soaring, roads winding, and views aplenty.

One day finds me hiking up the road to where I've been told there are dinosaur tracks. The hill is a bit of a trek and a car stops to ask if I want a ride. I hop in and explain where I am going. My rudimentary kitchen Spanish and his limited English work out. He drops me off, with a shake of his head. It's off-season here so a lone wanderer is an odd sight. The tracks impress me with their size, and I snap pics for The Old Bird, as I know this is something she'll appreciate.

There is one tiny restaurant down on the main road running through town. I pop in a few times to eat. I find hearty vegetable soup and "vegetarian" salad (with egg and tuna), all fresh and good. Mostly I cook for myself with groceries purchased at the small store owned by the couple who run the hostel.

They ask if I'd mind being taken up a bit further into the mountains to Santa María en Cameros, where they have another hostel, as they've booked a family group into the one I'm staying at. I don't mind at all. More mountain trails to trek or sluggishly run, more small villages to wander through.

Then it was a few bus rides more, taking me on to Bilbao. I was really looking forward to this, as chef and tour guide friends had suggested my spending time here. The art and food scene here set it apart somewhat from the rest of Spain. If I was to try to broadly paint the feeling the native Bilbaos give me, it would be artsy-fartsy. I saw more mullets sported by women of a certain age, and dyed every color under the rainbow, than anywhere I have ever been before.

This is strongly Basque Country. They revel in their "otherness," and their food is a perfect example of this. Tapas rule the rest of Spain, pintxos reign here. They are often eaten in bars or taverns as a small snack while hanging out with your friends or family. "Pintxo" means "spiked," so they are usually served with a skewer or toothpick, often atop a piece of bread.

There I was in a bar/restaurant that tour guide friend Kathy had recommended, eating the traditional pintxos that Chef Andy had plugged,

eavesdropping on the conversation going on next to me. Me being me, I intruded. That is how I spent the next few days hanging out with expat English as a second language teachers from Alabama; Boise, Idaho; Dublin; Wellington, New Zealand; and Brighton, England. Of course, one of them had grown up in Boulder, Colorado.

When they asked, "Want to come along with us?" I said "Yes!" And there I was, watching the traditional Basque Semana Santa penance processions of the several Catholic brotherhoods. And you thought Easter was all about bunnies and chocolate. Oh, how wrong you are!

Memories of pictures and stories of these processions from *National Geographic* spark my interest. I can't believe I am seeing this in person. It's surreal as the hooded penitents march by, some barefoot, their heads covered (a la KKK hoods) to cover their "sinful" faces. They play booming drums and horns in woeful tunes to set the tone of their parade.

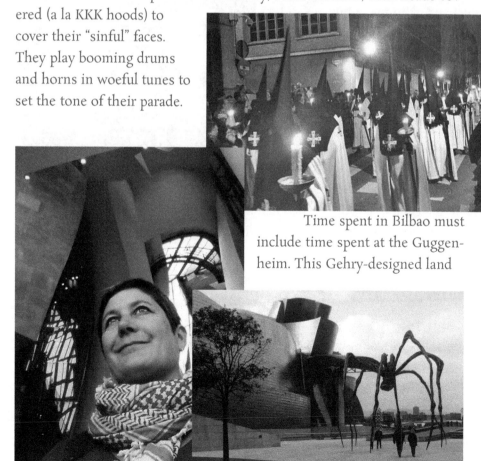

Time spent in Bilbao must include time spent at the Guggenheim. This Gehry-designed land

yacht of soaring silver walls is central to the art scene here. Not only did I get to wander the museum and see the amazing art, including a Jeff Koons sculpture and an Andy Warhol exhibit, but I also did a video call with The Old Bird from outside the museum as it was her 75th birthday.

My new friends suggested I head to San Sebastian, where I find a hostel easily. My hostel experiences have been very positive so far. I usually stay in the mixed dorm, as it is cheaper and most of the other travelers are 20 somethings. The one downside to this hostel was the couple in the bunk next to me pleasuring one another when they could have just as easily walked the few feet to the bathroom and left the rest of us out of it. Hey, it ain't always sunshine and roses.

The wandering, eating, and nightlife here in San Sebastian is perfectly suited to the narrow streets and small restaurants. My friends arrive a day after me to explore the sights and eat. As they had lived there for a time, they were eager to show me the best places for pintxos.

We find a bakery, where I grab a pantxineta, which is a Basque cream-filled puff pastry dusted with powdered sugar and topped with sliced almonds. Ridiculously good and very much not vegan. There is also a torrija eaten, a traditional Basque Easter dessert made with old bread that's pretty much a French Toast or Pain Perdu, but richer than any I've ever had. I will make a torrija, of this I'm certain.

The group knows the best place to go for Spanish omelets and cheesecake. This cheesecake blows every other one I've ever had away. Edged with caramelized, almost burnt, dips and bumps, it's creamy, smooth, and yet light. And yes, I know I'm eating a lot of non-vegan pastries. Don't judge me, I don't.

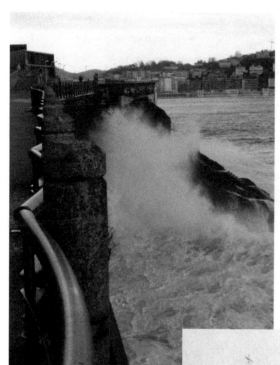

One more day here on my own and I get some runs in along the coast, as the ocean rages and slams against the sea front. In the park, the air is filled with Easter church bells and the echo of the mass being broadcast through the trees from speakers. A truly noteworthy day.

Kathy had also proposed that I spend time in Hondarribia, a short bus ride from San Sebastian and also right along the sea coast and the border of France. Sections of the famous trail and pilgrimage, Camino de Santiago, wind through. No problem. Don't mind if I do.

Pilgrims and through hikers alike spend weeks and even months hiking along the trails here that run from France into Spain, going all the way to the coast. I do a much shorter run along the path overlooking the

ocean. The views are glorious, the trail well-marked, and the day warm and friendly.

Hondarribia is well-known for its pintxos as chefs have found a welcoming place outside of San Sebastian to showcase their talents. I find the pastry shop no problem. Well, it may become a problem, but if I keep running it should balance out right? Hopefully.

My host at the guesthouse is so friendly, she leaves me alone in the house for a few days and goes off to visit her daughter. I spend those days living here. running to and entered unsure and

here as if I really live Hunting for new shoes, taking buses fro, and just wandering about. I Spain a bit wary and but left with heart stomach full—and with more contacts added to the ever-expanding list.

The morning of my departure, I set out early to walk the 45 minutes to the train. I give myself plenty of time and hope to not dig into my budget with an Uber or taxi, hence the

walking. And then I realize that I am a 30-minute walk away from the train station I need across the border in France. Taxi it is. And although it only takes 10 minutes for the journey, the euros I pay are painful for me. But that is a part of it. Mistakes will be made.

Morocco and Spain Recipes

I hopped from Spain into Morocco and back again, so it seemed apropos to put their recipes together. Plus, it is a great way to travel, plate by plate and bowl by bowl.

Vegetable Tagine with Golden Couscous
Serves 4-6

It's the spices that truly make this dish. Otherwise, it's just some cooked vegetables on couscous.

Ingredients:

Vegetable Tagine:

2 TBS Olive Oil

1 each Onion, thinly sliced

1 tsp Ground Turmeric

2 tsp Cumin Seeds

2 tsp Coriander Seeds

1 tsp Ground Cinnamon

1 each Red Serrano Chile, seeded and finely chopped

3 cups Canned Diced Tomatoes, about 28 oz

1 TBS Tomato Paste

¼ cup Dried Apricots, soaked in boiling water for 20 minutes, drained and sliced

¼ cup Dried Currants, soaked in boiling water for 20 minutes, drained<<OK?>>

½ cup Oil-cured Black Olives, pitted and roughly chopped

1 large Idaho Potato, cut into chunks

1 each Carrot, thickly sliced

2 cups Green Cabbage, cored and thinly sliced (or use coleslaw mix; I did!)

2½ cups Canned or cooked Chickpeas

1 bunch Flat-leaf Parsley, finely chopped

1 bunch Cilantro, finely chopped

Salt and freshly ground Black Pepper, to taste

1-2 TBS Harissa Sauce, or to taste

Golden Couscous:

6 cups Vegetable Broth

3 TBS Olive Oil

½ cup Onions, minced

2 tsp Ground Turmeric

1 tsp Ground Cumin

3 cups Couscous

⅔ cup Sliced Almonds, toasted

Method:

Vegetable Tagine:

- *Heat half the oil in a large saucepan over medium-low heat.*
- *Add the onions, turmeric, cumin, coriander, cinnamon, and chile, and cook gently for 10 minutes, until the onions are softened and translucent.*
- *Stir in the tomatoes and tomato paste, and simmer for 10 minutes.*
- *Add the apricots, raisins, olives, potato, and carrots, and continue cooking slowly for about 45 minutes, until the carrots are tender.*
- *Heat the remaining oil in a skillet, add the cabbage, and stir-fry, until just starting to soften. Add to the saucepan with the vegetables, then add the cooked chickpeas, and cook until heated through, about 5-8 minutes more.*
- *Stir in half the parsley and cilantro, and season with salt and pepper to taste.*

Golden Couscous:

- *While the tagine is cooking, bring the vegetable broth to a boil in a medium saucepan.*
- *Reduce the heat to very low; cover to keep hot.*
- *Heat the olive oil in a large saucepan over medium heat.*
- *Add the onions and sauté until tender and light golden, about 8 minutes.*
- *Add the turmeric and cumin; stir, cooking for about 1 minute.*
- *Toss in the couscous and stir, until coated with the onion mixture.*
- *Pour in hot broth and stir to coming.*

- Remove from heat, cover and let stand until broth is absorbed, about 12 minutes.
- Fluff couscous with fork. Season generously with salt and pepper. Mound on platter. Sprinkle with almonds.
- Pour the vegetable tagine over the couscous, garnish with the rest of the parsley and cilantro, and serve.

Moroccan Pancakes (Beghrir)

Serves 6-8

Eat these for breakfast, brunch, or afternoon tea with sugared mint tea, just as long as you try them. They are phenomenal.

Ingredients:

1½ cups Fine Semolina or Durum Flour

3/4 cup All-Purpose Flour

1 tsp Salt

1 tsp Sugar

2 tsp Baking Powder

3 cups + 2 TBS lukewarm water

1 TBS Dry Yeast

Method:

- Mix the flour, semolina, salt, sugar, and baking powder in a bowl.
- In a mixing bowl, measure lukewarm water to just over 3 cups.
- Add the yeast, and mix on low speed to blend.
- Gradually add the dry ingredients, about a 1/4 cup at a time.
- Increase the speed, and mix for a full minute, or until very smooth and creamy. The batter should be rather thin, about the same consistency as a crepe batter.
- Cover the bowl with plastic wrap, and leave to rest for 10 minutes or a bit longer, until the top of the batter is light and a bit foamy.
- Heat a small nonstick skillet over medium heat.
- Stir the batter, and use a ladle to pour batter into the hot skillet. Pour carefully and slowly into the center. The batter will spread evenly into a circle. (Do not swirl the pan as you would for a crepe; the batter should spread itself.) Make them as large as you prefer.
- Bubbles should appear on the surface of the as it cooks. Don't flip the as it only gets cooked on one side.

- Cook for about two minutes, or until they feel spongy, but not sticky or gummy when touched lightly on top

- Transfer to cool in a single layer on a clean kitchen towel. Once they are cool, they can be stacked without sticking.
- Repeat with the remaining batter. Serve plain at room temperature with softened vegetable margarine, golden syrup, or the toppings of your choosing.

Bessera Soup

Serves 4 as a soup, 6-8 as a dip

I enjoyed this as a hot soup right in the midst of the Kasbah in Tangier. I fucking love that I can say that! If you want it as a dip, use less liquid to thin it out. I like cilantro, so I use it for garnish, but if it ain't your thing, go with chopped parsley.

Ingredients:

1 ½ cups Dried Fava Beans

2 cloves Garlic

⅓ cup Olive Oil, plus more for garnish

¼ cup Lemon Juice, plus more for garnish

2 TBS reserved cooking liquid

½ tsp Salt

1 tsp Ground Cumin, plus more for garnish

½ tsp Sweet Paprika, plus more for garnish

½ tsp Cayenne Pepper, plus more for garnish

¼ cup Italian Flat-leaf Parsley or Cilantro, chopped, for garnish

Method:

- Put the dried fava beans in a large bowl, and cover with a generous amount of cold water. Set aside to soak overnight or all day.

- Drain the beans and peel the skin off the outside, using a paring knife to assist you. Yeah, it's time consuming, but the payoff is fantastic.

- Transfer the beans to a pot, and cover with a generous amount of water.

- Bring to a boil over high heat, then reduce the heat to a simmer. Cook the beans until tender, one hour or longer.

- Drain the beans, and reserve the liquid.

- Use a stick blender, regular blender, or a food processor to puree the beans with the garlic, olive oil, lemon juice, two tablespoons of the reserved liquid, and measured spices until smooth.

- *Add in additional liquid if necessary to thin the bessara even more if a thinner soup-like consistency is preferred.*
- *Taste the bessara, and adjust the seasoning as desired.*
- *Reheat the bessara, and serve warm, preferably in a warm dish so that it doesn't cool.*
- *Garnish with any of the following: ground cumin, paprika, salt, harissa or cayenne, olive oil, and chopped parsley.*

Torrijas

Serves 8

This is traditional Easter fare in Spain, and I was lucky enough to eat it in San Sebastian during Easter week. I've gone a bit off the traditional path here to make it vegan, but I think it's going to be just fine.

Ingredients:

1 loaf White Italian bread (light crumb, crispy crust, not rustic loaf or baguette) and stale (this is very important)

4 cups Coconut Milk, canned

3 TBS Sugar (plus a bit more for garnishing)

1 each Cinnamon Stick, gently smashed

1 tsp Ground Cinnamon, for garnishing

4-6 TBS Canola Oil, for frying

Method:

- Slice the loaf bread into 16 1-inch slightly diagonal slices. Arrange the slices in a shallow baking pan.
- Put all the coconut milk, 3 tablespoons of sugar, and the cinnamon stick in a saucepan and bring to a boil. Remove from the heat as soon as it starts to boil, and set aside for 5 minutes.
- Remove the cinnamon stick, and pour the milk mixture over the bread. Set it aside to soak for one hour.
- Heat a tablespoon or two of the oil to medium heat in a large non-stick or well-seasoned frying pan.
- Carefully transfer the soaked slices with a large spatula into the hot pan.
- Work in batches, and fry them for 3-4 minutes on each side, until golden brown.

- Re-
move
the
slices
to a
sheet
pan
lined
with

parchment paper, and gently sprinkle them with sugar and cinnamon.
- Enjoy warm or at room temperature.

Patatas Bravas

Serves 4

I love a potato anyway I can get it. And this is a potato-based tapa that originated in Madrid and you can now find all over Spain.

Ingredients:

2 lbs. Red Skin Potatoes cut into bite-size pieces

Salt, to taste

4-6 cups Canola Oil, for frying

1 TBS Olive Oil

½ each Yellow Onion, chopped small

3 cloves Garlic, minced

½ tsp Paprika, smoky or hot; it's up to you

A pinch cayenne, or to taste

1 6-oz can Tomato Paste

1 ½ cups water

¼ cup Parsley, roughly chopped

Method:

- Preheat the canola oil to 360° F.
- As the oil heats up, place the potatoes in a pot, and cover with salted water. Bring to a boil and cook for 8 minutes, or until just tender. Drain, dry, and set aside.
- Prepare the tomato sauce by heating 1 tablespoon of the olive oil in a large sauté pan over medium-low heat.
- Toss in the onion and garlic, and slowly cook, stirring, for about 8 minutes or until the onions become soft and translucent.
- Add in the paprika and cayenne.
- Mix in the tomato paste and water, bring to a boil then turn to a simmer.
- Simmer for 10-12 minutes or until the flavors are well blended.
- Taste, and adjust seasonings as needed.

- *Puree the sauce with a stick blender or a regular blender until smooth. Serve at room temperature.*

- *Fry the potatoes in batches, until golden, and set on a cooling rack over a sheet pan to drain. Season with salt when they are removed from the fryer.*

- *Serve them hot with a generous drizzle of the sauce and a sprinkle of the parsley.*

Spanish Omelet (Tortilla)

Serves 4

A Spanish omelet can be found in every corner of Spain. I'll leave it up to others to debate whether it is a tapa or pintxos. You have no idea how excited I was when I figured out how to replicate it in a vegan way.

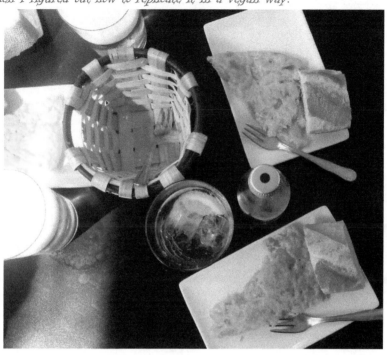

Ingredients:

1 lb Red Potatoes, peeled and diced small

¾ cup Aquafaba (canned garbanzo bean water)

14oz Extra-firm Tofu, drained

2 tsp Indian Black Salt (the sulfur flavor gives a very distinct egg flavor to the dish)

2 TBS Garbanzo Bean Flour

1 ¼ tsp Turmeric

½ cup Yellow Onion, diced small

4 TBS Olive Oil

 Salt and Pepper, to taste.

Method:

- Preheat oven to 375° F

215

- Heat 2-3 tablespoons of olive oil in a sauté pan over medium heat.
- Then add potatoes and onion.
- Sauté until the potatoes are tender, about 8 minutes.
- Remove the potatoes from the pan with a slotted spoon, and set aside.
- Blend the tofu, garbanzo bean flour, black salt and ¼ teaspoon of the turmeric together with 2 tablespoons of the aquafaba and set aside.
- Whisk the rest of the aquafaba and turmeric in a mixer until firm peaks are formed.
- Gently fold the whisked aquafaba into the tofu mixture, and season with salt and pepper to taste.
- Pour the rest of the olive oil into the hot pan (nonstick preferred, but a well-seasoned cast-iron pan works great), tilting the pan to thoroughly coat and heat through over medium heat.
- Pour the tofu mixture into the pan, and gently sprinkle the potato onion mixture into it.
- Cook until the mixture starts to set, about 5 minutes. Push the sides gently down to loosen, and shake the pan to make sure the tortilla is easily slid around the pan.
- Place in the oven and cook on just until it is firm, and the tortilla turns a light golden color, about 10 minutes.
- Remove from heat and let cool for 5 minutes.
- Place serving dish over tortilla in pan, then flip over onto platter and serve warm or at room temperature.

Serves 8 as an app or 4 as a main dish

I fell in love with this chilled soup when I first tasted it in Malaga, Spain. It's creamy—without cream—and garlicky, because, duh, there is a shit ton of garlic in it.

Ingredients:

3 TBS	Salt, plus more to taste
8 each	Plum Tomatoes, cored, halved, and seeded (I strained the seeds and used this tomato water to add to the reserved soaking liquid, see below)
1 clove	Garlic, crushed
6 cups	Rustic Bread Loaf, cut into large pieces (I removed some of the crustier crust)
1/2 cup	Yellow onion, chopped
1 cup	Extra-virgin Olive Oil, plus more for drizzling

2 TBS Sherry Vinegar

Freshly ground black pepper, to taste

Method:

- Place salt, tomatoes, garlic, bread, and onion in a bowl, cover with boiling water, and let sit for 1 hour.
- Drain the mixture, reserving 1 cup of the soaking liquid (add to the strained tomato water). Remove the bread, and squeeze any liquid from it.
- Add the bread back to the vegetables with the reserved soaking liquid, oil, and vinegar.

- Either use a stick blender or a regular blender to puree until smooth.
- Then season with salt and pepper, and chill.
- Pour into serving bowls and top with a drizzle of oil.

··

France, Andorra, , and Italy

A Bite of France and Andorra

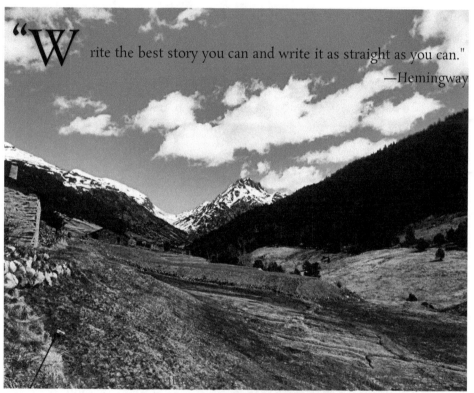

"Write the best story you can and write it as straight as you can."
—Hemingway

passion) and my time in France aided my decision. A book about my travels will happen. (And yeah, here it is, you are reading it right here, right now.)

I take a taxi from Spain into France to grab the train, and I'm here. Just like that. Two weeks cat- and chicken-sitting in the quiet city of La Roche-sur-Yon gave me time to mull it over, plan, and brainstorm. My blog will keep me on track, and once I'm home, I can sit down at my laptop and pour it all out.

La Roche-sur-Yon is on the western edge of France, a short train ride west to the Bay of Biscay. It gives me a real taste for what life in France is like outside the usual tourist spots. Other than a different language, currency and food, it's similar to home. I take a bus to find new running shoes at a sports store at a mall. Very familiar.

My high school French comes in handy. I'm adept at letting folks know, in French, pardon but my French is very bad. They appreciate it, seemingly.

Some more runs, some reading and ruminating on writing on rainy days filled my time there. A day trip to the Bay of Biscay to partake of some oysters and I'm feeling A-OK with things.

My new crew in Spain told me about Bla Bla Car, a ride-sharing app similar to AirBnB but for car rides. I start using it here in France as the trips

are less expensive than a train or bus and I get to interact with folks who are just as curious about me.

A Bla Bla Car trip to Toulouse was brought about by a family of four who "rented" me a seat in their minivan. Their 13-year-old daughter tried her English out on me and I did what I could with my French. We stop halfway through at a parking area. Other travelers pull out sandwiches and we are right there with them. Just like our trips as children, though they now have brie and jamón on baguette, while we had PB&J on white bread then. Similar but not the same.

One night is spent in Toulouse at a hostel. This is the worst one I've stayed at so far. The folks checking me in are kind, and I usually stay in mixed dorms to save money. Often, my fellow guests are young men, like James in Spain, but here I am not so lucky. Two salesmen in their 50s share the dorm with me. It smells like feet in here, and I quickly open a window to let in the warm spring air. Life isn't always perfect.

I really like the vibe of Toulouse otherwise. There is a diverse university-bolstered population, lots of fresh markets, and gorgeous historical architecture. I put it on my list of possible places to land.

Another Bla Bla Car ride diverts me to Andorra for a week. The group I ride with here are heading to the small principality to take advantage of the

duty-free shopping. Sales tax is very low, so many people shop for designer clothes, alcohol, tobacco, charcuterie, cheese, gourmet chocolate, and tinned seafood, with some making monthly trips to stock up.

I, on the other hand, am heading there because the Schengen Agreement fucked me up. Let me explain. Schengen is an EU agreement between 26 of the EU countries, including Iceland, that allows a borderless area. That means you can travel from Spain to France, or Germany to Italy, etc., without being stopped at the border and proffering your passport for review. Which sounds great.

Yet as part of the agreement, travelers within this area are allowed to stay for a total of 90 days within a six-month period. And that fucked me up. I had planned on spending about 4 months wandering about Europe and two weeks in Iceland. Schengen says no. ... Luckily, when I was in Datça, Turkey, my housemate informed me of the border agreement and I scrambled to alter my plan. Part of that scram- bling meant hopping out of Schengen areas for a time and then back in. Which is how I came to spend such a long and wonderful time in Morocco.

And why I am now in Andorra for a week, as they are in the EU and not a part of the Schengen Agreement. Andorra is a tiny (you can drive from one side of the country to the other in about an hour) principality nestled in the Pyrenees Mountains along the Spanish-French border.

The language is Catalan as is the cuisine. I've been cooking simply for myself here at the hostel to save some $$, so I haven't partaken of their meat-heavy dishes. Yet again, as I've arrived off season, I'm the only one

checked into the hostel. Silent and comfortable with a large well-equipped kitchen. Just what I need.

Ski resorts line the valley here, much like those along the I-70 corridor of Colorado—very familiar. Ski season has finished, and mountain bike season isn't for another month, that means it's quiet and peaceful. The weather has been sunny, rainy, and even snowy so I was only able to get in one trail run. But it was a truly fantastic trail, running parallel to the main road, but up high above, giving me some much-needed elevation gain.

Another day, after shopping at one of the fantastically stocked grocery stores, I await the bus to take me 20 minutes back to my hostel. A small car pulls up. A woman asks if I'm waiting for the bus. Yes, I respond. "Where are you headed?" she asks. I explain, and she says she can give me a ride as the bus isn't ever on time. I gladly accept. We chat familiarly, and I'm at my accommodations quickly. Yet another example of the kindness I've found wherever I go.

At the end of my stay, another Bla Bla Car full of shopping enthusiasts takes me out of Andorra. They are here for the day to stock up on cigarettes and alcohol. When they find out I need neither of those things, they stock up more for themselves, as each car is allowed a certain allotment per rider. We have a friendly chatty ride and they drop me at the Toulouse train station where I grab a train heading off to Paris, where I plan to spend a few days in the culinary mecca.

Paris beckoned me next, somewhat because of the food, but I must confess something many of you will think sacrilege. French food bores me. "Sacre bleu!" you exclaim, but let me explain. For 15 years, I worked and taught at a cooking school in Boulder, Colorado, where French techniques were the basis of the curriculum. I've eaten more crème brûlée than most of you can count. I'm over it. I partook of this and that, but I was no gourmand.

What drew me, personally, to Paris was the writers who have lived and written here.

Hemingway, Hugo, and Balzac are but three of the authors whose writings have fed my literary Paris fire. I found my way to 74 Rue du Cardinal Lemoine, where Ernest and his first wife Hadley squirreled away in the attic their first few months of marriage.

Then on to Shakespeare & Co., where Hemingway, James Joyce, Ford Madox Ford, and Ezra Pound found a patron in bookstore owner Sylvia Beach. It's literally across the street from Notre-Dame Cathedral, which I didn't even realize until I saw it looming there. Famously, the church played a part in Victor Hugo's *Hunchback of Notre-Dame*. Of course, I went on to the Victor Hugo museum, complete with a Rodin bust...of course....

Then there was the Balzac museum, where he toiled away on 30 cups of coffee a day. I can barely function with a cup of caffeinated tea. Here there was

yet another Rodin bust. Thick on the ground it seems, these busts.

Every corner in Paris reveals delights. My hostel is in the famous Montmartre neighborhood. The Metro and Vélib' city bikes make it easily accessible and affordable to explore outward from there. Walking and hiking up

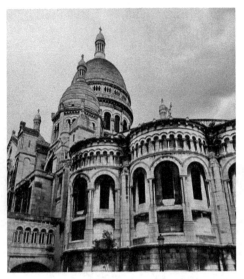

the hill behind my neighborhood brings me to the very impressive, domed Sacré-Cœur Basilica. There is also a splendid view of the city from up here. Further in Paris proper, I walk by a few of the must-see tourist spots, the Eiffel Tower and Arc de Triomphe, etc. But wandering by is all I do, not even a tour of the Louvre. Instead, I see Paris my way.

Escargot-stuffed mushrooms are eaten for lunch one day at a restaurant that old cooking school friend, Chef Andy recommended. Luxuriously bathed in butter and garlic, I partake so that I can say that I did. They tasted wonderful, as they should. Falafel are also found in the old Jewish quarter. The restaurant I try is said to have the best in the world, and I will not argue with that. Better, I think, than the ones I had in Bangkok.

I'm directed to stop by E. Dehillerin by many of my chef friends. It's a grand culinary tools emporium, with just about everything one would need to outfit their kitchen. I spend a good chunk of time window shopping and wishing my

budget would allow me to buy something. But then again, carrying anything more in my lone suitcase isn't feasible. One day, when I have more time and money, I'll explore more.

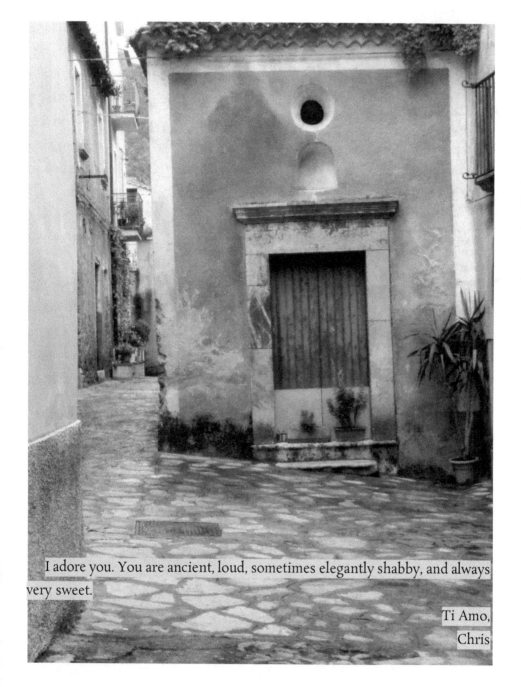

I adore you. You are ancient, loud, sometimes elegantly shabby, and always very sweet.

Ti Amo,
Chris

Almost half my ancestors came from Napoli, so spending my time in the south of the boot was my way of honoring their contribution to my genetic makeup. I didn't get to all the places I'm told you should go. But where I went will always be a part of me.

Cheap flights from Paris to Italy were easy to find if I flew into Bari, on the south-eastern coast. Then I wandered straight into a place for gelato—the first thing I ate in Italy. Luckily my mostly vegan life was still somewhat on track as it was made with almond milk. My binge-eating disorder seems to be kept at bay when I get my wandering or running in, so I'm not worried about the occasional sweets.

My hostel offered a free tour of the area with the price of the bunk, so who am I to say no? We were taken to more dinosaur tracks, which again I did it more for The Old Bird then myself. Then it was on to a bakery that has been making focaccia pomodoro in the same way for over 400 years. Watching the baker work the huge mounds of dough and keeping an attentive eye on the glowing oven before he pulled out a crusty, greasy tomato-filled delicacy only peaked my hunger. As I was waiting on line to buy a piece for myself, a woman and her bulldog appeared behind me. I started praising him in English, and she replied with a thank you. After asking his name

she informed me that it is, Steve McQueen, because of course it is.

We were taken to the very top of the city to look out over the ancient architecture. Its buildings have been kept in such great shape through the centuries that they are often called upon for movie sets. In my mind's eye, I see the ancient city dwellers walking around, going about their days here in this sunny, lovely place.

I wandered on my own along the waterfront, where I saw yet another fisherman working an octopus on the rocks to tenderize it. Two very different countries and the same technique (Tanzania and now Italy)—that means something. The perfect roasted version I had in Turkey was probably tenderized in a similar way. I'm not sure it's the way I would do it, but damn, I bet it works.

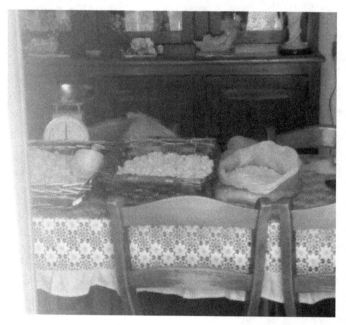

Bari is also known for its orecchiette. The small ear shaped pasta is made by hand by local artisans and set out to air dry in screened boxes. A simple tomato-sauced dish of them at a restaurant, with fresh basil on top, gives me an in-depth taste of what all the fuss is about.

Then I'm off again, on a train west across the boot and then south, to the small town of Policastro. My farm host and his 3-year-old son, Corrado, greet me and drive me up winding hills to the even smaller village of San Giovanni a Piro, which has been situated under the mountain for over 300 years. My host's family house, located up the road from the farm in the village, which I

stayed in, was that old and held secrets of family history for at least that long. An ancient olive-oil press fills the bottom floor, because of course it does.

My room—and my very own bathroom—is on the very top floor, the fourth floor, in this ancient rambling house. It's warm, and the view out over the hills and ocean is absolutely stunning.

I'm here to work on a vineyard and in the kitchen of the hotel connected to it. It's a small, boutique hotel. The owner, my host, makes his own wine,

limoncello, olive oil, and preserves from the numerous fruit trees dotting the property. Even the soup he makes for our daily luncheon is made from wild greens picked from the pasture on the side of the house. It's made with pureed beans and potatoes. Filling, healthy, and just perfect with a crusty slice of bread. It's all I need to fuel my workdays.

Those days are spent tending to grapevines, planting zucchini in the veg garden, watering plants in the greenhouse, and caring for the goats, chickens, donkeys, duck, and Rosa the dog. They slide languorously into one another. I trudge down the hill in the morning, after letting out the goats from their room at the bottom of my house and setting them to munch back the overgrowth along the roads. Then it's a quick visit to let the chickens out and on to breakfast, where I learn of my work for the day. Next, I head out for a full morning's work, then back for lunch, a little more work, then a hike back up the hill to my house in the village. Afternoons are either spent chatting with family back home, reading, napping, or wandering. I do all I can not to visit the pastry shop that is only a 10-minute walk up the cobblestone streets from my house. It's a quiet, fulfilling three weeks.

Working in the veg garden one day, I find that Rosa has done her duty and killed a rat, leaving only half of it behind. She's small, but she's mighty.

I am eternally amused by little Corrado. His English is just as good as his Italian. One day, he rushes in as I'm cleaning up lunch and, with hands gesturing wildly to convey his distress, pleads with me. "Chris, you haffa help me! My car, it is stuck!" Kids and I always seem to get along, probably because I don't have

parent buttons for them to push, and I'm just ridiculous enough for them to enjoy.

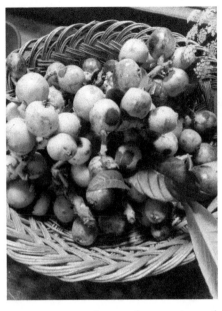

My host teaches me of the fruits and greens that I am unsure of. A basket full of nespola fruit, turn out to be loquats. They are pear-like in texture and flavor, and I find myself snacking on them whenever they are in my sight lines. Delicious.

Then there is parietaria, or pellitory, a green growing up the walls all around the property. I'm directed to feed much of it to the chickens, as it is incredibly healthy. But as it's a diuretic for human consumption, it's not thrown into the soup.

I'm relegated to working the vines until guests arrive at the hotel. Then I'm conscripted to help my host in the kitchen to get dinner together for them. Halfway through the evening, as I hand him the ladle he'll need and clean up behind him, he realizes, out loud, that he should have had me assisting with the cooking the whole day as I know my way around the kitchen. For the rest of the guests' stay, I do just that. Setting out breakfast with homemade yogurt, freshly brewed coffee, soft-boiled, farm-fresh eggs and rustic breads. Or putting together an antipasto platter with his homemade salami and cheeses. Nothing too taxing, but very much appreciated by the guests.

The soup he makes for us to eat is often served with a rustic bread called Padula bread after the village it comes from. It's been made the same way for centuries, and it's what all bread should just grow up to be. Strong, tender, and filling.

During another lunch, he informs me that he has too many eggs so he's going to fry up a few for us. He sets them before me, and I look them over, then look up him inquiringly as they are sprinkled with something. "Oh,"

he says, "I had some white truffle, too." Well, hell yeah! Back in the U.S., I shy away from truffled items, as they are usually made with truffle oil and I find the flavor to be overwhelming. But these eggs are perfect—golden orange yolks—with a gently heady and earthy truffle, as well as that strong bread. Good lord, that was good.

Edible nasturtiums are to be found all around the house, bursting forth with their peppery oranges, yellows, and reds. I pick them to add to our salads. There are also baby artichokes to be found down near the creek, and another day, we have them boiled and served with his fruity olive oil and potatoes.

He made a trade with a fisherman on another day, so for dinner we have linguini and white-clam sauce. The clams are tiny and almost sweet in their briny magnificence. A barter well-done, sir.

On an afternoon off, I wander up to the steep hill above the village, to the cliffs overlooking the Mediterranean Sea and peer down to Policastro, which sits right upon it. The views from the house looking down are impressive, but these are even more so. This area of Italy is all I've really seen, but its beauty has romanced me. Maybe it's my DNA feeling at home.

For dinner on my day off, I'm directed to try a local restaurant where the pizza is said to be the best in the area. And although it is perfectly passable pizza, it's the appetizer of fried olives that really bowls me over. First, it's fried food, so good on ya there. Then it's the salty brininess of olives that works—works really, really well.

After my first two weeks, I'm joined by fellow volunteers from Argentina and New Zealand. Again, they are much younger than I am, but it's always good to meet new people and we

share our traveling experiences. I also welcome their company when working in the vineyards.

We are driven, one day, up to "Under the Mountain" to work away the morning. I love that he calls it his vineyard under the mountain. It sounds like we are part of a Tolkien story.

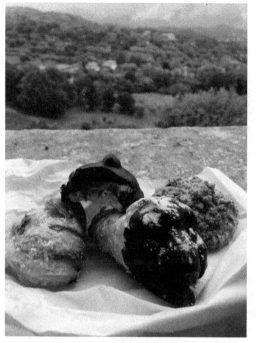

As we make our way down the rows, tying up young vines, we chat away. I find myself explaining the U.S. to them. They know of us only through other travelers they have met, the Internet and TV.

There I was, working in a tiny vineyard in a tiny village in the south of Italy, explaining states' rights and the original 13 colonies to these two curious fellows. Later I tell The Old Bird, the retired teacher, so she can gloat over the fact that such things have been kept somewhere in the dark recesses of my brain.

A haircut is in order, so the Argentinian and I take the 45-minute hike down the hill into Policastro. He uses his much better Italian to inquire at a bakery where we can find a barbershop and we are directed down the street. Several men are sitting outside drinking coffee as we approach. One of them stands to greet us, his 1980s styled silver flowing locks immediately tag him as the stylist, and he gestures us into his shop. I hop into his chair, smiling because I've been looking forward to this transformation. He immediately gestures me out. "No, no donnas, no donnas!" he repeats. No women. Oh, for crying out loud. My hair is shorter than his glorious do yet he won't cut my hair. We search further in the village with no luck. Although we do find more gelato, so all is not lost.

Napoli drew me next. I was afraid, from stories I'd heard, that this city would be rough and dangerous. Except it wasn't that for me.

I've been afraid as long as I can remember. My shyness when I was young was crippling. In high school and college, I always felt like an outsider. For years my binge drinking was my feeble attempt to cover up my presumed shortcomings. Now that I'm older, I'm bolder, and these months of travel have given me much stronger insights into the situations and people around me.

Napoli is a loud, louche city. The folks yelling back and forth to one another, mocking and teasing, were my family. Different country and different time, perhaps, but the tastes, sounds, and shabby beauty of that ancient place

were very familiar and comforting. There were fried pizzas and sfogliatella, vistas and views.

On one of the winding streets, I find shops selling small figurines for the Christmas Crèche. They have been updated from the usual shepherds and angels to pizza makers and laundresses. I find a baby Jesus for The Old Bird, who lost hers several years ago. Back then she threatened to remove the wings from one of the angels to take its place. I am non-religious, but I was horrified!

The fried pizza here is exactly as my mother and grandmother made it for us so many years ago. I used to think it was just their way, now I see it is the Neapolitan way. I find a place selling a hubcap-sized one, folded in half and handed to me in a piece of paper. I stand in the street blissfully chewing the hot dough and am transported back into a Proustian memory.

The temperature has started to rise, and I find myself wilting and sweating as I wander. Lemon ices are not my go-to dessert but finding a freshly made lemon granita at a small shop helps to cool me down. Refreshing doesn't even begin to describe it.

I try taralli napoletani, which are salty ring cookies, and sfogliatella, a lobster tail-shaped, cream-filled pastry, neither of which are anywhere near vegan as they use lard generously throughout.

Ah, when in Napoli....

Another train, and I'm north to Rome, but only for a night. I've found a hotel near the airport for my early morning flight out to Malaga and then on to Dublin. I video chat with the Old Bird and tell her I was on the street with the crèche figurines. Oh, shoot, she says, I wanted you to get... "The baby Jesus?" I excitedly exclaim. "I got it!" I'm one step ahead of her.

In Malaga, I have a 10-hour layover, so I leave my luggage in a rental locker and head via metro into the city. My former apartment mate from Turkey has just flown in to spend some time in the city, so we share a few hours wandering and, of course, grabbing lunch. These spontaneous travel moments are some of my favorite parts of this trip.

France and Italy Recipes

I did most of my own cooking in Andorra, and the food there was very heavily influenced by Spain and France, so no recipes added in here. France has only one. Italy, however, between the gelato and pizza in Naples...I did my share of research.

Stuffed Mushrooms
Serves 6-8

I've been making these things since I was a preteen. They are universal, but when I had them in France, they had snails in them. Just in case you didn't know, that ain't vegan. So here I have replicated them, but with a lot less snail, as in no snail at all, yet still full of flavor.

Ingredients:

16-20 each	Button or Cremini Mushrooms, stems trimmed, removed, and set aside
6 TBS	Olive Oil, divided
3 TBS	Garlic, minced, divided
3 TBS	Shallot, minced, divided
3 TBS	Parsley, minced, divided
¼ cup	Nuts, minced (your choice here; I'm partial to almonds or pistachios)
¼ cup	Breadcrumbs
2 TBS	Nutritional Yeast
	Salt and Pepper, to taste

Method:

- Preheat the oven to 375°F.
- Pour 1 tablespoon of olive oil onto a sheet pan, and spread around with a paper towel.
- Mince the reserved mushroom stems.

- In a bowl, mix together the minced stems, 1 tablespoon of olive oil, 1 tablespoon of garlic, 2 tablespoons of shallots, 2 tablespoons of parsley, all the bread crumbs, and nutritional yeast. Season the mix with salt and pepper.
- Stuff the mushroom caps with the bread-crumb mix, and place on the prepared sheet pan. Season with a little more salt and pepper, and place in the oven.
- Roast in the oven until golden and the mushrooms have softened, about 25 minutes.
- While the mushrooms are roasting, place a sauté pan over medium-high heat, and pour in the rest of the olive oil to heat through.
- Toss in the rest of the garlic and shallots.
- Sauté until the garlic and shallots are fragrant and slightly golden, about 3 minutes. Remove from the heat and toss in the parsley. Season with salt and pepper.
- Serve the mushrooms with the olive oil-garlic-shallot mixture drizzled over the top.

Wild Greens and Bean Soup

Serves 4-6

For three weeks, I had this soup for lunch almost every day. And I never tired of it. It's filling and gorgeous. And having a slice of rustic bread on the side ain't so bad either.

Ingredients:

2 TBS	Olive Oil
1 cup	Onion, chopped
3 cloves	Garlic, minced
6 cups	Vegetable Broth
½ lb	Red or White Waxy Potatoes, cut into bite-sized pieces
1 ½ cups	Cooked Beans, like brown lentils or borlotti, drained
1 tsp	Dried Oregano
1 tsp	Dried Basil
1 TBS	Fresh Rosemary, roughly chopped
¼ tsp	Red Pepper Flakes, or to taste
½ lb.	Wild Greens, like dandelion/arugula, stems removed and roughly chopped

Method:

- Heat a soup pot over medium-high heat. Add in the olive oil, and heat through.
- Toss in the onions and garlic, and sauté until starting to sweat, about 3 minutes.
- Add in the vegetable broth and potatoes.
- Bring to a boil then turn to a simmer. Cook until the potatoes are soft, about 20 minutes.
- Add in the beans, oregano, basil, rosemary, red pepper flakes, and greens.
- Cook for about 10 minutes more, or until the greens are very tender.
- Puree the soup with a stick blender or in a regular blender until smooth.
- Taste for seasoning, and season with salt.

Lemon Granita

Serves 4-6

For me it has to be ungodly hot to eat this. But you ain't me, so you eat it whenever you want.

Ingredients:

3 cups Water

1 ½ cups Sugar

1 cup Fresh Lemon Juice

Method:

- In a small saucepan over high heat, combine 1 cup of the water with the sugar, and bring to a boil, stirring occasionally to dissolve the sugar.
- Let the mixture cool for about 10 minutes.
- Add the rest of the water and the lemon juice, stirring to combine.
- Pour this lemon mixture into a 9- by 13-inch glass baking dish, and freeze until slushy, about 2 hours.
- Use a fork to scrape the ice crystals into the center, spread back out and freeze again.
- Repeat this scraping and spreading every 30 minutes or so, until the entire mixture has turned into ice flakes.
- Spoon into small glasses and serve.

Fried Pizza

Serves 4-8 (depending on the size you make them)

Did my mom invent these? Nope, the Neapolitans found a way to make pizza that much better. I'm glad that that DNA came down to me, because I love these damm things so much. And I love my mom for carrying on the tradition.

Ingredients:

3 cups All-Purpose Flour, with a little more for dusting

2¼ tsp Active Dry Yeast or 1 Package Active Dry Yeast

½ tsp Salt

2 tbs Olive Oil

½ TBS Sugar

1 cup Water, lukewarm (105-115° F)

2 cups Vegan or Regular Ricotta

2 cups Vegan or Regular Mozzarella, shredded

6 cups Canola Oil, for frying

3 cups Marinara Sauce, your favorite or find an easy one following this recipe.

Method:

- Mix the yeast, water, and sugar together, and let sit to begin to become active. When it starts to bubble and looks like a mocha latte in color, it is ready to use; about 10 minutes.

- Sift the flour and salt into a mound on a clean counter space. Make a well in the center. Pour the yeast mixture into the center along with the olive oil, and stir it with your hands, slowly drawing in the flour. Keep working the dough until it starts to come together. Rub off any dough that is stuck to your hands.

- *Lightly flour the surface of the counter and your hand, and begin to knead the dough, using the heel of your hands, until smooth and elastic. This should take about 5-10 minutes.*

- *Place the dough in a lightly oiled bowl, cover with plastic wrap, place in a warm part of your kitchen or house, and let rise until double in size. The time for this will depend on your altitude (it rises faster at higher altitudes) and the warmth of the area where it is resting.*

- *Heat the fry oil to 350 F.*

- *Mix the ricotta and shredded cheese together.*

- *Punch the dough down, and cut into quarters.*

- *Cut those quarters in half and using two of them, spread them out into equally sized circles. Use your hands to stretch the dough, lifting and allowing the dough to hang down off your hands as you go.*

- *Place ¼ cup of the cheese mix onto one of the rounds, spreading out, leaving about a half inch around the edge free from the mix.*

- *Place the other round over the top and press down around the edges to seal.*

- *Do this with the rest of the dough and cheese mix.*

- *Gently place one of the pizzas into the heated fry oil.*

- *Fry until golden, turning over to ensure golden all around.*

- *Serve with the marinara on the side for dipping.*

Easy Marinara

Makes 3 or so cups

There were fierce debates with my brother on how to make a marinara. I like to add onions, he adheres to my mom's garlic only rules. And as the fried pizzas were handed down to me by my mom, I'll stick with her recipe here.

Ingredients:

2 TBS Olive Oil

2 cloves Garlic, sliced thin

4 cups Tomato Puree

1 TBS Dried Basil

½ TBS Dried Oregano

Salt and Pepper to taste

Method:

- Heat the olive oil over medium-high heat in a sauce pan.

- Toss in the garlic, and sauté until fragrant and almost golden, about a minute.

- Pour in the tomatoes, carefully as it will spit at you.

- Turn the heat to high, mix in the basil and oregano, and bring to a boil.

- Turn to a simmer and cook, stirring occasionally, for 2 minutes.

- Season with salt and pepper, and use as you will.

Fried Olives

Serves 4-6

These are ridiculous. I mean, I love olives and frying them sounds like overkill, I know. But dammit, I don't care! Fry 'em, eat 'em. and leave the judgment out of it.

Ingredients:

1 ½ cups	Green Olives, pitted and stuffed if you are so inclined (I used Garlic Stuffed)
2 TBS	Vegan Egg Powder (or 1 Egg)
6 TBS	Water
2 cups	Fine Bread Crumbs
3 cups	Canola Oil, for frying

Method:

- Mix the vegan egg powder with the water. This is more water than is usually needed, but it is important that the mix isn't too thick.
- Mix the olives into the vegan egg mix, one at a time, until they are well-coated. Shake off any excess.
- Roll the olives in the bread crumbs until coated. Shake off any excess.
- Place the coated olives in the fridge to chill for 20 minutes. This sets the bread-crumb coating and will make for a crispier outside once fried.
- Preheat the fry oil in a large pot, to 360°F.

- Gently set the olives into the oil to fry, a few at a time, so as not to overcrowd the pot. Fry until golden, gently moving them about to ensure that they are golden all around.

- Remove with a slotted spoon and place on a cooling rack over a sheet pan to cool slightly.

- Serve, and enjoy!

EIGHT

••••••••••••••••••••••••••••••••••••••

Iceland, Ireland and England

Beyond Belief is Iceland

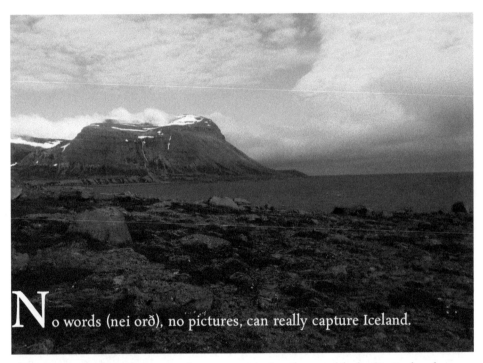

No words (nei orð), no pictures, can really capture Iceland.

I'll try. But I will fail. I can only say again, that beyond belief is Iceland.

While in the hostel in the small village in the mountains of Spain, I was chatting on Facebook with my old climbing buddy back in Boulder. I'd been wanting to hit up Iceland at some point along my journey, but I was worried

about how expensive it is. She was wanting to visit the island nation as well, for a two-week vacation. Plans started to foment for us to meet up there. I asked her to do the majority of planning. This would be almost the end of my year out and about, where I did about 90% of the preparation and arrangement of where I would go and what I would do. Since she was wanting to cram as much as possible in her two weeks, I asked her to map it out. I'd go along with most of it, and if something didn't fit into my budget or adventure expectation, we would go it alone.

We met up in Reykjavik, and I arrived a night before her. I found a hostel for myself and got my wander on. A lot of research went into where to buy groceries, as they are the most budget friendly way to feed yourself when visiting. I also found a rustic bakery where I bought a loaf of Danish rye, moist, strong, filled with seeds, and long lasting. It more than made up for its $11 price tag.

The next morning, she arrived, and we went on another wander through Reykjavik. Some research also found us a pod hostel to stay in. She wasn't used to the hostel experience and my budget request was to stay somewhere other than a pricey hotel. The compromise worked out well once she got over her preliminary hesitation.

As hot dogs are a favorite food in Iceland, similar in native fervor to our burger fascination, and are the cheapest meal you can have out when there, we find a place recommended to us. It was a small stand right outside a neighborhood hot springs pool. Luckily, everyone here speaks perfect English and credit/debit cards are the standard payment option. Not having to hit up an ATM makes life much easier.

The next day, we head to the car rental to get our camper SUV stocked up and head out. The car has GPS, a sleeping area where the back seats used to be, a sink (which we never used), and curtains to block out the sun, as it's out for about 20 hours at this time of the year. She brought sleeping bags and a tent, so we were set.

Driving our camping SUV became my job, and she became the captain, setting our course. It worked wonderfully. Her organization and my spontaneity merged into a memorable camping trip of 12 days on the Ring Road, circumnavigating the country over 3,000 miles.

Iceland has set itself as a perfect place for a camping vacation. The roads are well-marked, and well-kept, even when unpaved. iCenters for information on the surrounding area are found in every town or city. Campgrounds with kitchens, showers, and bathrooms are also easy to find.

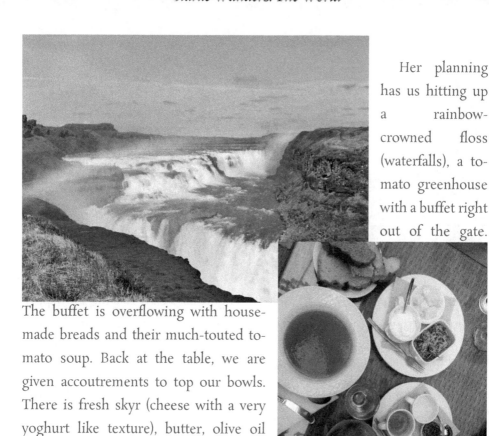

Her planning has us hitting up a rainbow-crowned floss (waterfalls), a tomato greenhouse with a buffet right out of the gate.

The buffet is overflowing with house-made breads and their much-touted tomato soup. Back at the table, we are given accoutrements to top our bowls. There is fresh skyr (cheese with a very yoghurt like texture), butter, olive oil with garlic, and a basil plant atop the table with scissors finish the meal off with a fragrant, fresh garnish finish.

I even made it to a museum she was keen on. We learned that the sod-house dwellers of yore didn't use a fireplace or furnace to heat their homes. They used body heat. Wool clothes, fatty foods and sleeping two to a bed were all that was required to keep you warm.

Not planned was finding a hot springs tub tucked behind a hillock with an unparalleled view of the ocean. We found it when I finally had to stop the car

to get my share of breathtaking photos. As soon as we realized what we were

seeing we ran back to the car, stripped down and tossed on our bathing suits.

Cell-phone reception was excellent everywhere we went in the country. As I had several bars, I called up one of my brothers for a video chat as we sat overlooking the water. "Are you supposed to be there?" he asks. Laugh-ingly I respond, "Not sure, but no one has chased us out yet!" About 20 minutes into our soak other bathers arrived so we ceded our place to them.

One of her Icelandic requirements was puffins. These fucking puffins, as we dubbed them, were too cute to eat. Though I suppose, back in the day, when the settlers were subsisting on whatever they could find, they kept many a Viking alive.

The weather and landscapes were subdued sometimes, and then a burst of color or sunshine would cause you to have to readjust your expecta-tions. The light was mesmerizing for me. I found myself waking up to see the sun rise at 2:30am. It's a light that, even now, I find myself dream-ing about. Almost clinical in its brightness, I realized that my usu-

ally tan skin still needed a reapplication of sunblock after 4 p.m. as the sun would be bright for hours yet.

I took pictures, but the phone camera couldn't capture how awe inspiring the vistas are. Around every corner, my mind would be blown—to the point of exhaustion. We were seriously tired from how amazing the landscape is. At one point, I was so exasperated by it all I kept exclaiming "Fuck you, Ice-land!" My brain just couldn't take it all in.

It took some convincing to get my buddy into a hot springs pool. She didn't get the draw. As Iceland utilizes primarily geothermal heat, almost every small town has one pool and cities have more. They are community gathering places where folks will soak and talk about their children's schooling or how well their football team is doing. (That's not American football they're discussing.)

Not only had I convinced her to go to what might be the northernmost hot springs pool in the world, but I also coerced her into bringing along a fellow traveler who was hitchhiking through our campgrounds. I understood

her hesitation, as she hasn't traveled solo as much as I have. The kindness I've seen all over the world makes me more open to asking the guy camping down the way where he's from and what he's doing in Iceland. Ultimately, she got the draw of both. We relaxed in the pool, chatted with locals and shared travel stories with our hitchhiking buddy. Three hours later, I was dragging her from the pool to find food. She took to it like...well you know....

As we winded down our car trip, we were just a bit out of Reykjavik, a little road weary, but exhilarated. As we drove along the winding road, we saw cars pulling over so that the folks could jump out and take pictures of the falls that were at the side of the road. She and I looked at one another,

chuckled, and declared, "Newbies!" Once you've seen hundreds of flosses, you've seen them all.

One of the last things we agreed to do in Reykjavik was to make a visit to the Icelandic Phallological Museum, aka the museum of penises, because why

wouldn't you? Their "collections" showcase every Icelandic animal phallus, including human. Although it is definitely a place that brings on the giggles, it also has a lot to teach. So there is that.

We met kindness at every stop. Whether it was the gals at the hot dog stand in a small fishing village, gesturing to the countless bins of candy and exclaiming, "Welcome to Iceland!" Or the family we chatted with in, what may be, the most northern hot springs pool on the planet. The wonderful pastry-baking witch who served us veggie burgers and cake at her café. And the fellow traveler Kevin from Ottawa who whole-heartedly joined us for a bit of wandering.

Iceland ain't cheap to visit, and it's almost impossible to move there, but I will go back. I want to explore, learn more, and maybe, just maybe, meet The Mountain (World's Strongest Man 2018!).

If nature can dream up Iceland, then I can surely dream too.

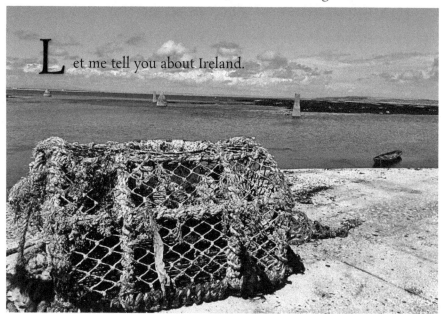

Let me tell you about Ireland.

The folks I met and stayed with were some of the sweetest I've met on my travels. Hospitable and kind. It's culturally in their DNA, I believe. And as half of my DNA hails from this Emerald Isle, I appreciated it.

After meeting D in Bilbao, she offered that I stay with her family on the outskirts of Dublin. Eagerly I agreed. It was a boon to my budget, which was blown apart after Iceland, and it gave me a true sense of life in Ireland. Her family was so welcoming that I felt right at home. Even the sound of the children at the preschool her mother runs reminded me of The Old Bird and her elementary-school classroom all those years ago.

I would grab a train into Dublin and do my usual wandering about. Number one on my list was the Trinity College Library. James Joyce studied here and wrote of it in many of his

stories *The Book of Kells*, housed here is a truly grand sight. But for me walking through the library, with the stacks soaring overhead and tables where the great writer probably toiled over his work gave me more satisfaction.

Runs along the canal and hikes were taken. Then a traditional music festival that my pal D took me to. I'm so grateful that she was able to give me a true experience. Bluegrass is a definite offshoot of the music I experienced here. The small room off to the side held a jam session that reminded me of similar jam sessions I've heard back in the states. Everyone knows the tunes and words to the songs.

One of my evenings in Dublin was spent eating a good pile of Indian food with cousins of mine from the U.S. In Ireland for a country ramble of their own, the invited me to dinner and we took on as much naan, saag, and other fabulous dishes as we could handle. Although from the Italian and Jewish side of the family, they found themselves as at home here as I did.

Cheap airfare from Ireland to London then from London to Iceland set me up with a 13-hour layover in London, so I spent the day wandering there as well. I settled my luggage into a locker and took the train into the city center. Wandering along the Thames with a wonderful view of the Shakespeare Globe Theatre and into The Tate is free, to get my then ducking Modern, which share of art.

Lunch was found at a hipster but fun place serving Soldiers and Eggs. Toast sticks with a soft- boiled egg. Just lovely. Felt right.

After Iceland, it was back to Dublin and the family for a day or two. Then I was on a bus heading out to Ennis, where Erin (friend of a friend) and her husband, Fergal, gave me the grand tour. Their hospitality only cemented my love for the Irish people. She was eager to show me the area and food. Even the simple brown sandwich bread was a revelation for me, as she showed me. Thick and strong, the way I like it.

Fergal grew up here, so his guidance was much needed as we went for a hike along The Burren. It's a large swatch of area that the glaciers cleared into a unique rock-carpeted landscape. The flora showcases arctic, Mediterranean, and alpine plants side-by-side, due to the unusual temperate environment. Pagans and Christians have also built tombs here over thousands of years. A truly unusual place and a perfect hike to give me a feel for the area.

I notice an ancient advertisement sign upon a building in one of the towns we drive through and Fergal pulls over, so I can quickly hop out to

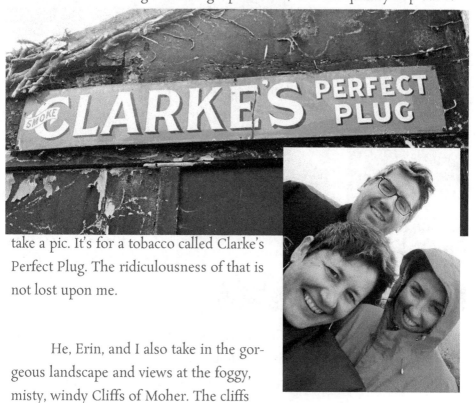

take a pic. It's for a tobacco called Clarke's Perfect Plug. The ridiculousness of that is not lost upon me.

He, Erin, and I also take in the gorgeous landscape and views at the foggy, misty, windy Cliffs of Moher. The cliffs

were barely seen through the mist, but the winds made themselves very much known. Tourists, from time to time, have been blown over the edge. What a truly Irish way to go, methinks.

I said goodbye and a heartfelt thank you to my Ennis crew and then moved on to Galway next, where I wandered for a day or so. Fergal had recommended a famous fish and chips shop here and told me I must order it with mushy peas. I didn't quite see the lure of the green sludge that sat on the side of my perfectly crisp main dish and chips. Fergal had explained that it was comfort food and came about when dried peas were used when fresh peas were out of season. Too much like baby food for my liking, but the fish and chips? Now that I did like.

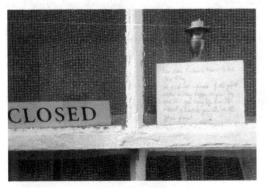 As part of my literary wanderings, I had to make way to the Nora Barnacle House in Galway. Nora was the longtime companion of James Joyce. Their intense and long-standing love has fascinated me almost as much as his writing. The tiny museum was closed as it was Bloomsday, of course. The note posted on the door exclaimed, "The Nora Barnacle House is not open today. We wish all admirers of the great writer a very happy Ulysses Day and that you enjoy

the day, the moment, wherever you are on this green planet." I found that to be most fitting.

I then hooked up with a new Galway hostel friend to take a ferry to the Aran Islands. One in particular, Inishmore. We rented bikes and spent the day riding around the island. It was a rainy day, but we avoided the raindrops and enjoyed the views. The colors of the landscape on this scantily inhabited isle were stunning. It tickles me that even after having traveled as much as I have so far, I am still astounded by new sights.

We also have dinner at a converted sea shanty down on the harbor in Galway. The ceilings are low, the menu a higher level of cuisine than the fish and chips, perhaps, with a pea-shoot risotto and dark brown bread with herbed butter. But both give me a glimpse into the cuisine here.

Next stop, Donegal. As I was walking down a footpath from my hostel, near the River Eske, I overhear a man on his phone. I shit you not, his words were, "Dis, Dat and Other...." Then back at the hostel, as I was chatting with an older couple from Scotland about the weather, one of them exclaimed, "Oh, No Dear" as if *Mrs. Doubtfire* herself had come back to life. Though I got a chuckle out of it, ultimately, I understood that I'm the one with the accent here.

The town and surrounding area, from family lore, is rumored to be where we Clarkes came from. I liked the small streets, quiet atmosphere, nearby river, and ancient buildings. An old cemetery drew my interest in the search for ancestors. I see many names that look familiar but no Clarke sightings anywhere.

For my last bit of time on the Emerald Isle, I decide to spend two days off up to Malin Head, the northernmost spot in Ireland. I take a bus to Carndonagh where I have time to waste until I can grab a taxi or bus to Malin Head. I find a sweet, little coffee shop with friendly folks who give me the directions I need to get my ride up north. And, of course, there is a sweet pastry.

My taxi takes me up the winding narrow roads as we head ever northward. As we get close to the hostel, there is a cat in the middle of the road. It lazes a bit looking up slowly at us, waiting patiently for it. Then it stands, stretches and takes its own time getting out of our way. That says a lot about where I am. There is no rush.

I should have spent more time here. It is ridiculously amazing. The views of the ocean are so astounding that *Star Wars* did some filming here.

I can see why. Two of my hostel mates drive to dinner as we share an evening at the water's edge, eating hearty, simple fare and sharing stories of our travels. The comradery of travelers has become most familiar. I am finding myself eager to chat with just about anyone. And yet, I'm also open to the fact that those I'm chatting with aren't always going to be my cup of tea. Pun intended.

Back to Dublin for a few days more. The weather has warmed, and I head to an international festival held in a large park. The food is unique,

from food trucks aplenty, and the music with rhythms that get you moving. I try some of the African food so that I can be carried back to my time in Tanzania.

I am pretty sure I will head back to Ireland one day. I only took in a tiny bit of the place, and I want more.

England, Ireland, and Iceland Recipes

There isn't too much different here. Some of the farthest most points of Ireland are similar in landscape and food as Iceland. And the day I spent in England, well it wasn't ALL food. Who am I kidding, the whole damn trip was ALL food.

Danish Rye Bread (Rugbrød)
Makes 1 Loaf

Food in Iceland is similar to England and the Nordic countries—not too exciting. But the bread I found, the rye, the $11 rye, was legendary. Before you start complaining about the ingredients and how to find them, go to the interwebs, it's on computers now, don't ya know? And either look on Amazon or the Bob's Red Mill site, and you'll find all you need. I promise.

Ingredients: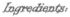

2 cups Lukewarm Water (between 95°F and 115°F)

2 tsp. Dry Active Yeast

2 TBS Sugar

2½ cups Dark Rye Flour

½ cup All-Purpose Flour

¼ cup Whole Wheat Flour

1¾ cup Cracked Rye Berries

½ cup Whole Rye Berries

½ cup Rye Flakes

¾ cup Whole Brown or Golden Flaxseeds

⅓ cup Barley (cooked, as in cook a bunch up ahead and then measure out ⅓ cup)

⅓ cup Sunflower Seeds

⅓ cup Pumpkin Seeds

⅓ cup Sliced Almonds

2 tsp Salt

1 cup Dark Yeasty Beer, room temperature (a stout or porter works fine)

1 cup Almond Milk mixed with 2 TBS Cider Vinegar (or 1 cup + 2 TBS Buttermilk)

3 TBS Traditional Rolled Oats

Method:

- *Mix the yeast and sugar into the lukewarm water, and let sit for 10 minutes until the yeast is bubbling and frothy.*
- *Mix all the dry ingredients (except the rolled oats) in the bowl of a stand mixer. Add the yeast mixture, beer, and almond milk-vinegar mixture. Stir to combine.*
- *Use the dough hook and knead on the second setting for 10 minutes, scraping down the sides of the bowl from time to time. The dough will be very sticky.*
- *Pour the dough into a very large plastic or glass bowl, giving plenty of space for the dough to rise and get bubbly. Cover loosely with plastic wrap, and set it to rest in a warm place for 48 hours to achieve the characteristic sourness of the loaf. Your house will smell yeasty and sour, which I like, but just so you know.*
- *Preheat the oven to 350°F.*
- *Line a 9- by 5- by 3-inch bread loaf pan with parchment paper. Cut it into to strips that hang over the ends and sides. Keeping some of it over the edge helps to remove the loaf once done baking.*
- *Pour the dough into the lined pan.*
- *Brush some water over the top, and sprinkle the oats evenly it to make crust.*
- *Place on the middle rack, and bake for 90 minutes, or until a skewer poked into the loaf comes out clean. The top will be very hard, which is typical.*

- *Let the loaf cool for 5 minutes in the pan, then, using the parchment paper tabs, remove and place on a cooling rack to cool completely.*
- *Slice thinly and enjoy with your favorite nut or dairy cheese spread. I ate it all broken up into pieces with Skyr (Icelandic cheese that is like yogurt).*

I suggest you have it that way too with your favorite nondairy, dairy yogurt, or even Skyr.

- *Store in an airtight container.*

- *The loaf also freezes very well, if you aren't going to be eating it all in 5-6 days.*

English Breakfast
Serves 4

Doesn't matter if you're a veg head or not, breakfast is important. And although I eat oatmeal for breakfast 90% of the time, the love I have for a heaping plate of English Breakfast will not be denied.

Ingredients:

1 lb. Red Skinned Potatoes peeled and cut small
¼ cup Vegan Margarine or butter, plus a bit more for sautéing and toast
¼ cup Non-Dairy or Regular Milk
3 tsp. Turmeric
1 tsp. Indian Black Salt (very important, as the sulfur in the salt gives the potatoes an eggy flavor)
4 each Tomatoes, cored and cut in half
12 each Button Mushrooms, sliced
2 cups Baked Beans (pg. 30) heated up
4 slices Whole Grain Bread
4 servings Vegan or Regular Sausage
4 servings Vegan or Regular Bacon
 Salt and Pepper, to taste

Method:

- Put the potatoes in a pot of cold water on high heat, and bring to a boil. Boil until nice and soft, about 15 minutes. Remove from the heat and drain.
- Melt ¼ cup of vegan margarine in a pan. Remove from heat, and mix in the black salt, turmeric, and non-dairy milk. Put the pan back on the heat to heat through. Pour this mixture over the boiled potatoes and mash. This will replicate eggs in the dish. Season with salt and pepper, and set aside.
- While the potatoes are working, cook up the vegan bacon and vegan sausage and set aside.

- *Sauté the mushrooms in a tablespoon or so of the vegan margarine, until soft and golden brown. Season with salt and pepper, and set aside.*
- *Place about a tablespoon more of vegan margarine in the sauté pan, and cook the tomatoes, starting with cut-side down, until golden. Then turn over, and cook the other side until golden. Season with salt and pepper.*
- *Toast the bread and spread with some more of the vegan margarine.*
- *To serve, each plate gets a serving of vegan bacon, vegan sausage, beans, potato, "eggs", mushrooms, tomatoes, and toast.*

Round the World Travel Tips

"How did you do it?" some of you have been asking. So here is how I managed to travel around the world for a year. (I did not receive any compensation for any of the recommendations here.)

Networking: Social media was a great way to network and put it out there that I was headed out into the world. I posted on Facebook that I was going on this trip with a link to my blog and a list of all the places I wanted to visit. And then social media did the rest. Friends who live the expat life, friends of friends, and the family members of friends all either got into contact or were put into contact with me. This gave me safe places to land with incredibly generous hosts and hospitality. I offered to and loved cooking with/for them to repay their kindness.

Country Choices: Countries were chosen for several reasons. Because of places I have always wanted to visit (Singapore, Naples, and Ireland), countries where I had friends or friends of friends (New Zealand, Australia, and Tanzania). After a U.S. State Department update told of troubles on the east coast of Malaysia, I instead traveled to Thailand and Cambodia. Some countries were chosen because of The Schengen Agreement (Morocco and Andorra) as I only had 90 days in six months to visit Europe and Iceland. A few were countries that intrigued me (Turkey and Iceland). Others were because of the food (India, Spain, Greece, and France).

Plane Ticket: My good friend Sara mentioned that there was something she had heard of—a Round the World (RTW) Ticket. I did the research, and lo and behold found it. It's through Star Alliance. They are a Lufthansa company. This gave me a ticket, going in the same direction (east for me) all the way around the world. Once I landed in each place, say Singapore or Malaga, Spain, I was on my own to get around the area. From there, I purchased trips on planes, trains, and automobiles to get me exploring. The RTW

ticket specifies that you have almost a year to use it for the amount of mileage (30,000 miles) that I purchased. Away we go!

Phone: I am a longtime T-Mobile user. I did my research and read a bunch of blogs from other travelers on the subject. Phone charges outside the states can be astronomical! All that research showed me that T-Mobile has the best plan out there. There are no upcharges, so my bill was exactly the same as when I was in the states (phone calls were 20 cents a minute). And the data was unlimited! I used Wi-Fi whenever I could, and most restaurants, coffee/tea shops and cafés had it. My Nexus 5 took great pictures and kept me connected no matter where I was. I had better reception out in the world than I do in my hometown in Upstate New York! The only two places I could not connect to a T-Mobile partner were Tanzania/Zanzibar and Morocco. I bought a $1 SIM card in Tanz and just used Wi-Fi in Morocco.

Banking: Again, digging in and researching helped a lot here. I found a CapitalOne360 Debit Card. No international or ATM fees. I carried another card as well, hidden away, in case anything was stolen. Each of the banks was informed ahead of time of the countries I would be visiting and approximately when I would be there. That way they wouldn't flag my card unnecessarily, and conversely would flag it if something odd showed up. I downloaded their banking apps and all my banking was done right from my phone. Super convenient. I made sure to photocopy the front and back of all my cards, my license and my passport. Again, in case of theft. These were kept on The Cloud, so I could access them from any computer if need be.

Budgeting: Researching blogs brought me to A Little Adrift and her experiences traveling the world. She posted a wonderful budget spreadsheet that I utilized every day to stay on budget. I sold my condo and much of my stuff to finance my trip (after paying off some loans and things) but wanted to have some $$ left over to help me once my trip was done. Volunteering in some places helped with the budget as well, as I got room and board for 4-5

hours of work a day for 5 days a week. Some were World Wide Organization of Organic Farms (WWOOF) placements (where you work on organic farms) and the rest were WorkAway. Two weeks housesitting in France came about from HouseCareers.com.

Health: I didn't really get sick anywhere. A little cold in Tanzania and a recurrence of it in Morocco were all that I had to deal with. Hot tea and rest were the perfect cure for that. A SteriPen came in handy in SE Asia where the water was suspect. Before I left the states, I went to a Travel Clinic to see what shots I needed. Some I had to have before I left the U.S., but others I could get in different countries, where they are less expensive. Perth, Australia, and Kuala Lampur both had wonderful clinics where I saved myself well over $300 getting the last of my shots and malaria pills (for India).

Luggage: The different countries I was visiting, varied modes of transportation, and general vagaboundness meant I needed luggage that would work in many different ways. My buddy Elizabeth handed off her favorite Go-Lite bag (no longer in business). It has wheels and straps so when needed I could carry it on my back. It worked perfectly. I also purchased a theft-proof bag for everyday use, to carry my passport, money, a book to read, sunglasses, et al. That and an easily tucked away grocery bag to carry boots and books on to planes, and I was ready.

Clothes and Shoes: Four seasons, 17 different countries, oceans, mountains, seas, plains, cobblestone streets, African savannas, beaches of white, black, and tan sands, snow, rain, insane humidity, heat, chilly days, gale force winds.... You're getting the idea of what I needed to pack for. I lost some things on the way, some replaced, some just left behind. I did not bring a dress. Why? Because I don't wear dresses, ever. So why bring something I won't wear?

Here is what I packed:

- 1 pair of blue jeans (which had to be replaced in SE Asia, they wore out!)
- 1 pair of 3-way convertible pants from Prana (they can be pants or capris and then the legs zip off into shorts)
- 1 pair of long shorts (they can roll down to cover the knees, which was a politeness in some cultures)
- 1 pair of running shorts
- 2 everyday tanks
- 2 running tanks
- 1 long-sleeve rash-guard shirt
- 1 long-sleeve athletic top
- 2 T-shirts
- 1 sweater (at the end of my trip I was ready to burn this damn thing. I loved having it, and I'm no real clotheshorse, but even I was sick and tired of the fucking thing.)
- 1 jacket
- 1 waterproof jacket (which I lost in India, so bought a winter worthy jacket in Tanzania and that kept me warm in Turkey!)
- 1 pair of gloves
- 1 knitted warm hat
- 1 baseball cap
- 4 pairs of running socks
- 3 pairs of regular socks
- 1 pair of tall warm socks
- 2 athletic bras
- 2 bras/underwear
- 1 bikini with 2 tops
- 1 pair of PJ bottoms
- 1 pair of hiking boots, waterproof
- 1 pair of running shoes, waterproof (walked everywhere in them, had to buy new ones once I got to Europe)

- 1 pair of Chuck Taylors (I lost my favorite Lucky Chucks, black plaid, in Marrakesh, but found a white pair of a mock brand in Europe to get me through)
- 1 pair of flip-flops
- 1 pair of walking sandals (not my favorite look for myself, but they really came in handy in the extremely hot and humid countries)
- 2 scarves (very handy for warmth and covering your head when it's polite culturally)

Lodging: I mentioned the wonderfully warm hosts who were friends or friends and family of friends who put me up as well as my volunteering in exchange for accommodations. I also found AirBnB, Hostels.com, Hostel-World.com, and Hotels.com to be the perfect resources for finding a roof over my head. Again, done all over the phone, including payments.

Takeaways: Do your research. Where you want to go, what you want to do, and who do you know. The months I had to do so before my trip was invaluable.

Public transportation around the world is much better and easier than here in the states. Subways, trains, buses, and domestic flights were all easily done, even last minute. I took very few city buses or taxis. And only the occasional Uber. And I walked A LOT. (Which made my pastry explorations much easier to justify.)

Leave yourself open to meeting new folks for new adventures and experiences. Chatting over breakfast with a gal in a Singapore hostel got me to Cambodia. Talking with a fellow hostel guest in Madrid about his travel writing career gave me more impetus to write a book about my own travels. And saying "OK" when asked "Do you want to go with us?" in Bilbao, Spain, not only got me to see Semana Santa Easter Parades, but in-depth knowledge of the food in San Sebastian and a place to stay in Dublin, Ireland!

Be adventurous with food but be smart too. I eat mostly vegan, and I am very sure that is what helped me NOT get sick in India. Use your instincts here. If it looks or smells unappetizing, it probably is not for you.

Know that not every day is going to be wonderful and exciting. Once a week, I took an admin day where I researched where I would be going next or soon, did laundry, and sometimes I just took a day to be lazy and do nothing.

There is no neat bow on the end of this trip. It was wonderful and something that I will always feel was an amazing time in my life. Yet life and the journey are never finished. There is a world of change that is needed in this country. And I hope to be positive part of that change.

And lastly, the world is a truly wonderful, kind place. Yes, bad things do happen, but they can happen no matter where you are.

ACKNOWLEDGEMENTS

There were so many folks who supported me before, during and after this trip. They put a roof over my head, fed me, cheered me on and were there for me no matter where I was. My brothers and sisters, Blaise, Justin, Katie, Aaron and Rachel Clarke, who gave me the emotional support to live out a dream. More family: My Aunts, Marguerite Webster and Ann Michele Ruocco; Nieces Emma and Sarah Clarke; and Cousins, The Vicaris and McGlinchey's, Jane and Warren; who were either right there with me in Dublin, or always a Skype or post card away. Rich Galdieri, who's real estate expertise enabled me to afford the journey. My travel buddies Chris Skees and Sheila Liewald. Opening their homes to me, many thanks go to: Juli and Greg Smith; Elizabeth O'Neil and John Heisel; Bruce and Dina Green; Carol and John Taussig; The Yellich-Landauers; Kelly Tappendorf; John Swift; Sean Conner and David Karlak; Helen and Mark Mastache; KB, DR and Pickles; Dave, Nikki, Hope, Olive and Virgil; Denise and John Frontczak; Meg and Frank Sine; Deidre and her Family Jordan in Dublin; The Coyle-Browns; Bill and Marilyn Hester; Libby and Robb; Jackie and Greg; and Peggy Markel. For their care packages: The Thompson Trio and Kainoa Raymond. For keeping me connected to home: The Jones'; Ann and Gene Fosnight; and Joe Kirwin. For pictures, recipe testing, editing and design help: Kainoa Raymond; Lisa Marino: Jeff Perry and Laurie Chipman; and Katie Genauer. For taking on the bulk of the editing and making sure I sounded like English was my first language-Lauren Piscopo.

No matter what language you use, Thank you doesn't begin to express my appreciation and love for you all.

Chris Clarke is a chowhound. She's worked in kitchens both big and small since she was 15. Now she has a podcast called "Something About Food," as she likes to talk about eating almost as much as she likes eating. She's hoping to make it as a writer and podcaster, so that the food and the conversation don't ever stop happening. Currently, she lives wherever she happens to be and may be vagabonding near you at any moment.